Material Identities

New Interventions in Art History

Series editor: Dana Arnold, *University of Southampton*

New Interventions in Art History is a series of textbook mini-companions – published in connection with the Association of Art Historians – that aims to provide innovative approaches to, and new perspectives on, the study of art history. Each volume focuses on a specific area of the discipline of art history – here used in the broadest sense to include painting, sculpture, architecture, graphic arts, and film – and aims to identify the key factors that have shaped the artistic phenomenon under scrutiny. Particular attention is paid to the social and political context and the historiography of the artistic cultures or movements under review. In this way, the essays that comprise each volume cohere around the central theme while providing insights into the broader problematics of a given historical moment.

Art and Thought
 edited by *Dana Arnold and Margaret Iversen* (published)

Art and its Publics: Museum Studies at the Millennium
 edited by *Andrew McClellan* (published)

Architectures: Modernism and After
 edited by *Andrew Ballantyne* (published)

After Criticism: New Responses to Art and Performance
 edited by *Gavin Butt* (published)

Envisioning the Past: Archaeology and the Image
 edited by *Sam Smiles and Stephanie Moser* (published)

Edges of Empire: Orientalism and Visual Culture
 edited by *Jocelyn Hackforth-Jones and Mary Roberts* (published)

Psychoanalysis and the Image
 edited by *Griselda Pollock* (published)

Museums After Modernism
 edited by *Griselda Pollock and Joyce Zemans* (published)

Material Identities
 edited by *Joanna Sofaer* (published)

Art's Agency and Art History
 edited by *Robin Osborne and Jeremy Tanner* (published)

Exhibition Experiments
 edited by *Sharon Macdonald* (forthcoming)

Pop Culture and Post-war American Taste
 edited by *Patricia Morton* (forthcoming)

Material Identities

Edited by
Joanna Sofaer

Blackwell
Publishing

BLACKWELL PUBLISHING
350 Main Street, Malden, MA 02148-5020, USA
9600 Garsington Road, Oxford OX4 2DQ, UK
550 Swanston Street, Carlton, Victoria 3053, Australia

The right of Joanna Sofaer to be identified as the Author of the Editorial Material in this Work has been asserted in accordance with the UK Copyright, Designs, and Patents Act 1988.

First published 2007 by Blackwell Publishing Ltd

1 2007

Library of Congress Cataloging-in-Publication Data

Material identities / edited by Joanna Sofaer.
 p. cm. — (New interventions in art history)
 Includes bibliographical references and index.
 ISBN-13: 978-1-4051-3234-3 (hardcover : alk. paper)
 ISBN-10: 1-4051-3234-5 (hardcover : alk. paper)
 ISBN-13: 978-1-4051-3235-0 (pbk. : alk. paper)
 ISBN-10: 1-4051-3235-3 (pbk. : alk. paper) 1. Identity (Psychology) in art. 2.
Material culture. I. Sofaer, Joanna R.

 N8217.I27M38 2007
 701—dc22
 2006020376

A catalogue record for this title is available from the British Library.

Set in 10.5/13pt Minion
by Spi Publisher Services, Pondicherry, India

The publisher's policy is to use permanent paper from mills that operate a sustainable forestry policy, and which has been manufactured from pulp processed using acid-free and elementary chlorine-free practices. Furthermore, the publisher ensures that the text paper and cover board used have met acceptable environmental accreditation standards.

For further information on
Blackwell Publishing, visit our website:
www.blackwellpublishing.com

Contents

Series Editor's Preface vii

List of Illustrations viii

Notes on Contributors x

Acknowledgments xii

Introduction: Materiality and Identity 1
Joanna Sofaer

Part I: Projecting Identities 11

1 Mai/Omai in London and the South Pacific:
Performativity, Cultural Entanglement,
and Indigenous Appropriation 13
Jocelyn Hackforth-Jones

2 Projecting Identities in the Greek Symposion 31
Robin Osborne

Part II: Material and Social Transformations 53

3 Bernini Struts 55
Michael Cole

4 Architectural Style and Identity in Egypt 67
Doris Behrens-Abouseif

5 Identifying the Body: Representing Self. Art,
Ornamentation and the Body in Later Prehistoric Europe 82
Fay Stevens

Part III: Politics and Identity 99

6 Aristocratic Identity: Regency Furniture and
 the Egyptian Revival Style 101
 Abigail Harrison-Moore

7 Architecture, Power, and Politics: The Forum-Basilica
 in Roman Britain 127
 Louise Revell

Bibliography 152
Index 163

Series Editor's Preface

New Interventions in Art History was established to provide a forum for innovative approaches to and perspectives on the study of art history in all its complexities. *Material Identities* brings together essays from scholars working across a range of disciplines to offer an authoritative and innovative consideration of the ways in which the material world is used to convey aspects of identity. The volume makes a welcome addition to a series that seeks to offer a theoretically informed transdisciplinary analysis of concerns that are germane to our understanding of the visual world.

In contrast to recent work that has stressed the personal, the individual, and the embodied, rather than the public projection and conscious manipulation of identity, this book seeks to reinstate the central role of public identities and their impact on social life. Material culture provides the means by which social relations are visualized and, as such, is the frame through which people communicate identities. The projection and the deliberate manipulation of identity raise questions about the relationship between power and identity, and here the emphasis on social practice and materiality presents a range of frameworks for a deeper understanding of the articulation of both identity and power, as well as a wider range of other reasons for the deployment of identity. This volume brings these important issues back into the mainstream of academic enquiry. The transdisciplinary approach of *Material Identities* means that it will be of value to academics and students working in the fields of art history, archaeology, material culture studies, anthropology, and design, while it fills a significant gap in the current field of identity studies.

Dana Arnold
London 2006

Illustrations

1.1 Sir Joshua Reynolds, *Omai*, 1775–6 14

1.2 *Omiah, the Indian from Otaheite, presented to their Majesties at Kew, by Mr Banks and Mr Solander July 17, 1774* 15

1.3 *Omai's entry into Tahiti, with Capt Cook, dressed in armour a gift of Lord Sandwich*, 1777 25

1.4 *A human sacrifice in a morai, in Otaheite*. Detail of an engraving after John Webber 26

2.1a–b Kylix attributed to the Foundry Painter, early fifth century BC 33

2.2 Kylix attributed to the Ashby Painter, c.500 BC 35

2.3 Kylix attributed to the wider circle of Nikosthenes, c.500 BC 40

2.4a–c Kylix attributed to the Painter of London E55, early fifth century BC 43

2.5a–b Kylix attributed to the Briseis Painter, early fifth century BC 48

3.1 Gianlorenzo Bernini, *Apollo and Daphne* 56

3.2 Nicolas Cordier, *St. Sebastian* 59

3.3 Gianlorenzo Bernini, *Apollo and Daphne* (detail) 61

4.1 The Mosque of Ibn Tulun in Cairo 72

4.2 The Mosque of Muhammad Ali in Cairo 76

4.3 The Mosque of Sultan Hasan in Cairo 78

5.1 Statue from the top of a burial mound at Ditzingen-Hirschlanden, Germany. Sandstone figure 90

5.2 Gold armlet from Aurillac, Tarn, France 91

6.1 Dominique-Vivant Denon, *Ruins of the Temple of Hermopolis* 117

7.1 Silchester forum and basilica showing approximate location of inscriptions and statues 133

7.2 Verulamium forum and basilica showing approximate location of inscriptions and statues 135

Notes on Contributors

Doris Behrens-Abouseif holds the Nasser D. Khalili Chair of Islamic Art and Archaeology at SOAS, University of London. Her publications include studies on the medieval architecture of Egypt and Syria, and urban and social history and aesthetics in the medieval Muslim world. She is the author of *Egypt's Adjustment to Ottoman Rule: Institutions, Waqf and Architecture in Cairo (16th & 17th centuries)* (1994) and of *Beauty in Arabic Culture* (1999).

Michael W. Cole is Associate Professor of Italian Renaissance and Baroque Art and Director of the Center for Italian Studies at the University of Pennsylvania. He is the author of *Cellini and the Principles of Sculpture* (2002), co-author of *The Early Modern Painter-Etcher* (2006), and co-editor of *Inventions of the Studio: Renaissance to Romanticism* (2004) and of *Idols in the Age of Art: Objects and Devotions in the Early Modern World* (2007).

Jocelyn Hackforth-Jones is a Professor of Art History and Provost at Richmond, The American International University in London. She has published widely on landscape painting and post-colonialism and on intercultural issues in relation to the visual arts, most recently in *Edges of Empire: Orientalism and the Visual Arts* (Blackwell, 2005). She is currently working on an exhibition for the National Portrait Gallery, London titled *Emissaries* and scheduled for spring 2007.

Abigail Harrison-Moore is a Lecturer in the School of Fine Art, History of Art and Cultural Studies at the University of Leeds, where she is program director for the BA in Art History with Museum Studies and the MA in Art Gallery and Museum Studies. She is author of *Architecture: The Key*

Concepts (2006) and co-editor, with Dorothy C. Rowe, of *Architecture and Design in Europe and America, 1750–2000* (Blackwell, 2006). She has also published in *Art History* (2002) and has a chapter in *Tracing Architecture: The Aesthetics of Antiquarianism* (Blackwell, 2003), edited by Dana Arnold and Stephen Bending. She is currently researching the British furniture trade in the early twentieth century and working on a book on key concepts in museum studies.

Robin Osborne is Professor of Ancient History at the University of Cambridge. He writes widely across the range of Greek history, Greek archaeology and Classical art history. He is the author of *Archaic and Classical Greek Art* (1998) and of *Greek History* (2004).

Louise Revell is a Lecturer in Archaeology at the University of Southampton. Her research interests focus on Roman public architecture and Roman identities, and she has worked in Britain, Spain, and Italy. Current projects include the inscriptions from the mid-Tiber valley, and regional difference in the Roman life course. She is also writing a book on imperialism and identity entitled *Exploring Roman Identities: Case Studies from Spain and Britain.*

Joanna Sofaer is a Senior Lecturer in Archaeology at the University of Southampton. She has published widely on ancient and modern material culture and identity, and is the author of *The Body as Material Culture: A Theoretical Osteoarchaeology* (2006), editor of *Children and Material Culture* (2000), and co-editor, with Dana Arnold, of *Biographies and Space* (2007).

Fay Stevens is a doctoral candidate at the Institute of Archaeology, University College London. She lectures in archaeology at the universities of Reading, Oxford, Bristol, and Birkbeck (University of London). Her research focuses on phenomenological research methods into the social construction of landscape and the role of material culture in prehistoric societies. She is co-director of the Bute and Arran Island Research project and is the archaeologist for an interdisciplinary research project that aims to shed new light on the prehistoric rock carvings of the Republic of Armenia. Her publications include an edited volume, *The Archaeology of Water: Social and Ritual Dimensions* (forthcoming), and she has published and exhibited a number of photographic works.

Acknowledgments

In a volume entitled *Material Identities* it seems especially apt to express my appreciation to those who helped to materialize this project. I would particularly like to acknowledge the support of Dana Arnold. Special thanks are due to Joshua Sofaer for many stimulating discussions on materiality, immateriality, and arts practice. Jill Phillips provided invaluable editorial backup and compiled the bibliography. Penny Copeland assisted with the preparation of the images. Last, but certainly not least, this book would not have been possible without the continued enthusiasm of all the contributors.

Joanna Sofaer
University of Southampton

Introduction: Materiality and Identity

Joanna Sofaer

Materiality conveys meaning. It provides the means by which social relations are visualized, for it is through materiality that we articulate meaning and thus it is the frame through which people communicate identities. Without material expression social relations have little substantive reality, as there is nothing through which these relations can be mediated. Art that is made of materials and which has a physical presence negotiates this extraordinary potential of materiality.

What to "do" about materiality – how to tackle it – is, however, a thorny issue for art historians, where what is at stake is both the exclusivity of art and the extent to which art history ought to go beyond the visual to interrogate other forms. A focus on the material pierces disciplinary boundaries and asks about the extent to which it is necessary or desirable to engage with the sociological implications or, indeed, the repercussions of art, as well as the historicity of interpretation. Nonetheless, at the same time the potential of art to convey meaning in material form is what allows it to become a critical field for commenting on social knowledge and perception. As a counterpoint to debates regarding the qualities and nature of the visual and art history's engagement with visual culture, a focus on the material asks us to explore the intersections between art history, architectural history, and archaeology as disciplines related through their common struggle to understand materiality and identity, and through these to develop interpretations of the past.

There are two key ways in which the notion and nature of materiality have previously been addressed. The first, largely that prevalent in art

history to date, relates to the ways in which artists or craftspeople manage materials and work with physical media, be those stone, metal, wood, cloth, or paint on canvas. Here discussion focuses on the physical constitution of objects[1] in terms of the ways in which works are made to "live" by their authors through revealing or concealing the materials and techniques of the ways in which they are made; what Stephen Bann has evocatively called "the quickening sense of the materiality of things."[2] It is thus about the ways in which artifacts "proclaim their presence," demanding of the viewer "a particular form of address to and negotiation with the persistence of its presentation."[3] In other words, it is about the ways in which objects provoke aesthetic responses.

The second approach to materiality, that prevalent in material culture theory, asks us to consider the relationship between people and objects, not only in terms of the ways that we come to know a work through an affective experience of it, but through the ways that objects have effects in the world at large by encoding or producing meanings – non-aesthetic responses as well as aesthetic reactions – creating or challenging the values attached to human relations. Such a perspective sees objects as agents that are active in creating social relations. This is not, however, a case of static material objects and symbols reflecting pre-existing ideas. On the contrary, the material reality anticipates the concept and it is from the creation of artifacts that the symbolic relationship between signified and signifier emerges.[4] Objects are, in this sense, "co-producers" of society in which society is built literally – not metaphorically – of arts and styles.[5] Objects have powers of transformation – one might even go as far as to say transubstantiation – qualitatively changing understandings of the world, and thus perceived realities. Objects have the power to turn savages into gentlemen, the serious-minded into fools, and artists into impresarios. They can deliver impressions of modernity or of tradition, forge class aspirations and political identities. This transubstantiation – the changing of a person or group from one kind into another – implies that the line between subject and object is blurred.[6] It is not that the object stands metaphorically for something else but that it is seen *as* the person or the identity.[7] The production of art is a creative act, not just in the sense of creating material culture but in bringing about – materializing – identities (which need not necessarily be those of the author); making them "real." Because they bring identities into being, objects are powerful media for social action and shared public understandings. Objects become "prosthetic extensions of ourselves."[8]

These two approaches to materiality – what one might broadly categor-ize as the aesthetic and the social – are not necessarily mutually exclusive. Indeed, it is in the intersection between them that some of the most fruitful ground may lie. Since experience does not reside in the object but with the viewer, one way of getting a response is to direct the viewer's attention to the formal properties of the object since its formal qualities affect the way in which the engagement with the object takes place. Here the active nature of objects also lies in their ability to elicit particular sensory responses from people and channel them, as the value and impact of objects comes, in part, from their sensory impact.[9] The response thus comes from components of materiality and the ways in which materiality is manipulated.[10] Connerton makes a similar point in his discussion of Victorian dress and embodied action.[11] The heavy, constricting, and complex clothing worn by Victorian women not only identified them as inactive, frivolous, and submissive but also created these attributes, while men's clothing allowed them to be serious, active and aggressive; the formal qualities of dress created the response and thus the identity of the person wearing it. Of critical importance is the way that an appreci-ation of aesthetic or formal qualities promotes an analysis that locates these qualities within a wider social context.

In this volume, art historians, architectural historians, and archaeolo-gists are invited to enter into a dialogue about materiality by considering both the physical and the cultural constitution of objects. They not only consider the construction of identity, but also explore the ways in which the activity of objects can be deliberately enrolled in the projection of public identities through a consideration of the ways in which the fabri-cation of identities are linked to the fabrication of the material world. Such an emphasis sits in contrast to much recent work on identity which has frequently stressed the personal and individual, whether in terms of objects as products of individual authors or in terms of individual responses to objects, rather than the deliberate manipulation of identity and a consideration of the publics for whom the consumption of particu-lar identities was intended.[12] This is, in part, a reaction against the perceived homogenization of identity in discourses of ideology and power. Yet in the search for the individual, the examination of strategies for the projection of the social persona or group identity, that might link the individual with the social, has often taken a back seat, though they form a conscious and conspicuous aspect of human life. Furthermore, an emphasis on the personal often tends to imply that there is a singular

authentic interior identity that can be revealed, although recent work in literary studies and the social sciences has shown how people can hold multiple or plural identities which may spring to the fore in different circumstances, times, and places.[13]

The manner in which these different forms of identities are expressed deserves attention. Although it is clear that materials and identities are different in different times and places, we have little idea of the specific ways in which the action of objects takes place.[14] We therefore need to focus on the specific rather than the general in considering the material articulation of identity and the ways that particular aspects of identity may be singled out, projected, and, in particular, used through specific forms of material culture. By implication, this also requires that we explore the ways that other elements of identity may be downplayed or concealed. The objects and settings explored in this volume range from Roman fora to pre-modern Islamic architecture, from portraits of the eighteenth-century Tahitian Mai to Bernini's sculpture of the mythical Apollo and Daphne, from ancient Greek drinking cups to nineteenth-century Egyptian Revival-style furniture in England, to the personal ornaments of the Iron Age. This variability of material provokes consideration of the complexity of personal and group identities and the diversity of forms of expression of identity including class, political identity, sexuality, occupation, ethnicity, gender, and combinations of these.

The complexity of identity and the ways that people can choose to play with the expression of identities in public arenas through objects form the focus of the first set of papers in the volume. In Part I, "Projecting Identities," Hackforth-Jones and Osborne explore how the material world acts both as stage and as provocation for the projection of identity, with deliberate choices made in presentations of identity for particular publics. Hackforth-Jones focuses on three different British constructs (both visual and literary) of the Tahitian, Mai (generally known by the British as Omai), who was brought back to London in 1774 by Captain Furneaux on the "Adventure" after Cook's second voyage: firstly, the representation of Mai as a gentleman, which she discusses in relation to eighteenth-century discourses of masculinity and also in relation to notions of imitation and mimicry; secondly, the more stereotypical European construct of the Tahitian as a comic buffoon; and finally, the manner in which Mai is represented during his voyage back to Tahiti in 1776, when he was (both at the command of George III and by his own request) repatriated with his own people. Not only was Mai presented in

the literature as an officer and a gentleman but he also played a crucial role as cultural interpreter, and we find him apparently acting out his relationship with his own people in accordance with his experience in London. Hackforth-Jones asks how, in the light of post-colonial studies, we might read these different views to include Mai's voice. By unpacking a number of issues in relation to indigenous agency, she argues that Mai is performing these roles and engaging in a kind of strategic mimicry for his own ends.

As a contrast to the study of a single named person, Osborne explores the ways that men were provoked into performing particular aspects of their identity in the specific context of the archaic and classical Greek symposium through the pottery that was provided by the hosts of such occasions. At these formal drinking parties, men competed in wit and put each other on the spot. The imagery on the pottery is frequently self-reflexive, suggesting the ways that those that attended these events presented themselves both in physical appearance and in behavior. The scenes on the vessels, as well as the form of vessels, establish the expectations about behavior that those scenes suggest or question. Different imagery on the drinking vessel created different expectations of the viewer, problematizing human relations in a range of ways. In the symposium there was an enforced interaction between, on the one hand, the guests' projection of their own identities by the ways in which they presented themselves and, on the other, the host's manipulation of their identities through the company his choice of pottery placed them among. Here objects were key to the construction of social relations through the performance of identity, and both guests and hosts would have been acutely aware of their own part in the interaction taking place through the vessels.

The fluidity of identity and the contextually sensitive self-conscious choices in the projection of identity pursued by Hackforth-Jones and Osborne are given a temporal dimension in the essays by Cole, Behrens-Abouseif and Stevens. In "Material and Social Transformations" they ask questions regarding the relationship between material transformations and transformations of identity. Cole discusses Bernini's *Apollo and Daphne*, a work that has come to stand as the antithesis to the modernist "truth to materials" and whose mythological theme centers on the notion of transformation through Daphne's metamorphosis into a tree. Cole argues, however, that the fantasy of the *Apollo and Daphne* itself centers on an artful transformation whereby the marble struts that act to brace the stone are part of the fantasy of the sculpture; to believe the work's illusion

is to see the "wood" between her fingers as something that has grown there, like a plant under the sun. In other words, part of the fiction of the *Apollo and Daphne* is that the fingers pre-existed the struts. Yet, the struts also look so unfinished in comparison to the rest of the work that this reminds the viewer of the transformation Bernini himself has effected. Bernini thus invited the viewer to appreciate the challenges of working with the marble block, while the sculpture also marked a change in Bernini's own professional identity, as he refashioned himself from a specialist in marble statues into an architect, designer, and general impresario. The transformations expressed by the *Apollo and Daphne* are therefore threefold: Daphne into a tree, the marble struts into leaves or twigs, and Bernini's professional identity.

Behrens-Abouseif investigates some of the mechanisms behind stylistic choices in pre-modern Islamic architecture, and the evolution of the perception of style in the nineteenth century in Egypt. Through a close historical analysis of the relationship between architecture and cultural imperatives from the medieval period to the nineteenth century, she argues that the dramatic European impact on the civil architecture of the Muslim world in the nineteenth century imposed a situation which required decisions to be made and choices to be taken for the development of mosque architecture. While medieval Egyptian descriptions of religious architecture were made primarily from the point of view of the craftsman, showing little awareness of architectural styles or links between style and political ideology, the Ottoman period introduced a new perception of architectural style in Islamic culture, associated with political meanings. In the nineteenth century when the modernization of Egypt and other Muslim countries provoked the triumph of foreign architecture in cities, the mosque acquired a retrospective character, epitomizing religious and cultural values rather than political power. Revivalism in architectural forms became a key element in the maintenance of Islamic and national identity.

Stevens explores the role of body ornaments and their associated art motifs in the expression of identity in later prehistoric Europe. The wearing and display of these striking and colorful decorative ornaments was embedded within complex social practices involving body gestures and the negotiation of meaning between the viewer and the viewed. Stevens argues that the ornaments were part of a phantasmagoria that tricked and manipulated the senses of the viewer, while the deliberate illusionary qualities of the imagery played with the fluidity of the wearer's

identity, scripting a public playing-out of shifting identities in a world where things were not as they seemed.

An emphasis on the projection and deliberate manipulation of identity naturally leads to a consideration of the links between power and identity. Previous engagements with power and identity have often been critiqued for their empiricism. A stress on social practice and materiality, however, challenges authors to develop a range of frameworks that go beyond this in exploring the articulation between identity and power, as well as a wider range of other reasons for the deployment of identity. In the section "Politics and Identity," Harrison-Moore and Revell consider a suite of relationships surrounding notions of power and identity and how these are worked through in two contrasting contexts. Harrison-Moore's essay examines the use of the Egyptian Revival style in furniture making in early nineteenth-century England in light of political and social allegiances and class identity. The Egyptian Revival style came into vogue as a result of Napoleon's expedition to Syria and Egypt in 1798–1801. Placing the furnishing of Regency homes within a wider context, she explores how the Egyptian Revival style and its association with an interest in French culture aligned those who chose it with certain political groupings, pre-dominantly associated with the Whig politics of Charles James Fox and the court of the Prince of Wales. Simultaneously it symbolized a move away from the majority who, led by the prime minister, Pitt the Younger, and George III, were concerned about French influence on English life at a time when France was perceived as the closest enemy and a threat to the safety of English society. Art and cultural consumption fulfilled a social function of legitimating social differences, and the decoration, styling, and furnishing of one's home became a vital political statement.

Revell's essay demonstrates the complexity of the relationship between power and identity, and the critical role of the material world in the constant negotiation and renegotiation that was required to maintain this relationship in the Roman Empire. She considers the rhetoric of political architecture in the Roman fora and basilicas in terms of the ways that they framed political events, and so enabled and constrained action. She explores the ways in which power was negotiated, but also how such political encounters became a moment of contention, with the possibility of failure as well as success. These encounters also created hierarchies of the less powerful by writing them out of the space, eluci-dating the ways that these areas were used to create and maintain the hierarchies of power through which the Roman Empire was held together.

All the contributors to this volume demonstrate how the material world offers a vital interpretative resource. We need to try to understand the processes that lie behind the use of objects and engage with the material if we are to develop new interpretations of the past; in this sense, identities are projected forwards and backwards through time. A trans-disciplinary interest in understanding the materiality of identity offers the opportunity for new and productive forms of scholarly engagement. In bringing together theoretically informed practitioners from different backgrounds with converging interests, this book reaffirms the central role of public identities and their impact on social life.

Notes

1 Throughout this essay, I use the word "object" to include architecture, painting, sculpture and material culture in general.
2 Stephen Bann, *The True Vine: On Visual Representation and the Western Tradition* (Cambridge: Cambridge University Press, 1989), p. 246. For a full discussion of the meaning of the phrase "the quickening materiality of things" see Richard Schiff, "Something is Happening" (*Art History* 28(5), 2005), pp. 752–82.
3 Peter de Bolla, *Art Matters* (Cambridge, Mass.: Harvard University Press, 2001), pp. 25–6.
4 Colin Renfrew, *Figuring it Out: What Are We? Where Do We Come From? The Parallel Visions of Artists and Archaeologists* (London: Thames and Hudson, 2003). See also Colin Renfrew, "Towards a Theory of Material Engagement," in Elizabeth DeMarrais, Chris Gosden, and Colin Renfrew (eds.), *Rethinking Materiality: The Engagement of Mind with the Material World* (Cambridge: McDonald Institute, 2004), pp. 23–31.
5 Bruno Latour, *We Have Never Been Modern*, trans. Catherine Porter (Cambridge, Mass.: Harvard University Press, 1991), p. 54. For further discussion see Lynn Meskell, "Introduction: object orientations," in Lynn Meskell (ed.), *Archaeologies of Materiality* (Oxford: Blackwell, 2005), p. 5.
6 For a parallel discussion of transubstantiation in terms of movement from one form of substance to another and links between different types of substance see Chris Gosden, "Making and display: our aesthetic appreciation of things and objects," in Colin Renfrew, Chris Gosden, and Elizabeth DeMarrais (eds.), *Substance, Memory, Display: Archaeology and Art* (Cambridge: McDonald Institute, 2004), pp. 37–8.
7 The notion of transubstantiation is thus closely related to Bourdieu's concept of "symbolic violence." See Pierre Bourdieu and Jean-Claude Passeron,

Reproduction in Education, Society and Culture, trans. Richard Nice (London: Sage, 1977).

8 Chris Gosden, "Making sense: archaeology and aesthetics" (*World Archaeology* 33(2), 2001), p. 164.

9 Ibid., pp. 164–5.

10 De Bolla, *Art Matters*, p. 18.

11 Paul Connerton, *How Societies Remember* (Cambridge: Cambridge University Press, 1989), p. 33.

12 For an exception to this and interesting discussion of the idea of publics see Michael Warner, *Publics and Counterpublics* (New York: Zone Books, 2002).

13 See, for example, Judith Butler, *Bodies that Matter: On the Discursive Limits of Sex* (New York: Routledge, 1993).

14 Meskell, "Introduction: object orientations" (2005).

Part I

Projecting Identities

Mai/Omai in London and the South Pacific: Performativity, Cultural Entanglement, and Indigenous Appropriation

Jocelyn Hackforth-Jones

The "Tahitian," or more properly the Raiatean, Mai was also called Omai, Omy, or Omiah by the British. "O" in Tahitian means "it is," so "Mai" is closest to the Tahitian pronunciation of the name. Mai was brought back to London by Captain Furneaux on the *Adventure* after Cook's second voyage and arrived in London (ahead of Cook) on July 14, 1774.[1]

The stereotypical visual reading of Mai as noble savage is largely generated by Sir Joshua Reynolds's famed and impressive grand-scale portrait titled *Omai* (figure 1.1) (1775–6, Private Collection, currently on loan to Tate Britain, London). Most interpretations of Mai as noble savage derive from scholars' analysis of this painting as exemplifying Reynolds' Grand Style. If the tattooing on Mai's hands (which was frequently remarked upon by his contemporaries) reinforces the notion of his otherness, his savagery,[2] the toga-like appearance of his robes perhaps suggest his civility in their appeal to a classical tradition. Interestingly, the visual representations are at odds with the literary portrayals. The visual

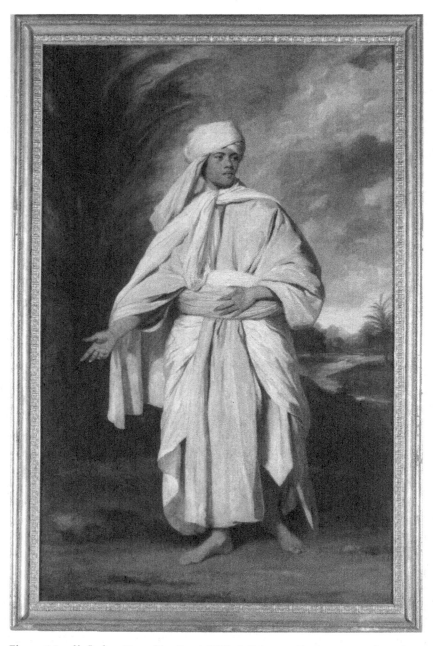

Figure 1.1 Sir Joshua Reynolds, *Omai*, 1775–6. Private collection, currently on loan to Tate Britain, London.

stereotype persists of Mai as *the* noble savage dressed in generic native clothing which (like the palm trees behind him) is freighted with notions of the exotic rather than the specificity of Tahiti.

Shortly after his arrival in London, Mai was also portrayed in an unsigned engraving of his presentation at court: *Omiah, the Indian from Otaheite, presented to their Majesties at Kew, by Mr Banks and Mr Solander, 17 July 1774* (figure 1.2), and represented as an exotic outsider, in contrast to Fanny Burney's written description of him after presentation at court (as we shall see). I will return to the Reynolds to suggest a slightly different reading of the painting which is illuminated by an analysis of Fanny Burney's descriptions and takes some account of indigenous agency.

This essay will consider different British constructs (both visual and literary) of Mai. Such an endeavor raises the issue of the challenge of reading "natives" via colonial texts, the uncertainty of this process and its speculative nature. There are a number of different perceptions of

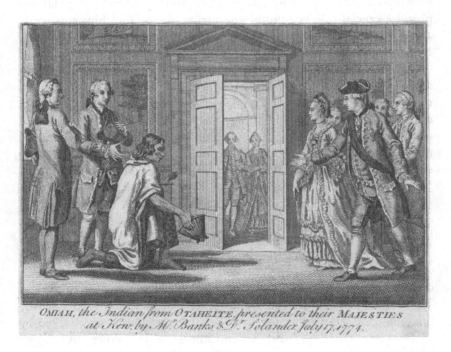

OMIAH, the Indian from OTAHEITE, presented to their MAJESTIES at Kew, by M.ʳ Banks & D.ʳ Solander July 17, 1774.

Figure 1.2 *Omiah, the Indian from Otaheite, presented to their Majesties at Kew, by Mr Banks and Mr Solander July 17, 1774.* Unsigned engraving. National Library of Australia NK 10666.

Mai – all British. How do we read these and how do we "insert" and include Mai's voice? Here I should emphasize that Western texts are my point of access to multi-sided European views of Mai and that the central question is not only how we read these perspectives but how we understand "speaking back" might take place.

Here I want to investigate at least three constructs of Mai that emerge in the literature and in many of the visual portrayals. Firstly, the representation of Mai as a gentleman will be considered in relation to eighteenth-century discourses of masculinity and also with regard to notions of imitation and mimicry. Secondly (and briefly), the more stereotypical European construct of the Tahitian as a comic buffoon will be examined. The final part of the essay will look at the manner in which Mai is portrayed during his voyage back to Tahiti in 1776, when he was (both at the command of George III and by his own request) repatriated with his own people (this was one of the reasons for Cook's third voyage). Not only is he presented in the literature as an officer and a gentleman, but Mai also played a crucial role as cultural interpreter and we find him apparently acting out his relationship with his own people, as a result of his experience in London. What is particularly interesting is the radical nature of two of these constructs: the notion of Mai not just as a gentleman but as a *model* gentleman (superior in manners, demeanor, and breeding to many contemporary English gentlemen, according to Fanny Burney), and the view of Mai as a cultural go-between and interpreter. In both instances Mai is performing these roles and engaging in a kind of strategic mimicry for his own ends. Here Nicholas Thomas's notion of cultural entanglement is helpful, particularly in his general proposition that "indigenous perceptions of, and reactions to, foreign people and goods must be taken seriously" and more generally that "in certain phases of…colonial history, indigenous peoples are no less powerful and no less able to appropriate than the whites.…"[3]

We don't know a great deal about Mai, and even his naming is a little uncertain. It may be that he chose this name to obscure his more humble origins and to link himself with the *arii* or nobility – the highest class in Tahiti. He was born on the island of Raiatea in about 1753 into the middling class or *raatira*.[4] When he was ten the island was attacked by the Bora Borans and his father died in battle. He joined numerous refugees who fled to Tahiti (one hundred miles to the south-east), where they settled. Mai was there in 1767 when Samuel Wallis arrived in Tahiti, and was still at Huahine in 1773 during the brief visit of the *Resolution* and the

Adventure in the course of Cook's second voyage. Having made friends with some of the *Adventure*'s crew, he embarked as a supernumerary, initially under the name of Tetuby Homy.[5]

Immediately upon arriving in London in 1773, Mai met Lord Sandwich, First Lord of the Admiralty, who in turn introduced him to Sir Joseph Banks and Daniel Solander. Banks introduced him to London society, installed him in his London townhouse, paid his bills, and presented him at court. There were a number of favorable circumstances which may have contributed to his emergence as a social "lyon" (to quote Fanny Burney): The educated public were already familiar with the Rousseauan notion of the superiority of the natural man over "civilized" man. More recently, the publication of two accounts of the Pacific, namely Bougainville's evocative descriptions of the paradise that was New Cythera (Tahiti) and Hawkesworth's massively popular account of Cook's first voyage in the *Endeavour*, published in 1772 and 1773 respectively,[6] had made much of the sensuous delights of the South Pacific. Both took the London reading public by storm. The climate was ripe for Mai's reception as the embodiment of "natural man."

It is evident, however, that Mai's own agenda was clear. He was aware that he needed the support of key individuals in London society to gain support and more crucially firearms in order to return to the South Pacific and annihilate the Bora Borans so that he and his family could lay claim to Raiatea. I would also speculate that Mai's appropriation of European ceremonies, modes of dress, and gentlemanly codes of behavior was the result of a conscious decision to enlist aid from influential individuals such as the King (George III), Lord Sandwich, and Sir Joseph Banks, together with that narrow band of people who constituted London "society." Here it is useful to remind ourselves of Nicholas Thomas's assertion in *Entangled Objects* that indigenous appropriation could productively be compared with European appropriation.[7]

A closer analysis of Fanny Burney's diaries provides a useful segue into understanding and unpacking Mai's performance of gentlemanliness. What we discover from reading Fanny Burney's diary is the *un*-Rousseauan notion of Mai as the "natural gentleman." She describes here her first meeting with Mai, a quiet well-mannered figure who conveyed gentlemanliness without speaking:

Omai came at 2, & Mr Banks & Dr. Solander brought him, They were all just come from the House of Lords, where they had taken Omai to hear the

> King make his speech from the Throne.... I found Omai... my Brother next to him [James Burney, Fanny's brother, had been an officer on the *Resolution*], & talking Otaheite as fast as possible. ... He rose, & made a very fine Bow. & then seated himself again. But when... told... that I was not well, he again directly rose, & muttering something of the *Fire*, in a very polite *manner*, without *speech* insisted upon my taking his seat, – & he *would* not be refused.... When Mr Strange and Mr Hayes were Introduced to him, he paid his Compliments with great politeness to them, which he has found a method of doing without *words*. [8]

Burney's emphasis on certain words (italicized above) is fascinating, hinging as it does on the notion of gentlemanliness and politeness not needing words. For in fact during the eighteenth century politeness was constructed via the art of conversation. Conversation was the supreme metaphor for politeness.[9] Clearly Mai here is not engaging in the art of conversation but outwardly conveying via expression, gesture, and the body itself all the outward forms of civility. His gentlemanliness is more to do with the visual than it is about conversation and the tongue.[10] Given that Mai came from a culture that was primarily visual and oral rather than literate, it should not be surprising that he was quick to pick up and appropriate European visual codes.

Fanny Burney's notion of Mai's gentlemanliness should also be seen via the filter of Lord Chesterfield whose recently published letters were indebted to the writings of John Locke. Mai fulfills Locke's criteria of gentlemanliness as outlined in his *Some Thoughts concerning Education*, first published in 1693 and regularly reprinted during the eighteenth century. He does this without the seduction of the word.[11] So, what we have here is Mai *performing* the role of a gentleman (I will return to this). To continue from the diary:

> As he had been to Court, he was very fine. He had on a suit of Manchester velvet, Lined with white satten, a *Bag*, lace Ruffles, & a very handsome sword which the King had given to him. He is tall & very well made... He makes *remarkably* good Bows – not for *him*, but for *any body*, however long under a Dancing Master's care. Indeed he seems to shame Education, for his manners are so extremely graceful, & he is so polite, attentive, & easy, that you would have thought that he came from some foreign court.[12]

This passage is of interest for a number of reasons. According to Locke, one of the most important components of a gentleman's education was

dancing.[13] Furthermore, Mai would have felt some affinity with the stratification, codes, and rituals of London society since there were parallels with the hierarchical and ritualized nature of Tahitian society and the emphasis on dance and movement as an integral part of a range of ceremonies. "So far from being an unsophisticated 'savage,' an untaught man of 'nature,' he was the product of a settled and relatively complex manner of life."[14] The final point of interest is Burney's view that "you would have thought he came from some foreign court"[15] – presumably a European court and therefore relatively unfamiliar – rather than that he was a native of some far-off and completely unknown land. So he was perhaps a force to be reckoned with rather than a figure deserving condescension. The diary continues: "During dinner, he called for some Drink. The man, not understanding what he would have, brought the Porter. . . . However, Omai was too well bred to send it back."[16]

Her approbation of Mai's breeding is interesting since it implies that in eighteenth-century terms he is at least the equal of his English gentlemanly counterparts. Locke had prioritized breeding which he regarded as closely allied with virtue and one of the four main qualities a gentleman desired for his son.[17] Above all, breeding for Locke was about sensitivity to others and about expressing that sensitivity in an agreeable manner.[18] In these terms Mai clearly satisfied both requirements for a gentleman of breeding. Burney goes on to suggest that in this first meeting, Mai was in some respects *superior* to English gentlemen:

> He never looked at his Dress, though it was on for the first time. Indeed he appears to be a perfectly rational & intelligent man, with an understanding far superiour to the common race of *us cultivated gentry*. . . .[19]

Here again she describes his exquisite gentlemanliness and the suggestion that as a true gentleman once attired, he was so at ease that he never once glanced down to see that his dress was in place. There is almost the sense that Mai *performs* this better than an Englishman.[20]

Mai Compared with Other English Gentlemen

To continue from Fanny Burney's diary a day or so later:

> The conversation of our house has turned ever since upon Mr *Stanhope* & *Omai* – the 1st with all the advantage of Lord Chesterfield's Instructions,

brought up at a great school [this is Chesterfield's natural son Philip Stanhope who attended Westminster School and was presented at court at Dresden when he was 15],...taught all possible accomplishments from an Infant, & having all the care, expence, labour & benefit of the best Education that any man can receive, proved after it all a meer *pedantic Booby*.[21]

Burney points out that Mai by way of contrast had had no tutor but nature, but after his relocation to England he had to change his dress, way of life, diet, country, and friends and appeared "in a *new world*" as if he had all his life

studied *the Graces*, and attended with [unre]mitting application and diligence to form his manners, [to] render his appearance & behaviour *politely easy* and *thoroughly well bred*: I think this shews how much more *Nature* can do without *art*, than *art* with all her refinement, unassisted by *Nature*.

While there are clearly echoes of Rousseau here, there are equally strong echoes of Lord Chesterfield (who in turn referred to Locke when bringing up his son). Chesterfield's letters had only recently been published by the widow of Philip Stanhope in 1774. The notion of the Graces, of polite ease and breeding, are indebted to Chesterfield. Above all, Chesterfield wanted his son Philip to be the best by imitating the best of society. The notion of imitation is essential to the acquisition of components of politeness and thus to becoming a gentleman (remembering that in the eighteenth century imitation was one of a higher order of skills). Burney is here suggesting that Mai is a gentleman because he has an innate understanding of the process of imitation which constitutes the gentlemanliness which was so valued by his contemporary English "society" counterparts. This is significant not just as imitation but because it implies that an individual can never be a gentleman unless he has been in the best of company.[22] This has the force of ensuring only limited and select access and reinforces the exclusiveness of society.

Harriet Guest has suggested that contemporaries regarded Mai's politeness and social polish "as evidence of their own cultural superiority."[23] One should also add that there is also the issue of Mai's own agenda which was to imaginatively appropriate imitation. Furthermore, as Homi Bhabha has demonstrated, the indigene may employ mimicry as a form of resistance to the colonizing power.[24] In this case I would argue that Mai is mimicking not just the external gentlemanly codes and rituals of the colonizing society, but the very process of imitation itself, for his own

ends – primarily to persuade George III and Lord Sandwich to send him back to Tahiti with firearms. The added impact is also to undermine the very discourses of civility that also defined this colonizing power.

Mai is mimicking gentlemanliness and civility and using not just the accoutrements of the gentleman: the dress, the jewelry, the sword, the hair, and the shoes, all of which are detailed in Omai's bill in the Banks papers[25] and demonstrate just how much he spent on hats, shoes, his tailor, toys, prints, wine, the ironmonger, and servants, totaling about £44,000 sterling or approximately $US80,000 while he was in London. Mai also *performed* being a gentleman using his entire body to suggest gentlemanly sensibility via gesture and expression in addition to mastering how to stand, walk, sit, and bow. One can only speculate whether at some level it was not also an irritation that this young man from Raiatea appeared to master so quickly and easily "natural" codes of gentlemanliness which took his English counterparts many years of specialist training to acquire with the assistance of dancing masters, tutors, and the Grand Tour.

It is with this picture of Mai's exquisite gentlemanliness and his imaginative appropriation of imitation in mind that we return to the Reynolds portrait of *Omai* of 1775–6 (figure 1.1). The costume and pose are usually thought to have been suggested by Reynolds. More recently, as Caroline Turner has argued, Pacific historians have enabled us to read this in a slightly different way. For not only the turban[26] but also the clothing, which in its particular form and thickness has been identified as tapa (bark), was in fact not some fictionalization of Reynolds's but genuinely recalls the white flowing robes worn by the highest class of Tahitians, the *Arii*.[27] Mai may have brought it with him and suggested it to Reynolds, or it may have been provided by Banks. One could therefore speculate that Mai perhaps had more to do with the staging of this portrait than has previously been thought.[28] It is also arguable that the patrician pose and presence are as much about Mai wanting to enhance his status in front of his English audience (given that he did not come from this class) as they are about fusing the classical idiom with the so-called representative of noble savagery. The painting then underlines the "assured place that Mai had won for himself... in English society – to be painted by one of the outstanding portrait painters of the day and exhibited along with" [29] an identical-size painting in the same Royal Academy exhibition of Georgiana Duchess of Devonshire. In this sense, then, the painting confirms Fanny Burney's impression of Mai.

Mai's grace of bearing, in this painting, in Francesco Bartelozzi's engraving, *Omai, a Native of Ulaietea, Brought into England in the year*

1774 by Tobias Furneaux (after Nathaniel Dance's drawing, *Omai*, of 1774), where he is shown carrying a feather whisk and his headrest,[30] and in William Parry's oil of *Sir Joseph Banks with Omai the Otaheitan Chief and Doctor Daniel Solander* (1775–6, jointly owned by the National Portrait Gallery, London, National Museums and Galleries of Wales, and the Captain Cook Memorial Museum, Whitby), reinforces this notion of his natural gentlemanliness and breeding, and again this may have more to do with the nature of the sitter than with a preconceived formulaic representation of the noble savage. In these visual depictions Mai is shown wearing a robe, whereas contemporary commentators such as Burney note that he wore European dress while in England. The only visual portrayal of Mai in England that makes reference to him in European dress is the engraving, published shortly after his arrival, of *Omiah, the Indian from Otaheite, presented to their Majesties at Kew, by Mr Banks and Mr Solander*, 1774 (figure 1.2). Here he is represented as more savage than gentleman, with bare feet and arms and makeshift trousers, the whole almost completely obscured by a cloak, carrying a triangular hat probably made of straw (again suggesting savagery rather than civility), and with undressed hair and no wig. There is no evidence of the suit of Manchester velvet with lace ruffles and lined with white satin described by Burney or the sword which the King had given him. Clearly there is visual resistance to portraying a "native" recently arrived in London as a gentleman in full court dress – he had to be shown as a native curiosity, as at least part savage.

Mai the Comic Buffoon

To return to Burney's account: about a year later, in December 1775, Mai paid Burney a surprise visit. She described him as "lively," "intelligent," "open," and "frank hearted."[31] As well as noting an improvement in his mastery of the English tongue, she commented on his acting skills and related that "by way of imitation"[32] Mai squeaked out his account of a recent operatic experience which by its very ridiculousness made them laugh. He also imitated pillion-riding on horseback and mimed Fanny's half-brother Dick reading.[33] Here, as a reminder that mimicry in itself is problematic and is not a homogeneous discourse, we have a slightly different (and more straightforward) account of Mai's *literal* skill as a mimic. In this instance he is aping English actions to amuse his English hostess and this clearly both engages and pleases Miss Burney.

There is a sense of the diarist perhaps shifting in her regard for Mai when her father comes in and asks him to sing a song from his native country.[34] The tune or air she finds "wild, strange, a *rumbling of sounds*" and remarks that "his *song* is the only thing *savage* about him." The story is also "laughable." She concludes with the observation that though the singing of "Omy is so barbarous, his Actions & the expression he gives to each Character, are so original & so diverting, that they do not fail to afford us very great entertainment, of the *risible* kind."[35] While the notion of Mai as performer is evident in this description we also see her shifting toward a view of Mai as a comic spectacle. Here we are increasingly moving toward a racial construction that we might expect: the other as buffoon. This shift is fascinating. When Mai is performing English actions and even excelling English gentlemen in his performance of gentility, he is deemed acceptable and at times even exemplary. When he performs his own actions and songs and refers directly to his own culture, the spectacle is no longer regarded as a performance but as indicative of his innate "barbarous" nature and thus risible. Burney seems unable to tolerate Mai's assertion of his own nature, his otherness.

A couple of weeks later (December 30, 1775) she mentions that Mai has called in with Dr. Andrews who speaks fluent Tahitian.[36] She complains that with Dr. Andrews to translate he makes very little effort to speak English and is "far less entertaining" as a result. What she seems to be suggesting is that Mai is no longer bothering to perform for his English audience. This may have been because George III had at last agreed to his going home.[37] So we see here a shift from a perception of Mai as the perfect gentleman that the ladies are ready to fall in love with to one of him as a clown.

Back to the Pacific: Mai as a Cultural Mediator

When he first encountered Mai in 1774, Cook had been unimpressed, describing him as "dark, ugly and a downright blackguard."[38] Cook was well aware that Mai was only interested in repossessing his father's land by force. During the second voyage Cook had been disappointed with Mai's skills as an interpreter and his failure to understand the language of some of the neighboring islands (the Tongapatu). By this third voyage to Tahiti in 1776, Cook had unequivocally reversed his view, both of Mai's character and of his skills as an interpreter. This perspective is substantiated in the many engraved portrayals of Mai after John Webber and in illustrations to

other accounts of the third voyage which portray Mai in British naval uniform acting as a mediator; *Omai's entry into Tahiti, with Capt Cook, dressed in armour a gift of Lord Sandwich, 1777*[39] (figure 1.3), represents him more fancifully as a triumphal European chivalric leader, dressed in armor and riding beside Cook into Tahiti, blazing his firearms, a striking personification of European power and prestige. While Lord Sandwich's gift of a suit of armor is well documented, John Rickman's description makes entertaining reading and, interestingly, he compares Mai to St. George:

> Omai, to excite their admiration the more, was dressed cap-a-pee in a suit of armour, which he carried with him and was mounted...with his sword and pike, like St. George going to kill the dragon, whom he exactly represented;...[40]

There are at times contrasting views of Mai in the written accounts of the third voyage. On the one hand he was valued as a mediator/interpreter and awarded privileged status. He was given his own cabin, special gifts, and so forth. But he was also criticized by Cook and his officers – Clarke, King, and Rickman – for being impetuous, thoughtless, tactless, and childlike. A case in point was his manner of calling out and asking the indigenous people (with whom he shared a common language) whether they ate human flesh, during the voyage from New Zealand to Tahiti.[41] Now there may have been a subversive element to this, or it may have been that Mai was using these kinds of encounters for his own ends, to demonstrate that they were "savage" and he was not. A visual case in point is a detail of Mai with Cook and other officers from *A Human sacrifice in a morai, in Otaheite*, an engraving after John Webber of 1777 (figure 1.4) which depicts Cook, Anderson, and Mai on the right, all with the dress and bearing of officers and gentlemen, observing the sacrifice in the center. According to Cook's journal, Mai expressed the Europeans' repulsion (presumably with the same agenda on Mai's part): "Omai was our spokesman and entered into our arguments with so much spirit that he put the Cheif out of all manner of patience."[42]

On Mai's return to Tahiti in August 1777 and his encounter with his own people, it is clear from Cook's and other officers' accounts, that he had been engaging in a double mimicry: not just imitating English gentlemanliness but also miming a position that he didn't occupy in his own culture. As one of Cook's officers put it:

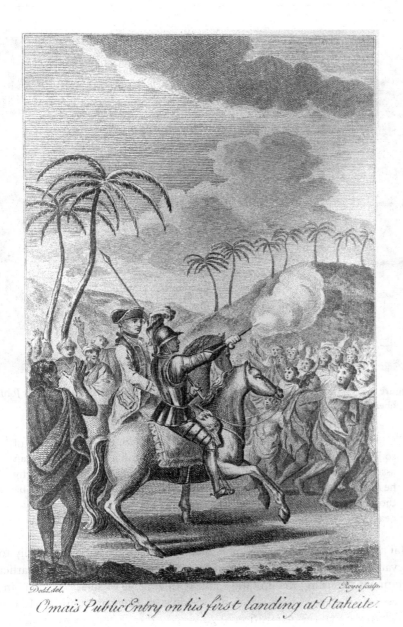

Omai's Public Entry on his first landing at Otaheite.

Dodd.del. Royce.sculp.

Figure 1.3 *Omai's entry into Tahiti, with Capt Cook, dressed in armour a gift of Lord Sandwich*, 1777. Engraving in J. Rickman (1781), *Journal of Captain Cook's last voyage to the Pacific Ocean*. E. Newbery, London. National Library of Australia NK 5094.

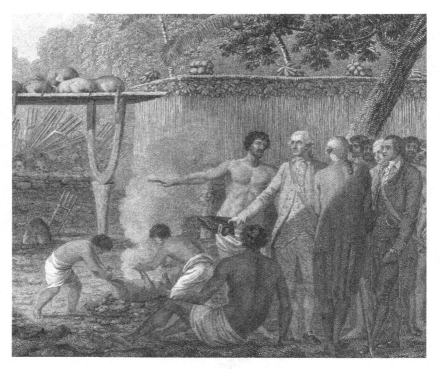

Figure 1.4 *A human sacrifice in a morai, in Otaheite.* Detail of an engraving after John Webber of 1777. National Library of Australia an 7722632.

> Captain Cook and Omai went on shore to Otoo the King, poor Omai was of so little consequence here as not to be known, we found that Omai was an assum'd name, his real name being Parridero; Captain Cook asked him why he had taken the former name in preference to his own, he reply'd that . . . he thought to pass for a great Man, by assuming ye name of a Chief who was dead,[43]

Mai appeared to be using his own encounter with Europe strategically to elevate his own position. This would seem plausible given both my earlier argument regarding his imitation and performance of model gentleman-liness and the speed with which he was able to gauge a situation. He was quick to see that the acquisition of guns and other European commodities would give him a superior status. According to Cook, he also insisted on taking two Maori boys as personal servants with him to Tahiti,[44] presumably with a view to elevating his status. Cook commented that both the

chief and Mai's family seemed indifferent to him until he presented them with gifts: "But it was evident to every one of us, that it was not the man but his property, they were in love with...."[45] For Cook, Mai's lack of prudence led to his compatriots envying his new-found wealth and acquisitions. In his view, this put Mai in a hazardous situation and it is Mai's contact with European civilization which has put him in jeopardy. What is also interesting is that Cook thought that Mai's time away in Europe meant that he had

> forgotten their customs, otherwise he must have known the extreme difficulty there would be in getting himself admitted as a person of rank, where there is, perhaps, no instance of a man's being raised from an inferior station by the greatest merit. Rank seems to be the foundation of all distinction here, and, of its attendant, power.[46]

Conclusion

Mai could successfully both mimic and excel at exquisite gentlemanliness in a manner that, arguably, undermined the very discourses of civility back in England *and* convinced the Europeans that he was a noble savage from the highest class or *arii*. This becomes more complicated and "entangled" when he returns home supplied with British arms and other gifts. However, he was also able to convince the Tahitians of his elevated status and went about dressed as an officer and a gentleman, so that, according to Rickman, he "could hardly be distinguished from a British officer."[47] This is evident also from the engravings in which he is portrayed always in European dress, acting as mediator between Tahitians and Europeans. Mai was, then, acting out his relationship with his own people as a result of his experience in London. He appears to have achieved his aim, for, before sailing on, Cook had his men build Mai a house and a strong box to guard his weapons and most prized possessions.

Nicholas Thomas may assist us in explaining both the complexity of cultural entanglement and the intricate nature of Mai's mimicry. For he suggests that

> indigenous appropriation may be compared with European appropriation to establish that both sides have creatively changed the purposes of abducted treasures, represented the other, and imagined a narrative of contact objectified in artifacts of alterity and artifacts of history.[48]

Representations of Mai as a natural gentleman embody the very notion of cultural entanglement – he was never really paraded as an exotic specimen, nor given a useful trade or educated in a bookish sense. Rather he was consistently able to mime being a gentleman and an aristocrat in two cultures for his own ends.

Acknowledgments

I want to record my heartfelt thanks to Mary Roberts and Michèle Cohen for reading and commenting on various drafts of this text. I am also extremely grateful to E. H. McCormick's pioneering and invaluable book *Omai: Pacific Envoy.*

Notes

1 Eric Hall McCormick, *Omai: Pacific Envoy* (Auckland: Auckland University Press, 1977), p. 94.

2 See also H. Guest, "Curiously marked: tattooing, masculinity, and nationality in eighteenth century British perceptions of the South Pacific," in J. Barrell (ed.), *Painting and the Politics of Culture* (Oxford: Oxford University Press, 1992).

3 For both quotes see Nicholas Thomas, *Entangled Objects: Exchange, Material Culture and Colonialism in the Pacific* (Cambridge, Mass., and London: Harvard University Press 1991), p. 184.

4 J. Tarlton and E. H. McCormick, *The Two Worlds of Omai*, exhibition catalogue (Auckland: Auckland City Art Gallery, 1977), p. 11.

5 McCormick, *Omai: Pacific Envoy*, p. 71.

6 See Louis-Antoine de Bougainville, *A Voyage round the World: Performed by Order of His Most Christian Majesty, in the Years 1766, 1767, 1768, and 1769 by Lewis de Bougainville... Commodore of the Expedition in the Frigate La Boudeuse, and the Store-ship L'Etoile*, translated from the French by John Reinhold Forster (London, 1772); and John Hawkesworth, *An Account of the Voyages Undertaken by the Order of His Present Majesty, for Making Discoveries in the Southern Hemisphere...* (London, 1773).

7 Thomas, *Entangled Objects*, p. 184.

8 Lars E. Troide (ed.), *The Early Journals and Letters of Fanny Burney. Volume II: 1774–7*, letter of December 1, 1774 (New York: Clarendon Press, 1988), p. 601.

9 Lawrence Klein, *Shaftesbury and the Culture of Politeness: Moral Discourse and Cultural Politics in Early Eighteenth-Century England* (Cambridge: Cambridge University Press, 1994).

10 Burney is also impressed by the way in which Mai evokes the notion of sensibility, reminding us that "a distinct concept and language of sensibility was also well established by the 1770s to describe styles of refinement distinguishable from and superior to those of the polite male." See P. Carter, *Men and the Emergence of Polite Society in Britain 1660–1800* (Harlow: Pearson Education, 2001).

11 I am grateful to Michèle Cohen for suggesting this phrase to me.

12 Troide, *Journals and Letters*.

13 "[B]ut you must be sure to have a good master, that knows, and can teach, what is graceful and becoming, and what gives a freedom and easiness to all the motions of the body." J. W. Adamson (ed.), *The Educational Writings of John Locke*. Cambridge: Cambridge University Press, 1922), p. 165.

14 Tarlton and McCormick, *The Two Worlds of Omai*, p. 12.

15 Troide, *Journals and Letters*.

16 Troide, *Journals and Letters*, pp. 59–61.

17 These were Virtue, Wisdom, Breeding, and Learning. See Adamson, *Educational Writings*.

18 Two things "are requisite: first, a disposition of the mind not to offend others: and, secondly, the most acceptable and agreeable way of expressing that disposition. From the one, men are called civil: from the other well-fashioned." Ibid., para. 143, p. 111.

19 Troide, *Journals and Letters*, p. 62.

20 See Homi K. Bhabha, *Nation and Narration* (London: Routledge, 1990), p. 297.

21 Troide, *Journals and Letters*, p. 63.

22 Imitation (or "contagion," as Chesterfield calls it) implies that you can never be a gentleman unless you have been in the best of company, since authentic gentlemanliness is obtained not from books but via contact. Chesterfield does not refer to contagion as a bad thing. This notion reinforces also the notion of the exclusiveness of society.

23 H. Guest, "Ornament and use: Mai and Cook in London," in K. Wilson (ed.), *A New Imperial History: Culture, Identity and Modernity in Britain and the Empire 1660–1840* (Cambridge: Cambridge University Press, 2004), p. 322. Some contemporaries, such as George Forster, lamented the acquisition of this gentlemanly politeness and social polish at the expense of education and improvement. See N. Thomas and O. Berghof (eds.), *George Forster: A Voyage Round the World*, 2 vols. (Honolulu: Hawaii University Press, 2000).

24 "The authority of that mode of colonial discourse that I have called mimicry is therefore stricken by an indeterminacy: mimicry emerges as the representation of a difference that is itself a process of disavowal. Mimicry is, thus … a complex strategy of reform, … which 'appropriates' the Other as it visualises power…. The effect of mimicry on the authority of colonial discourse is

profound and disturbing." Homi Bhabha, *The Location of Culture* (London: Routledge, 1994), p. 86.

25 Sir Joseph Banks, Papers 1745–1820. Things intended for Omai manuscript list. National Library of Australia MS9/14.

26 A similar turban is seen in drawings made in Polynesia by Hodges, such as the red-chalk drawing of Potatow by William Hodges in the Mitchell Library, Sydney, Australia.

27 "White tapa was...an indication of high rank." Pacific historians such as Bronwen Douglas believe that the drape and thickness of the turban and sash indicate tapa. See C. Turner, "Images of Mai," in *Cook and Omai*, exhibition catalogue (Canberra: National Library of Australia, 2001), p. 27.

28 Ibid.

29 Ibid.

30 The headrest was recently purchased by the Bishop Museum in Hawaii for £80,000.

31 Troide, *Journals and Letters*, pp. 193–4.

32 Troide, *Journals and Letters*, p. 195.

33 McCormick, *Omai: Pacific Envoy*, p. 159.

34 Troide, *Journals and Letters*, p. 196.

35 Troide, *Journals and Letters*, p. 197.

36 Troide, *Journals and Letters*, p. 198.

37 This was subsequently announced in the *General Evening Post*, January 25–7, 1776. See McCormick, *Omai: Pacific Envoy*, p. 163.

38 James Cook, *The Journal of Captain James Cook on his Voyages of Discovery. Volume 2: The Voyage of the Resolution and Adventure, 1772–75*, ed. John Cawte Beaglehole (Cambridge: Hakluyt Society, 1961), p. 428.

39 This is an engraving from John Rickman, *Journal of Captain Cook's Last Voyage to the Pacific Ocean* (London: E. Newbery, 1781).

40 Ibid., p. 134.

41 McCormick, *Omai: Pacific Envoy*, p. 206.

42 James Cook (1967). *The Journals of Captain James Cook on his Voyages of Discovery. Volume 3: The Voyage of the Resolution and Discovery, 1776–80, Part 2*, ed. J. C. Beaglehole (Cambridge: Hakluyt Society, 1967), pp. 197–9.

43 Williamson's journal in Cook, *Journals, 1776–80*, p. 1343.

44 James Cook. *A Voyage to the Pacific Ocean: undertaken by the command of his Majesty, for making discoveries in the Northern hemisphere*, 3 vols., vols. 1 and 2 written by J. Cook (London: W. & A. Strahan, 1784), vol. 1, pp. 135ff.

45 Ibid., vol.2., p. 9.

46 Ibid, p. 106.

47 Rickman, *Journal of Cook's Last Voyage*, p.137.

48 Thomas, *Entangled Objects*, p. 184.

2

Projecting Identities in the Greek Symposion

Robin Osborne

The proposition that parties are occasions when individuals self-consciously project identities is hardly one that will strike a contemporary reader as at all surprising. In a world where the number of occasions when a particular sartorial presentation is prescribed has become small, parties remain occasions for which participants expect to "dress up." Even by modern standards, however, the ancient Greek symposion (literally "drinking together") was a very particular sort of party. It took place in special rooms ("men's rooms," in Greek *androns,* singular *andron*) which were always arranged in the same way with couches around the edge. It was an event at which only men were guests, though women might help provide the entertainment. It had strict limits upon numbers. The drinking was regulated by the master of ceremonies, who decided how much to dilute the wine and how many mixing-bowlfuls should be consumed. The participants did not simply chat to one another but might be performed to, by dancers or actors, or be expected to perform themselves to the assembled company, whether by making speeches, singing songs, playing music, or engaging in various drinking-games.[1]

Several literary works surviving from ancient Greece either describe symposia (as in the early fourth-century works by Plato and Xenophon, both Athenians, preserved under the title *Symposion*) or were themselves performed at symposia (for example, much of archaic elegiac and iambic poetry). In the Roman period a Greek from Naukratis in Egypt, named Athenaios, composed a long work, the *Deiphnosophistai,* which is entirely devoted to information about what was done and said, eaten and drunk, at the symposion.

One of the things in which Athenaios interests himself is the vessels used at the symposion for the consumption of wine. Those vessels, and the imagery on them, are the subject of ·this chapter. Although the metal vessels which were certainly employed on some sympotic occasions have almost entirely been lost, very large numbers of ceramic vessels survive. These take a very wide variety of forms, and although some are plain, others bear a very wide variety of figurative decoration, some of it directly related to the symposion. I examine some of those vessels and the decoration on them, and explore some of the ways in which the vessels were the product of the demand by their purchasers for objects which would enable the projection of particular identities, or themselves required or encouraged the projection of a particular identity.

A Sympotic View of the Symposion

Large numbers of pots made in Greek cities between the end of the seventh and the fourth centuries BC carry images of reclining drinkers. There may be a solitary reclining figure, lying either on a couch or simply on some form of cushion directly on the ground, or there may be a number of such figures. They may themselves drink, play *kottabos* (a game involving throwing the dregs from one's cup), sing, or play a musical instrument.[2] They may be accompanied by other figures who are not reclining but offering entertainment, sometimes simply ministering to the needs of the reclining man for drink but at other times singing, dancing, or putting on some kind of musical performance.

The scenes on a shallow cup, of the shape known to modern scholars as a "kylix," which is now in Cambridge, show a number of these elements.[3] In the interior of the cup (figure 2.1a), which is attributed to the Foundry Painter and was painted in the early fifth century, a bearded and balding man is shown reclining on a couch; his cloak (*himation*) has slipped down so that it covers only his legs and he is playing the double reed pipes of the *aulos*. Beside his couch dances a smaller figure of a naked boy holding a spear. Above the couch hangs a stringed instrument of the shape known as the *barbitos*.[4] All around the exterior of the cup are further drinkers reclining one or two to a couch. On one side there are four bearded men, one of them seen back view from the end of the couch. These men pass kylikes between them or, in one case, throw up the wine they have already drunk. A lyre hangs in the background. On the other side (figure 2.1b) four

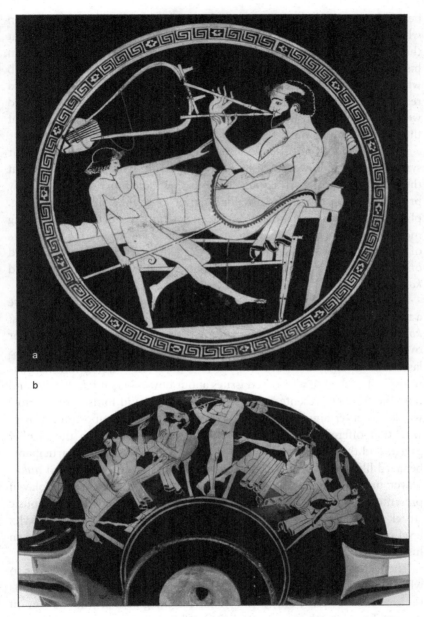

Figure 2.1a–b Kylix attributed to the Foundry Painter, early fifth century BC. Reproduced by permission of the Syndics of the Fitzwilliam Museum, Cambridge (on loan from Corpus Christi College, Lewis collection).

bearded men, reclining two to a couch, are entertained by a naked woman who plays the double *aulos*. One of the men throws back his head to sing; at the same time his companion holds the singer's kylix while drinking from his own. On the other couch one man spins his kylix around his thumb while his companion holds out kylix and jug (*oinochoe*) in one hand and reaches forward with the other, groping toward the thigh of the naked woman. All the men on this side have thrown off their himatia so that these cover nothing more than their legs.

This cup should not be seen as a snapshot of the events at a particular symposion. It is, however, clear from comparison with other images that the elements that it portrays are elements that were more or less regularly projected before those who attended symposia. Games of *kottabos*, song, playing of stringed instruments and reed instruments, drinking, admiring men or women dancing, making sexual advances, and suffering the effects of overindulgence – these are the activities which drinkers found reflected on the cups from which they themselves drank and with which they played *kottabos*.

Cups bearing such images asked those who drank from them to choose a role for themselves: what would they play at this symposion? The *aulos*? *kottabos*? the *barbitos*? Would they restrain their consumption of drink, or overindulge? Would they restrict their sexual activity to the more or less lascivious glance, or would the entertainment offer irresistible temptations? But such cups also raised issues about how others might behave and how the drinker presented with such behavior would himself react. How would the entertainment provided by the host at this symposion compare with that offered at the imaginary symposion upon which the drinker gazed? Did the drinker want to be part of a symposion whose participants behaved like that? What would he do if the host produced a naked *aulos*-player or a naked boy to do an armed dance? What would he play if presented with the *aulos* or *barbitos*? What would he sing when the music struck up and it was his turn? Could he manage to hold another's full kylix level in his left hand while drinking from his own kylix which he held in his right hand?

The self-reflexivity of sympotic images puts a limit on the degree to which they take leave of the real world. A sympotic image on a cup puts the viewer in his place only if the viewer can imagine that what he sees on the cup he might also see around him. While it is not necessary that the viewer will have been at a symposion at which women were brought in who played the *aulos* naked, it is necessary that such a possibility is one

that he can entertain. Skilled hosts will have equipped themselves with sympotic pottery suitable to produce a *frisson* among their guests, while not causing those guests to think the host crude. It was appropriate for guests to be on the edge of embarrassment, for that was the condition in which they could best show, for better or worse, their mettle. It was not appropriate that they should be too embarrassed properly to interact. If the naked *aulos* player appeared, no guest should disgrace himself. If the party ended without a naked *aulos* player ever appearing, the departing guests should feel pleasant relief, not angry frustration.

The host had one further weapon in his armoury, the shape of the drinking-vessel. Not only did kylikes come in a wide variety of shapes and sizes, but the kylix was not the only possible sympotic vessel. In particular, there was an option of providing much deeper cups, of the shape known to modern scholars as the skyphos (and there are intermediate shapes which scholars call "cup-skyphoi," too). A cup in the British Museum (figure 2.2), attributed to the Ashby Painter and dating from c.500 BC, has a scene of bearded men reclining running all round its exterior.[5] On one side, we see a naked young boy with a jug approaching a bearded and beribboned drinker who holds out a kylix. Behind him, another man, his

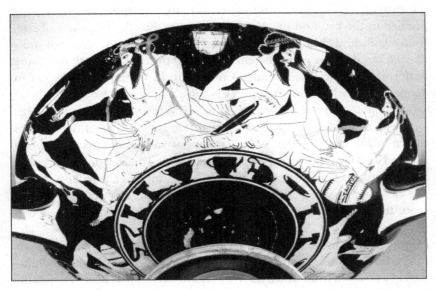

Figure 2.2 Kylix attributed to the Ashby Painter, c.500 BC. © Trustees of the British Museum.

kylix silhouetted against his body, looks back toward a man who holds up a skyphos. In a band beneath these symposiasts is a row of silhouettes of drinking-vessels and boots. This includes kylikes, jugs, and skyphoi, and also pairs of boots and a footstool.[6] Skyphoi were a lot easier to handle than kylikes, and although in scenes of drinkers reclining they are very much in a minority, when drinkers are shown having left the *andron* and reveling in the streets it is often skyphoi that they have equipped themselves with.

Skyphoi encouraged drinking deep; kylikes made that very much more difficult. How difficult they made it depends upon their size. Kylikes come in a wide range of sizes: they vary in the height of the foot, the diameter of the bowl, and the length of the handles. As can be seen in figures 2.1b and 2.2, drinkers tend to be shown holding cups by the foot, although they may use the handles when passing a cup to another symposiast. The taller the foot the more sensitively the cup needed to be tilted. Similarly, the wider a cup was in diameter the more difficult it was to drink from without pouring some of the contents down the sides of one's mouth. This is particularly difficult where the sides of the bowl do not curve sharply upwards toward the lip.[7] Some variation in size, height of foot, shape of handles, and profile of bowl is apparent in the various cups shown in use in the two scenes illustrated, and further variation is apparent in the cups profiled in the band on the Ashby Painter cup. But the full range of size, from significantly below 20 cm to above 34 cm in diameter does not show up, and nor does the very different capacity of the cups, those shown being uniformly shallow. The Foundry Painter cup in Cambridge is 29 cm in diameter, the Ashby Painter cup in the British Museum 29.6 cm.

To the potential embarrassment of the drinker unable to handle a large and deep or tall-footed cup, others might be added. One of the skyphoi shown in silhouette by the Ashby Painter has an ordinary handle on one side and a phallus spout on the other. One vessel of that shape has survived, and a number of such vessels appear in scenes on other cups or pots.[8] In one case, such a vessel is shown in use: a naked woman puts the phallus spout to her lips. It is a naked woman, too, who is shown handling a cup with a phallus-foot on a late sixth-century cup now in New York.[9] The identity of the users reveals very clearly the way in which such vessels transgress the boundary between good and bad taste, placing the symposiast in a position from which no witty repartee can rescue him. It is notable that the black-figure cup with a phallus foot, known as the "Bomford Cup" and now in the Ashmolean Museum in Oxford, is also one of the largest of

surviving cups (34.4 cm in diameter).[10] A drinker had to cope simultaneously with the size of the cup and with the fact that he was trying to control it by gripping his fingers round testicles and a hard phallus.

For the most part, the self-reflexive images of the symposion are better at giving us an idea of what the guests were faced with than of how they reacted. Most of those shown in these scenes are beardless or bearded men, dressed in himatia which have slipped more or less completely from their upper bodies but remain over their legs, normally covering their genitals; they wear wreaths or garlands, hold cups or musical instruments, and may turn, as if in conversation, or throw back their heads to sing. Although individuals are sometimes given specific words – the opening of a known piece of archaic elegiac poetry in one case – most images of the symposion, like those already illustrated, leave the specifics of the interpersonal relations at best merely hinted at.[11]

Just occasionally, however, the viewer is given hints of the identity projected by the drinker in what that drinker wears. In a small number of images, bearded men appear wearing the head-covering which scholars usually refer to as the "sakkos."[12] Men so attired appear more frequently in scenes of reveling, where they are further marked out by their wearing a long chiton and often by their carrying a sunshade or a *barbitos*. Modern discussion of these figures, traditionally associated by scholars with the poet Anacreon, has concerned itself largely with whether they are to be seen as orientalizing or as transvestite. There is good reason to think that both associations are present, neither of them exclusively, and that the figures allude to and partake of the ambivalence of the god Dionysos.[13] Dionysos is frequently presented, as most obviously perhaps in Euripides' *Bacchae*, as coming from the East and as having something feminine about him. By drawing attention to the qualities of the god who was most closely associated with wine and ecstatic states, the symposiast who donned the sakkos distanced himself as an individual from what went on at the symposion, and projected an identity as one to some degree removed from the merely human display of intoxication or sexual desire. The normally attired drinker who faced up to images of men in sakkoi and long chitones was made to ask himself just how removed from this world were the events of the symposion in which he found himself: what sort of a Dionysiac occasion was he involved in? The Bomford cup, already mentioned, juxtaposes to the experience of holding it by its peculiar foot the image, in its tondo, of drinkers in sakkoi and long chitones. Any symposiast drinking from this cup is faced with a choice of ways of construing

the occasion in which he is taking part: just how this-worldly and just how other-worldly is his experience? Just how this-worldly, and just how other-worldly, does he want it to be?[14]

The sakkos is not the only item of head-covering which sympotic scenes occasionally show men wearing. Some drinkers appear wearing the Scythian cap, a bonnet with long lappets. The Scythian, identifiable by his cap and by the tunic and trousers that he wears, is a familiar figure on late sixth-century pots, particularly as an archer in scenes involving heavily armed warriors.[15] But the Scythian caps which appear in sympotic scenes are worn by figures who have nothing else Scythian about their clothing.[16] This is true even in the exceptionally sketchy back views of single symposiasts wearing a Scythian cap, and with not a cup but a drinking-horn, that one particular painter at the end of the sixth century, the so-called Pithos Painter, specialized in. Scythians were notorious among the Greeks for drinking wine neat, rather than mixed with water, and to appear at a symposion wearing a Scythian bonnet was surely to indicate an intention to drink hard.[17] Once more, whether or not any Athenian ever turned up at a symposion wearing a Scythian cap, images of Athenians so dressed on sympotic vessels indicate that Athenians could imagine someone doing so; these images make the drinker who views them ask himself whether he should be projecting a Scythian identity himself, and how he would react were a fellow drinker to project such an identity.

The sakkos and the Scythian cap should be seen as projecting two diametrically opposed identities: those who donned the sakkos suggested that others should see their involvement in the symposion as "spiritual," and the actions of the symposion as somehow sublimated; those who donned the Scythian cap, by contrast, suggested to others that they had no intention of keeping to the urbane rules of the symposion but felt free to act in a barbarian manner. Men in sakkoi frequently appear in groups, but Scythians appear alone. Sublimating the occasion demanded cooperation, but disrupting the rules could only be done effectively by one drinker at a time.

Drinking in Company

Although images of the symposion are frequently found on drinking-vessels made in the red-figure technique and in the period between around 520 and 460, even during that period most cups show other scenes. Earlier

cups, in the black-figure technique, and later red-figure vessels show the symposion very much less frequently: drinkers at symposia during those periods were not challenged directly to compare themselves to symposiasts who featured in the imagery but to project their identity in the face of the mythological exploit, scene from everyday life, or whatever, which the painter had selected to portray.

The links between non-sympotic scenes on a pot and the sympotic activity could be more or less direct. I take here three cups which between them give an idea of the range of possible relations. I try to show how the drinking viewer is encouraged to interact with the images and challenged by them to take a stand on the sort of identity he will project.

A moderately large cup (27.3 cm in diameter), painted around 500 BC and attributed by Beazley to "the wider circle of the Nikosthenes Painter," shows, on one side, a scene of four beardless young men reclining at a symposion.[18] One figure holds a kylix but the others raise their hands in animated gestures. Below them is a band on which are silhouetted various sympotic vessels and other equipment, such as we have seen above. On the interior it shows a beribboned bearded man, naked but for a himation draped over his shoulders, in a crouched/running posture and holding a stick and a *barbitos*. This is more or less a classic "komast" pose, showing, as it were, a man who has just come from a symposion and is now reveling through the streets. These two scenes pose the sorts of direct challenges to the drinker about the identity he will project which we have examined above.

The third scene on the cup is quite different (figure 2.3). It shows a scene of warfare. Five warriors engage in vigorous fighting. There are two pairs, each consisting of one standing and one collapsed warrior, and a fifth figure who strides into the combat from the right side but does not actually engage with any other figure. One of the collapsed warriors turns his helmeted and bearded face to look out of the picture field and straight at the viewer. He is completely naked, apart from his helmet and greaves, as is the other collapsed figure and the warrior striding in from the right. The other two, victorious, figures wear helmets and have some garment tied around their waists, although in one case this garment does not conceal the genitals.

What is the drinker who finds himself handed this cup to make of this image? There is a broad, but clear, compositional "rhyme" between the scene of warfare and the sympotic scene. In both cases there is a body leaning in from the right and triangulating with a body just right of center

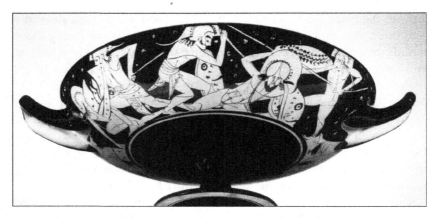

Figure 2.3 Kylix attributed to the wider circle of Nikosthenes, c.500 BC. Reproduced by permission of the Syndics of the Fitzwilliam Museum, Cambridge.

which sprawls or lunges rightwards. The left arm of this lunging figure in the scene of warfare disappears into a very rounded shield; the left arm of the reclining symposiast in the matching position falls across a very plump and rounded cushion or pillow. In both scenes there is a further right-wards-leaning body just left of center and then a hump of bodies forming an end block at the left side of the scene; in the case of the symposiasts this hump is made up of the draped legs of a reclining figure together with the fourth figure in the scene; in the case of the warriors it is made up of the two remaining figures who are in close combat.

The compositional rhyme serves as an explicit invitation to the sympo-siast to compare and contrast not only the two scenes with each other but his own position with each of them. Such a contrast raises the question of the symposiast as citizen and of the relationship between private and public life. How does the drinker's own performance compare with the liveliness of the conversation in the symposion that is pictured, or with the performance of the warriors in the scene of warfare? Does the drinker want to be remembered as someone who won in the repartee of the symposion, or someone who won in the combats of the battlefield? What does matter most to him, and what does he want others to think matters most to him?

There are two particular features of the two scenes that sharpen these questions about projection of identity. These are the frontal face of the falling warrior and the nakedness of that and of the other defeated figure.

Frontal faces are not common on painted pottery, and occur only in some very particular circumstances.[19] Those shown frontally may be dead or dying, in extreme pain or (sexual) pleasure or intoxication, or in an ecstatic state induced by music. They are all figures who are, in one way or another, taken out of themselves. It is a crucial feature of the face that stares out of the picture plain not simply that it connects with us, the viewers, but that it has broken its ties with the rest of what is going on around it in the painted scene. The frontal face of the warrior here both indicates the extremity of his suffering and makes the viewer come face to face with the possibility that this figure may at some future time offer a mirror image of his own. Fighting is not something that happens in another world but in the world to which the drinker himself belongs, just as he is part of the world of the drinkers on the other side of the cup. Will he be reduced to the last extremity by this bout of drinking or does this fate await him when he next does his martial duty for the city?

The nakedness of the fallen soldiers in the scene of warfare is not of itself unusual. Painters of this period often chose to show warriors wearing helmets and greaves but nothing else. One way of seeing this choice is that to represent warriors thus is both to make clear that they are heavily armed warriors and at the same time not to conceal in any way their manliness. But in this scene something different seems to be at issue. The painter does indeed choose to show, despite equipping him with a loin cloth, that the victorious figure in the centre of the scene is a man. But the warriors whose bodies are fully exposed are defeated. This is all of a part with the literary association in Homeric epic of nakedness and weakness. It is the defeated who are stripped of their armour. So here, the bodies of the defeated are exposed.

This exposure of the defeated warrior's body gains a perspective from the bodies of the symposiasts in the scene on the other side of the cup and the body of the bearded komast in the cup interior. The beardless symposiasts all have their torsos bare, but their legs and genitals are covered with their himatia, which they have tied round their waists in the usual way of symposiasts. But the bearded komast has slung his himation across his shoulders in a way that guarantees that his body is fully exposed to view. What will the drinker who uses this cup choose to do? Is throwing off the himation the bold thing to do, or the feeble thing to do? A sign of having drunk too much and having ceased to keep to conventions of decency, or a sign of the triumph of reason over convention? Does the man who is on top need to display his physical manliness, or does the loss

of the covering of manliness show that one is exiting from the civilized world? The drinker who looks at the scenes on this cup will have to decide, at some point in the evening's entertainment, whether he will tighten his himation round his waist or sweep it off and throw it over his shoulders. What sort of a drinker will he choose to be?

A cup painted perhaps a quarter of a century later by an artist known to scholars as "the Painter of London E55" has no scenes which depict either symposion or post-symposion revel, but its scenes allude to other areas of life with potentially close links to the symposion.[20] In the central tondo of the cup a woman is depicted who wears a chiton reaching down to her bare feet and is wrapped in a himation, from which only her right hand emerges, holding a flower bud to her nose (figure 2.4a). A richly decorated scarf is tied round her head, leaving only the front of her hair to view. Behind her, an ornate wool-basket stands on the ground and a large mirror hangs on the wall. In front of her is the end of a couch, with a mattress overhanging the end. Above the couch is written "Handsome girl" (*he pais kale*).

On each side of the exterior of this cup stand five figures, three males separated by two females (figures 2.4b and 2.4c). The two leftmost males on both sides face right, the third male and both females face left, giving two pairs, with a male "spectator" figure to the right. On one side, the men are all bearded and the women wear headscarves, on the other, the men are all beardless and the women have garlands in their hair but no covering. All the men wear only himatia, in all but one case draped over one shoulder only, to leave part of the chest bare. The women wear long chitones with himatia wrapped round them; the women on the left on both sides have both arms free and hold alabastra in their left hands; the women on the right on both sides have only their right hands extending outside the himation. All the male figures carry tall sticks with curved tops, and the bearded men to left and right have pouches hanging from their left hands. The side with the beardless men has a mirror hanging in the background between two of the figures.

It takes the viewer very little time to realize that there is a close relationship between the three scenes on this kylix. The very close parallels between the two sides, coupled with the systematic differences, compel a close viewing, while the figure in the tondo has sufficient features shared with the women on the exterior to make it clear that any interpretation of

Figure 2.4a–c Kylix attributed to the Painter of London E55, early fifth century BC.
© Trustees of the British Museum.

the exterior scenes needs also to take her into account. But what exactly is the drinker to make of these scenes?

None of the elements of these scenes is peculiar; all can be paralleled elsewhere. Take the interior scene. Ferrari has recently collected three other examples in which "standing figure at wool-basket holds bloom," although all of these are on lekythoi (with one further probable example on a lekythos and one on a kylix).[21] If we enlarge the range of possible comparanda to include women without blooms, but with wool-baskets and mirrors, the number of parallels increases enormously: these elements are very frequently combined. The interior scene to the tondo of a fragmentary cup in Paris is particularly helpful in determining the resonances of the scene: here we find a female figure, holding a mirror and an aryballos, standing beside the end of a chair on which there is an ornate wool-basket.[22] But in this case the woman is frontal, as in a mirror, with her himation elaborately draped symmetrically over both shoulders rather than wrapped around her, and on the side opposite the chair stands a laver. What these additional elements do is stress the connection with the woman's toilet and adornment: whether we choose to see this woman as having just bathed or just about to bathe, the placing of the wool-basket on the chair (rather than having the woman sit on the chair and work wool from the basket beside her on the ground), the aryballos, the holding of the mirror, and the laver all stress washing and adornment. That parallel images occur on lekythoi, themselves used for perfumed oil, further stresses the links with the female toilet. Seen against this image, the image on the tondo of the British Museum cup seems to be a subsequent moment in an imaginary narrative of washing and dressing: the woman is here fully adorned and kitted out after bathing, the mirror is hung up again and the fragrance given by the aryballos evoked by the allusion to the sweet smell of the flower which the woman holds. The woman remains in her domestic setting, for the wool-basket is still present, but the woman has hardly adorned herself in order to work wool, and the couch offers a possible hint of alternative activities.

When we turn to the outside of the cup we might, again, offer any number of parallels for the interaction of paired men and women. Once more, I draw attention to just one, a cup in Oxford. This shows, on one side, from right to left, a young man in himation with a stick facing a woman in sakkos, himation, and chiton and carrying a distaff, a bearded man in himation leaning on a stick and looking on as a woman in sakkos, chiton, and himation holds out a pair of boots in his direction while

looking toward a further bearded man whose posture more or less mirrors his own.[23] On the other side, where the presence of two columns explicitly indicates that we are in an interior scene, three young men in himatia are found and between them two women, both wearing sakkos, himation and chiton but with one closely mantled in her himation with no arm free, and the other raising one hand and looking more or less directly out of the picture. The interactions here are no more transparent than those on the British Museum cup, but some of the elements in question are more clearly articulated, in particular by the presence of the distaff and boots. We have met such boots before – in the frieze of silhouettes that also includes skyphoi and other sympotic vessels. There can be little doubt that the question of the transition of women from the domestic world of the distaff to the world of the symposion is in some sense at issue here.

Seen against the Ashmolean cup, the cup ascribed to the Painter of London E55 stands out for three things: the careful segregation of bearded and beardless men, the peculiarly detailed delineation of hand gestures, and the presence of pouches in the hands of two bearded men and aryballoi in the hands of two women. We do not as yet fully understand the language of hand gestures on Athenian vases, but, whether or not these gestures carry particular significance, there is no doubt that they draw attention to the liveliness of the exchanges going on between the figures. These are not men and women who are simply passing the time of day together, they are men and women who are engaged in sorting something out. What exactly they are sorting out depends in part on what we think is in the pouches carried by two of the bearded men. Scholars have argued about whether such pouches, which make a frequent appearance in scenes in which both men and women appear, are to be seen as moneybags or as bags containing knucklebones.[24] Neither interpretation well suits all the circumstances in which such pouches appear, and rather than opt for one or the other interpretation we should contemplate the possibility that the contents of the pouches were as inexplicit for an ancient viewer as they are for us. These images become not images of an exchange of a definitive kind, but images for which the drinking viewer has to supply the crucial information himself, according to how he is inclined to view the scenes. The presence of aryballoi here, and of the mirror in the background, suggests that the viewer's attention is being drawn to the adornment of these women: these are women who have presented themselves to men with care. But what sort of women are they, and what sort of interaction might ensue? Do we have the innocent chat of young men and maidens?

Or the serious courtship that involves exchanging gifts? Or are the fragrant attractions of these women to be acquired for money? The drinking viewer is challenged by these scenes to consider the identity which he himself chooses to project in his relations with women. Does he wish to be seen as the sort of man who buys his pleasures? Or as an innocent youth content with lively conversation? Or will he merely stand to one side and watch his fellow symposiasts as they go variously about their courtship?

A cup attributed to the Briseis Painter, and painted around 480 BC, develops a quite different side of sympotic identity.[25] On the exterior of this cup is a scene of satyrs and maenads dancing in a rocky landscape and in the presence of the god Dionysos (figure 2.5a). The cult of the god Dionysos was notoriously associated with women going off to isolated mountainsides, handling, and even tearing apart, wild animals, and generally raving. The question of the acceptability, or otherwise, of such Dionysiac cult activity is the subject of Euripides' tragedy *Bacchae* from the last decade of the fifth century (but probably following a plot that had already featured on stage in the early fifth century). Vase painters had shown Dionysos with female worshipers and with satyrs from early in the sixth century, and while the presence of satyrs guarantees that these images could not be seen as straightforward representations of cult activity, there is no particular story articulated in myth which involves satyrs, maenads and the ecstatic worship of Dionysos.[26] Satyrs had virtually no place in mythology, but they did acquire a presence on the stage, in plays which formed part of the festival of Dionysos and which had actors dressed as satyrs forming the chorus in humorous enactments of various myths.

The scenes on this cup can largely be paralleled in scenes on other pots, but it is unusual in two particular respects. One is that the god himself is shown dancing in a drunken or ecstatic way, holding out a thyrsos and a snake and kicking high his heel (shod in a wonderful "Thracian" boot, of the sort more normally associated with the traveling god Hermes).[27] The second is that one of the maenads carries a wineskin. The allegation that women have secret drinking sprees is found in Athenian comedy, and Euripides has it alleged that the Theban women possessed by Dionysos drink wine, but respectable women and wine did not mix. Although the women associated with Dionysos may pour libations they are normally not shown drinking or equipped with cups.

The presence of the god Dionysos on a drinking-cup must always raise the question of the relationship between the Dionysiac activities of the symposion and the Dionysiac activities of cult. But the peculiarities of this

cup concentrate the drinker's attention unusually sharply on the question of the difference between the two. Should cult be seen as the final stage of sympotic excess, when the mixed wine of the crater (wine-mixing bowl) has been replaced by the unmixed wine of the wineskin and when participants are freed to act in the unconstrained manner of Thracians or satyrs? Is the contrast between the domestic and enclosed space of the *andron* and the rocky space of the countryside parallel to a contrast between the constrained behavior expected in the symposion and the unconstrained behavior allowed in cult? Does the liberation of Dionysiac cult justify behaving like a satyr in the symposion and ignoring conventions of self-control?

The drinker whose encounter with the scenes on the outside of this cup prompts such considerations will, on draining the cup, be faced with a rather different scene in the interior (figure 2.5b). This is the scene of a bald man with stubbled chin, wearing a decorated chiton under his himation, arriving at a door where he is met by a young man holding a spear and with a himation thrown round his shoulders. Neither figure is identified by a label, and the viewer is left to construct a narrative according to the visual clues offered. Of these, the most striking is the shaved chin of the old man. As Williams has shown, on Athenian pots it is almost always old men who are shown with shaven beards or heads, and these men are generally closely related to moments of transition – they mourn a death, or are fathers of daughters about to be married or of sons who depart for war.[28] The shaved beard was particularly associated with Priam, the father who had most to mourn about, so much so, indeed, that a comic poet could use "to be priamed" for "to be shaved." Priam is frequently shown shaved on the popular vase imagery in which he is shown visiting Achilles to ransom the body of his son Hector. One possibility which the sympotic viewer would certainly have entertained, therefore, is that this figure is Priam, and that the door stands for Achilles' tent, within which lies Hector's corpse. Yet this is not the standard iconography of that scene, which shows Priam inside the tent before Achilles himself, and there is no sign here of Hermes who guides Priam to the tent or of the large ransom which Priam brings. No ancient viewer can have been confident of his interpretation, and the focus of the scene must lie not in thinking about Priam and Achilles, or about any other particular myth, but in thinking about old men, young men, and the moments of transition that come with the warfare here signaled by the young man's spear.

Figure 2.5a–b Kylix attributed to the Briseis Painter, early fifth century BC. © Trustees of the British Museum.

The drinker whose view of the outside of this cup has encouraged him to project a liberated identity and contemplate the Dionysiac world outside the confines of the *andron* is here made to think about encounters not with the gods but with other men, and in particular to think about the ways in which family transitions may impinge on his life as a father and on his father's life. If the exterior encouraged a mature Athenian symposiast to fluff up his beard to emulate the luxuriance of the facial hair of Dionysos and the satyrs, the interior reminded him of those occasions when that beard would be shaved. If the exterior encouraged a beardless Athenian to wonder about those occasions on which the influence of Dionysos encouraged even the mature and bearded to project a satyric identity, the interior encouraged him to think of those occasions when mature Athenians had to project a very different identity.

Conclusion

Sympotic scenes appear for the first time on pots made in Corinth around the end of the seventh century. Within a very short time there is a proliferation in the shapes that are deployed in the symposion. Craters come as round vessels requiring stands (so-called *dinoi*) and with a variety of handle shapes, including elaborate volutes. In the first half of the sixth century cups change from being small vessels with rounded bodies and short feet to shallower shapes with a variety of forms of lip and heights of foot. All this is quite apart from varieties of decorative scheme. Although there is good evidence for the symposion as an occasion for competitive display of wit and of sexual and alcoholic prowess from the middle of the eighth century onwards, there is little doubt that these innovations in sympotic equipment also marked a development in sympotic sophistication. The range of shapes and of imagery available to the person who wished to entertain his male companions now demanded a much more sophisticated response: imagery and form alike demanded that the drinker negotiate the identity he chose to project in the face of the challenges and provocations of the vessels he had to use.

The tests posed by the symposion were multiple, and the skills demanded included manual dexterity and sexual self-control as well as speed of wit. For all that it might be slave-boys and female entertainers who appeared at the symposion naked, it was men who were laid bare. Practice was no doubt vital to successful negotiation of the sympotic

equipment, as it was vital too to acquiring the requisite capacity for alcohol, but no amount of practice could prepare a man for all the surprises that a sympotic host could spring. The symposion was a binding experience, in which a group of men found themselves facing together the same challenges (they might even come, as the night became rough, to see themselves as sailing together in a single storm-tossed ship). But it was also a competitive testing, in which reputations could be won or lost. The ability to project and maintain an identity in the face of all that a sympotic host could throw at one was an essential part of maintaining the sort of reputation on which social standing was based.

Fifth-century Greeks told the story, preserved for us in the histories of Herodotos, of how, when Kleisthenes, the tyrant of the Peloponnesian city of Sikyon, held a competition for the hand of his daughter Agariste, an Athenian named Hippokleides outshone suitors who came from all over Greece in the athletic and other challenges posed by Kleisthenes. But when Kleisthenes held a final party, Hippokleides got carried away and danced upon the table. When a shocked Kleisthenes announced that he had just lost the bride, the response came: "Hippokleides doesn't care!"[29] By failing to project the appropriate identity in the face of the challenges of that symposion Hippokleides had lost not only the most desirable bride but also one route to significant political influence. Whether at the court of a tyrant or in the democratic city, reputations were made and lost in the symposion. Hosts and guests indulged in a game of projecting and maintaining identities in which the former made a nice judgment of where the boundary lay between wit and crudity in the challenges they posed and the latter attempted to meet those challenges in ways that showed that they recognized the questions being posed and had the wit, gallantry, self-control, and continence to respond in an appropriate fashion.

In this survey I have tried to indicate some of the ways in which the challenges of the symposion were sharpened by the drinking-vessels that were employed, by their shape and by their imagery. That imagery might present the drinker with a scene that closely mirrored the occasion he was taking part in or which offered a more or less oblique reflection on that occasion. On different occasions, and with different equipment in front of him, the drinker's attention might be focused on the nature of the Dionysiac occasion, on his relations with such women as were, or might become, present, on the relationship between his private pleasures and his civic duties, or simply on his relationship to his fellow drinkers. Although he might mask his face temporarily as he lifted his cup, the drinker could

never cease to be conscious that the symposion was an occasion when he was under observation and where the choices he constantly made about the identity that he projected would affect the person he was able to be in the group with whom he lived.[30]

Notes

1 The best introduction to the symposion is provided by François Lissarrague, *The Aesthetics of the Greek Banquet: Images of Wine and Ritual* (Princeton, N.J.: Princeton University Press, 1990). Note also James Davidson, *Courtesans and Fishcakes: The Consuming Passions of Classical Athens* (London: Harper-Collins, 1997), pp. 43–53, 91–7. On entertainment at the symposion, see Alfred Schäfer, *Unterhaltung beim griechischen Symposion* (Mainz: Philipp von Zabern, 1997).

2 See further Lissarrague, *Aesthetics*, pp. 80–6 on *kottabos*, pp. 123–39 on music.

'3 J. D. Beazley, *Attic Red-Figure Vase-Painters*, 2nd ed. (Oxford: Oxford University Press, 1963) (henceforth abbreviated to *ARV²*), 402.12, Fitzwilliam Museum, on loan from Corpus Christi College (Lewis collection); see *Journal of Hellenic Studies* 31 (1911), pp. 223–4.

4 On ancient stringed instruments, see Martha Maas and Jane McIntosh Snyder, *Stringed Instruments of Ancient Greece* (New Haven and London: Yale University Press, 1989).

5 *ARV²* 455.9, London BM GR 1867.5–8.1061 (E 64); for detailed publication see Dyfri Williams, *Corpus Vasorum Antiquorum. Great Britain, Fascicule 17; The British Museum, Fascicule 9* (London: British Museum Press, 1993), fig. 8, pp. 22–4.

6 See Williams, *Corpus*, p. 24 for references to further vases with similar friezes.

7 See Williams, *Corpus*, figs. 4–13 for a sample of cup profiles.

8 See John Boardman, "A curious eye-cup," *Archäologischer Anzeiger* 1976, pp. 282–90, at p. 289.

9 New York, Metropolitan Museum of Art 56.171.61, *ARV²* 50.192.

10 For full publication of this cup see Boardman, "A curious eye-cup."

11 For the poetry sung on pots, see Lissarrague, *Aesthetics*, pp. 125–35.

12 See Boardman, "A curious eye-cup."

13 Françoise Frontisi-Ducroux and François Lissarrague, "From ambiguity to ambivalence: a Dionysiac excursion through the 'Anakreontic' vases," in David M. Halperin, John J. Winkler, and Froma I. Zeitlin (eds), *Before Sexuality: the Construction of Erotic Experience in the Ancient World* (Princeton, N.J.: Princeton University Press, 1990), pp. 211–56; Margaret

Miller, "The parasol: an oriental status-symbol in late archaic and classical Athens," *Journal of Hellenic Studies* 112 (1992), pp. 91–105; Hélène Delavaud-Roux, "L'énigme des danseurs barbus au parasol et les vases 'des Lénéennes'," *Revue Archéologique* (1995), pp. 227–64.

14 Compare also Robin Osborne, *Archaic and Classical Greek Art* (Oxford: Oxford University Press, 1998), pp. 133–4.

15 M. F. Vos, *Scythian Archers in Archaic Attic Vase-Painting* (Groningen: J. B. Wolters, 1963); François Lissarrague, *L'Autre Guerrier: archers, peltastes, cavaliers dans l'imagerie attique* (Paris: La Découverte, 1989); Robin Osborne, "Images of a warrior: on a group of Athenian vases and their public," in Clemente Marconi (ed.), *Greek Vases, Images and Controversies*, Columbia Studies in the Classical Tradition (Leiden: Brill, 2004), pp. 41–54.

16 See *ARV*[2] 432.55 with the discussion in François Lissarrague, *Greek Vases: The Athenians and their Images* (New York: Riverside Book Company, 2001), p. 30.

17 Lissarrague, *Aesthetics*, pp. 90–1.

18 *ARV*[2] 135.13, Fitzwilliam Museum, Cambridge GR 19.1937.

19 Yvonne Korshak, *Frontal Faces in Attic Vase Painting of the Archaic Period* (Chicago: Ares Publishers, 1987) for a list; Françoise Frontisi-Ducroux, *Du masque au visage: aspects de l'identité en Grèce ancienne* (Paris: Flammarion, 1995) for a full discussion.

20 *ARV*[2] 449.4, London BM GR 1843.11–3.94 (E 51); Williams, *Corpus*, no. 26.

21 Gloria Ferrari, *Figures of Speech: Men and Maidens in Ancient Greece* (Chicago: Chicago University Press, 2002), list on p. 223.

22 *ARV*[2] 432.60, Paris, Louvre S 3916; see Frontisi-Ducroux, *Masque*, p. 125.

23 *ARV*[2] 785.8, Oxford, Ashmolean Museum 517 (G 279).

24 M. Meyer, "Männer mit Geld," *Jahrbuch des deutsches archäologisches Instituts* 103 (1988), pp. 87–125; Ferrari, *Figures of Speech*, figures, pp. 14–16.

25 *ARV*[2] 406.2, London BM GR 1843.11–3.54 (E 75), Williams, *Corpus*, no. 51.

26 See Robin Osborne, "The ecstasy and the tragedy: varieties of religious experience in art, drama, and society," in Christopher Pelling (ed.), *Greek Tragedy and the Historian* (Oxford: Clarendon Press, 1997), pp. 187–212 with further references.

27 Thomas Carpenter, *Dionysian Imagery in Fifth-Century Athens* (Oxford: Clarendon Press, 1997), p. 38.

28 Dyfri Williams, "Close shaves," in H. A. G. Brijder (ed.), *Ancient Greek and Related Pottery* (Amsterdam: Allard Pierson Museum, 1984), pp. 275–81.

29 Herodotos *Histories* 6.126-31.

30 For cups as face masks see Lissarrague, *Aesthetics*, pp. 141–3.

Part II

Material and Social Transformations

Bernini Struts

Michael Cole

Few works in the history of sculpture are more admired for the sheer skill of their carving than Gianlorenzo Bernini's *Apollo and Daphne* (figure 3.1). Charles Avery counts it among the pieces that established Bernini as "the greatest sculptor in the world."[1] Peter Rockwell maintains that "any sculptor who looks at Bernini's *Apollo and Daphne* can only come away astonished."[2] And Howard Hibbard concludes his discussion of the statue by suggesting that it is *too* dazzling, showing "a quality of immature excess, of virtuosity for its own sake."[3] The *Apollo and Daphne* has come to stand as the perfect antithesis to the modernist principle of "truth to materials," the ultimate illustration of the artist defying his medium's very nature. Indeed, it has become difficult, in view of the *Apollo and Daphne,* to imagine what Bernini could *not* make marble do. No wonder Jennifer Montagu caused a small sensation when she argued that its most famous features were executed by Bernini's gifted assistant Giuliano Finelli rather than by the master himself.[4]

Bernini began the *Apollo and Daphne* in 1622 and had largely completed it by 1624, the last year of his employment with Cardinal Scipione Borghese. Roughly contemporary with the sculptor's *David* (1623–4) and still standing in the building for which it was made, it represents the culmination of a series of works that, as Rudolf Preimesberger suggested in a classic article, ask to be measured collectively against a sixteenth-century, largely Florentine, tradition.[5] The *Apollo and Daphne* and the other statues Bernini made for the Cardinal were collectors' pieces, appealing explicitly to a cultivated audience with a historical sensibility and a keen awareness of sculptural practice. They engage themes from

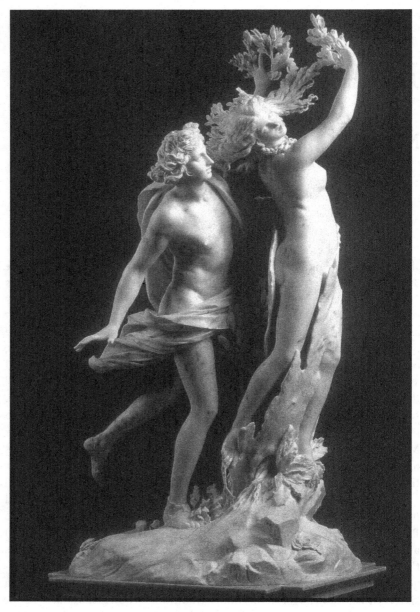

Figure 3.1 Gianlorenzo Bernini, *Apollo and Daphne.* Reproduced from Kristina Herrmann Fiore (ed.), *Apollo e Dafne del Bernini nella Galleria Borghese* (Milan: Silvana, 1997).

Renaissance art theory, and they consistently show the artist identifying and overcoming conventional ideas of marble sculpture's "difficulties," often by doing things said to be possible only in other media. To follow Preimesberger, the group to which the *Apollo and Daphne* belongs aims to isolate and erase what sixteenth- and early seventeenth-century writers presented as the *limits* of sculpture: the representation of fire, for example, or of lightness, or of transparency, or of transformation.

The importance of this way of thinking is evident in much of the recent literature, including, notably, the catalogue for the *Bernini Scultore* exhibition at the Galleria Borghese in 1998.[6] More recently, though, it has become possible to evaluate Preimesberger's theses in somewhat different terms, with a new eye to the actual facture of the sculptures. One of the revelations of Anna Coliva's 2002 book *Bernini Scultore: La Tecnica Esecutiva*, for example, is that Bernini initially accepted a prescript adhered to by many of his Cinquecento predecessors: that to offer a truly virtuoso display of technique, the sculptor's composition had to be monolithic. Like Michelangelo, Baccio Bandinelli, Giambologna, Ippolito Scalza and others before him, the young Bernini looked for ways to carve complex groups in a single piece of stone.[7] Evidently, Bernini's sculptures were also appreciated in these terms: Paolo Alessandro's 1704 *Raccolta di statue antiche e moderne*, for example, states that "the Cavaliere Gianlorenzo Bernini sculpted the well-known story of Apollo and Daphne *in un solo marmo* for Cardinal Borghese."[8] To be sure, his increasingly ambitious works reveal an apparent willingness to piece in sections of marble where this couldn't be easily perceived: part of Proserpina's hair, for example, is inserted into the otherwise monolithic statue showing her abduction, as is a large section of drapery in the *David*.[9] It seems safe to assume, nevertheless, that even these works were meant to be taken, like the *Laocoön* a century earlier, as monoliths.

Later in his career, Bernini began more freely to combine large pieces of marble, and even to mix marble with other materials. His duties at St. Peter's, in particular, required him to think on a substantially larger scale and to adapt his practices accordingly: by mid-century, in fact, Bernini's 1631–8 *St. Longinus*, along with the other statues he designed for the crossing, were serving as examples of how to hide joins with draperies and other devices.[10] This new method, like his later chapels, where stucco pretends to be stone and subtle shifts of color and textures make it difficult to see just where a piece of marble ends and a less noble material begins, marks a crucial technical departure from the ambitious sculptures of the

previous century. It is difficult to imagine Michelangelo or Giambologna doing anything of the sort, and even Francesco Mochi seems to have followed Bernini's path only when working from Bernini's designs. The works from the 1630s and after consequently raise questions about how we are to take the Borghese marbles. Do the early examples of piecework in any way anticipate Bernini's later colossi? Where Bernini resorted to adding pieces to a statue, was this planned from the outset or a response to accident? The cord of the sling in the *David*, the stone of which is not continuous with the rest of the statue, shows how difficult these questions can be to answer.[11] Indebted as the *David* is to Florentine precedents, and to Michelangelo's scowling giant in particular, Bernini has pursued a sort of form that sculptors only began to attempt in the later sixteenth century, piercing the single marble block at various points and dramatically excavating the figure's limbs. Bernini must have realized that David's liberated arms would be challenging enough to execute, and he may well have decided that the cord would be impossible to make as an integral feature of the statue. It is equally conceivable, however, that Bernini decided here to test what the stone would allow and that, under the pressure of his instruments, the marble simply snapped, requiring Bernini to carve and attach a new weapon.

Either way, such passages indicate that, by the time he undertook the last details of the *Apollo and Daphne*, Bernini would have been well aware of the dangers his daring approach to the marble block presented. Hands, fingers, and the things they held were frequently the zones of highest risk, as not only the *David*'s sling but also an attached finger in the *Pluto and Proserpina* demonstrate.[12] This casts Bernini's eventual treatment of Daphne's own hands in a surprising light. Passages like these fell into the category that Benvenuto Cellini, one of the most informative early modern writers on the craft of marble sculpture, referred to as "extravagant attitudes."[13] Cellini meant to draw attention to poses that were striking and unusual, but he also uses the term "extravagant" in something like its literal sense of "straying beyond bounds," denoting sections of marble that project dramatically outward from another surface or core. As the painter Pontormo, too, noted, these were the achievements that most impressed viewers, even viewers who were not practicing marble-cutters.[14]

Frequently, as Cellini notes, the sculptor would begin to execute such features not with a chisel but with a drill.[15] One can see the results of the procedure Cellini had in mind in works like Vincenzo de' Rossi's 1586 *Hercules and Cacus* or Nicolas Cordier's 1605 *St. Sebastian* (figure 3.2).[16]

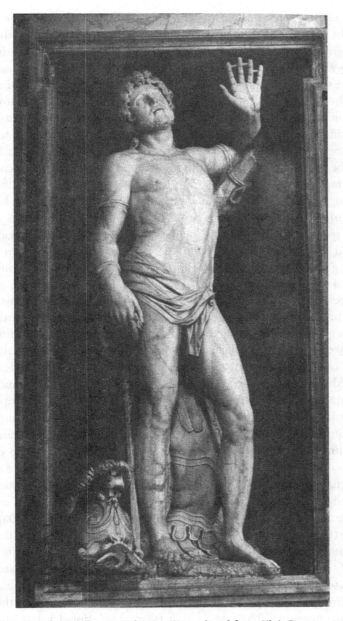

Figure 3.2 Nicolas Cordier, *St. Sebastian*. Reproduced from Silvia Pressouyre, *Nicolas Cordier: recherches sur la sculpture à Rome autour de 1600* (Rome: Ecole Française de Rome, 1984).

Intending to represent a hand with splayed fingers, the sculptor would begin by boring out the spaces that would separate the digits – that this was Bernini's first step in the *Apollo and Daphne* is evident from a *pentimento*, the hole he began to drill in the stone that now constitutes Daphne's right ring-finger, before realizing that the space he aimed to open should go farther to one side.[17] After drilling through the stone, the sculptor would then hollow out the area with a rasping file (*raspa*) or small chisel (*scalpello*), leaving a series of struts or bridges in place to brace the stone while he worked. Only when the hand was finished would these struts be cut away. The fact that many sculptures survive with such struts still intact indicates that their removal was among the last things the sculptor would do on the work, presumably in the interest of keeping the figure's most fragile parts protected, even while other areas of the statue were being carved. It also suggests that sculptors who had once planned for hands arranged in dramatic poses sometimes lost their nerve, deciding that a seemingly "non-finito" statue was preferable to one with replaced or added fingers, arms, or legs.

There is no doubt that Bernini, too, regularly followed this same procedure, for a number of his later sculptures retain their struts. And that even such a brilliant carver as he left sculptures with added fingers – the broken and repaired fingers on Apollo's right hand being a particularly telling case in point – demonstrates that the fears such technical aids betrayed were not unwarranted. Research by Coliva, Rockwell, and their collaborators reveals that the *Apollo and Daphne* depends more heavily on drillwork than any other early Bernini statue.[18] It is unclear just what implications this has for its authorship: a number of Finelli's portrait busts show him to have been a great master of the drill, but then so do the statues of Pietro Bernini, Gianlorenzo's father and teacher, that are closest to Lorenzo's first works in date. Questions of attribution notwithstanding, knowledge that the maker used the drill extensively in the work encourages the viewer to look at the branches of stone that run between Daphne's fingers (figure 3.3) in a particular light: whatever else they are, they are traditional struts, sections of marble that the carver did not quite bring himself to cut away. It seems likely that Bernini and Finelli both used such devices whenever they carved hands; the added weight the laurel stems and leaves brought to Daphne's fingers, however, would have made these all the more necessary. That they retain their conventional role within the carving process is reinforced by the fact that the area adjacent to the struts counts among the most unfinished-looking in the whole statue: chisel and

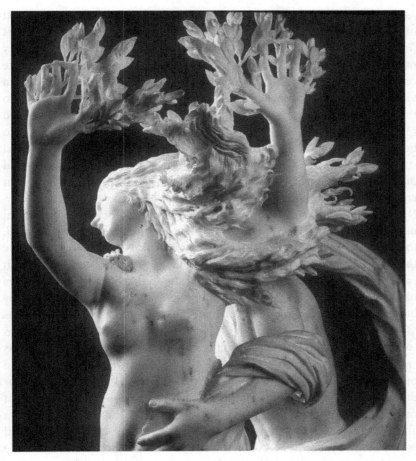

Figure 3.3 Gianlorenzo Bernini, *Apollo and Daphne* (detail). Reproduced from Kristina Herrmann Fiore (ed.), *Apollo e Dafne del Bernini nella Galleria Borghese* (Milan: Silvana, 1997).

file marks are visible across the inside of Daphne's hands, one of her fingers is so roughly sketched that it looks faceted, and the thumb is almost entirely uncarved. Traces of graphite, moreover, suggest that Bernini still thought there remained work to do.

From one point of view, this adds weight to Rockwell's assertion that the sculptor's carving technique was, on the whole, traditional. Certainly Bernini seems to have been following later sixteenth-century practices, which themselves followed the examples of more ancient techniques.

At the same time, Bernini's struts are uniquely ingenious, for, unlike most of their counterparts, which undermine the illusionism of the work, his at first remain almost unnoticeable. Possibly for the first time in the history of marble carving, an artist has attempted not to remove devices that were conventionally employed as temporary supports, but rather to make then virtually diappear into the work's fiction. The move might be compared to the use Adriaen de Vries made, in the same period, of the sprues used to channel molten bronze into his molds, turning the metal tubes into branches and other motifs rather than simply sawing them off the finished statue.[19] Bernini was more likely inspired, however, by the tree stumps and other forms that marble sculptors had long used to prop up figures that could not stand on their own two feet. The branches that run between Daphne's fingers are akin to the disguised structural devices that Bernini used elsewhere in his early marbles – the armor that supports his David, for example, or the drapery that braces his *Aeneas* – with the difference that the *Daphne* points to concerns about the marble's tensile strength rather than about statics as such. The irony is that the passages viewers have long regarded as proof of Bernini's bravado would, in almost any other context, have made him look cautious.

The struts in the *Apollo and Daphne* don't look like miscalculations (overestimating the poses the sculptor could get away with) or retreats (reassessing the marble's strength once the fingers were actually blocked out); one reason for this, of course, is what surrounds them. The sculptor did not just clear out the four hollows separating the fingers and thumb of each hand; he bored a host of voids, leaving forms that ramify out from and around the fingers. Some of these are clearly motivated by structural as much as by aesthetic concerns: the stem that grows out from the knuckle of Daphne's left index finger braces the leaf it joins, and a billowing lock of Daphne's hair helps support the burst of leaves from her left thumb. Thanks to Bernini's or perhaps Finelli's fine carving, however, some of the stem-bridges become the most delicate parts of the whole sculpture, reversing the role we expect such structures to serve. Bernini's addition of forms that evoke struts at places where they are unneeded – stretching from the toes of Daphne's perfectly solid left foot to the ground, for example – affects the way the viewer sees others as well. The tendril cues the viewer to read the struts within the context of the statue's narrative; looking from the foot to the hand, it becomes difficult to believe that the struts there, too, are present for any other reason than to make the depicted story all the more vivid.

This is to read these motifs not for their irony but for their paradox. Elsewhere I have suggested that Bernini's *Apollo and Daphne* takes up a Cinquecento conceit, identifying the sculptor as a kind of sun god and his wondrous object as something notionally moved and even created by the work of light.[20] The fantasy of the *Apollo and Daphne* itself centers on an artful transformation, Daphne's metamorphosis into a tree; to believe the work's illusion is to see the "wood" between her fingers as something that has *grown* there, like a plant under the sun. Part of the fiction of the *Apollo and Daphne*, in other words, is that fingers pre-existed the struts. The statue creates a false memory of fingers with nothing between them, an effect that makes it all the more possible to imagine the connections away. That modern art historians have not seemed to notice their function only speaks to the power of Bernini's device.

The other side to the paradox, of course, is that once we see the struts as struts, it is difficult to see them as anything else. In truth, Bernini has not worked terribly hard to make them look otherwise: those bridging the middle three fingers of each hand have no attached leaves or anything else that would indicate that they are animate. The fact that they look so unfinished in comparison to the rest of the work makes them the most salient vestiges of the original block and reminds the viewer of the transformation Bernini himself has effected. In this respect, the struts seem almost to advertise their conventional function. As struts, the marble bridges between Daphne's fingers make the statue seem unfinished, and thus they explicitly solicit attention to Bernini's transformation of the block. This, as much as Bernini's virtuosity *per se*, must have delighted his earliest viewers, first and foremost his patron Scipione Borghese, who would have enjoyed trying to see for himself where the technical difficulties in Bernini's sculpture lay, inviting the sculptor to reveal what challenges were really at issue.

In all of these respects, the *Apollo and Daphne* marks a kind of conclusion to Bernini's early practice. Though recent scholarship has given a good deal of attention to the conditions in which Bernini's *Apollo and Daphne* was displayed, it was only after Bernini left the Borghese cardinal to enter the service of the newly elected Pope Urban VIII that the expectation of close inspection that that work still asserted truly began to be subordinated to a real concern with site. The years following the completion of the *Apollo and Daphne* saw broad changes in Bernini's sculpture; apart from the busts he produced more or less continuously throughout his career, Bernini leaned increasingly to the design not of autonomous works but of what

we would today call "installations," beginning with his 1624–6 *S. Bibiana* and continuing with his work on the baldachin for the crossing of St. Peter's. The transition would also mark a change in Bernini's own professional identity, as he refashioned himself from a specialist in marble statues into an architect, designer, and general impresario.

Later sculptures, too, retain their struts, but their conspicuousness is telling. Consider Bernini's 1654–68 *Constantine*. Here, as he had in his youth, Bernini gives his figures "extravagant" poses, and here again he relies on a strut, running between the rearing horse's front legs, to stabilize the work. This time, however, Bernini does not make any effort to disguise the function of his marble brace. The most that can be said is that, from certain points of view, it would not be seen. True to Bernini's sculptural origins, the *Constantine* stands on a pedestal, as if to announce that it should be regarded as a figure in the round, and not just as narrative relief. But unlike Bernini's early productions, the *Constantine* is not meant to be admired especially as a transformed "object." In a decisive rejection of the Renaissance tradition that shaped the young Bernini's priorities, the sculpture becomes an image.

In other works, the difference becomes still more stark. The *Truth* (1646–52), the *St. Jerome* (1661–3), and the *Bust of Clement X* (c.1676) all likewise include prominent struts. In these cases, though, the works, like de' Rossi's and Cordier's statues before them, simply look unfinished. What are we to make of this? It is possible that, after a certain point, the sculptor's studio no longer commanded the talent to turn out the mesmerizingly virtuoso pieces of Bernini's youth. The fact that the struts remain in these works may constitute further evidence that it was Finelli rather than Bernini who put the finishing touches on the Borghese statues, and that Finelli's departure in 1628 imposed new limits on what the master could do. Equally likely, though, is that Bernini simply lost interest in blinding his viewers with skill as he had as a youth. Once Bernini went to work for the Pope, his reputation no longer depended on his ability to cut marble. With the exception of the rare portrait commission, Bernini would position himself as a conceptual artist far more than as a craftsman.

Acknowledgments

I owe thanks to Steven Ostrow for reading a draft of this essay and for his helpful suggestions.

Notes

1 Charles Avery, *Bernini: Genius of the Baroque* (London: Thames and Hudson, 1997), p. 17.

2 Peter Rockwell, "La tecnica scutorea di Apollo e Dafne," in Kristina Herrmann Fiore (ed.), *Apollo e Dafne del Bernini nella Galleria Borghese* (Milan: Silvana, 1997), pp. 139–47, at p. 139.

3 Howard Hibbard, *Bernini* (New York: Penguin, 1982), p. 54.

4 Jennifer Montagu, "Bernini sculptures not by Bernini," in Irving Lavin (ed.), *Bernini: New Aspects of his Art and Thought* (University Park: Pennsylvania State University Press, 1985), pp. 23–43. For the debate over whether Bernini or Giuliano Finelli carved passages including the leaves that Daphne sprouts, see most recently Kristina Herrmann Fiore, "*Apollo e Dafne* del Bernini al tempo del Cardinale Scipione Borghese," in Herrmann Fiore (ed.), *Apollo e Dafne*, especially pp. 103–4 (with further references). The standard monograph on Finelli is Damian Dombrowski, *Giuliano Finelli: Bildhauer zwischen Neapel und Rom* (Frankfurt am Main: Peter Lang, 1997).

5 Rudolph Preimesberger, "Themes from art theory in the early work of Bernini," in Irving Lavin, *Bernini* (University Park: Pennsylvania State University Press, 1985), pp. 1–18.

6 Anna Coliva and Sebastian Schütze (eds.), *Bernini scultore: la nascita del barocco in casa Borghese* (Rome: Edizioni de Luca, 1998).

7 On the importance of the monolith to Renaissance sculptures, see especially Irving Lavin, "The sculptor's 'Last Will and Testament,'" *Allen Memorial Art Museum Bulletin* 35 (1977–8), pp. 4–39, and *idem*, "*Ex uno lapide*: the Renaissance sculptor's *tour de force*," in Matthias Winner, Bernard Andreae, and Carlo Pietrangeli (eds.), *Il cortile delle statue. Der Statuenhof des Belvedere im Vatikan* (Mainz am Rhein: Philipp von Zabern, 1998), pp. 191–210.

8 Quoted in Hermann Fiore, "Apollo e Dafne," p. 76.

9 See Anna Coliva (ed.), *Bernini scultore: la tecnica esecutiva* (Rome: De Luca, 2002), pp. 153–5, 174.

10 See Orfeo Boselli, *Osservazioni sulla scultura antica*, ed. Antonio P. Torresi (Ferrara: Liberty House, 1994), p. 152: "istorie e statue grandi si possono fare di più pezzi ogni volta, che le commissure vengono occultate dentro panni, nuvoli, architetture, o altra cosa a ciò atta e sufficiente al bisogno, come è il colosso dell'Apostolo Sant'Andrea in Vaticano, opera del non mai abbastanza lodato Francesco du Quesnoy Fiammingo, da me in altri luoghi nominato e la Santa Veronica del Mochi e il San Longino, opera del Bernino con altre che io non mi ricordo."

11 See Coliva, *Bernini scultore*, pp. 174–5.

12 For Proserpina's finger, ibid., p. 153.

13 Benvenuto Cellini, *Due trattati, uno intorno alle otto principali arti dell'or-eficeria, l'altro in materia dell'arte della scultura*... (Florence: Velente Panizzij and Marco Peri, 1564) (anastatic reprint, Modena: Edizioni Aldine, 1983), p. 57v: "Pigliasi poi i Trapani, i quali si adoperano quando le lime, saluo se si hauesse à cauare in qualche difficile sottosquadro di panni, ò in qualche attitudine strauagante della figura."

14 See the letter published in Paola Barocchi, *Scritti d'arte del Cinquecento* (Milan and Naples: Riccardo Ricciardi, 1973), pp. I, 504.

15 See the useful illustrations in Coliva, *Bernini scultore*, pp. 194–5, as well as Rockwell's comments, "La tecnica scutorea," p. 197, on Bernini's novel use of the rasping file (*raspa*) like a saw (*sega*).

16 Compare the discussion in Montagu, *Roman Baroque Sculpture: The Industry of Art* (New Haven: Yale University Press, 1989), pp. 44–5.

17 For the *pentimento*, and for Bernini's technique generally in the work, see Rockwell, "La tecnica scutorea," pp. 139–47, at p.142 and fig. 5.

18 Compare the diagrams in Coliva, *Bernini scultore*, pp. 194–5 and *passim*.

19 See Frits Scholten (ed.), *Adriaen de Vries, 1556–1626*, exhibition catalogue (Amsterdam: Rijksmuseum, 1998), pp. 201–9, 243–7.

20 Michael Cole, *Cellini and the Principles of Sculpture* (Cambridge: Cambridge University Press, 2002), p. 155. For a much fuller treatment of closely related ideas, see Frank Fehrenbach, "Bernini's Light," *Art History* 28 (2005), pp. 1–42.

4

Architectural Style and Identity in Egypt

Doris Behrens-Abouseif

In the nineteenth century European architecture began to spread in the countries of the Muslim world. However, the adoption of European styles was restricted to civil architecture, while religious buildings maintained a traditional Islamic style that remains visible to the present day. In some countries this traditional style was a natural continuity. In Iran, for example, the architectural vocabulary, which developed under the rule of the Safavid dynasty described as the golden age for Persian art, between the sixteenth and the eighteenth centuries, has been basically maintained by their successors, with the natural modifications that time and evolution bring about. Similarly, Moroccan religious architecture never departed from the architectural and decorative vocabulary developed under the rule of the Merinid dynasty, who ruled between the thirteenth and the sixteenth centuries. These styles, which had taken shape and reached maturity centuries earlier, never fell into disuse as far as religious architecture is concerned.

Revivalism rather than continuity characterizes modern religious architecture in Turkey and Egypt, albeit out of different circumstances. In both countries there has been a return to a style associated with a specific period viewed as a golden age in their respective histories, which had subsequently, through evolution or rupture, been superseded by other styles. In Turkey the classical style created by the great architect Sinan in the sixteenth century[1] has been revived in contemporary mosques, disregarding the interesting and bold innovations which took place in Ottoman architecture during the eighteenth and nineteenth centuries. By the late nineteenth century Ottoman architects had moved far away from

the Sinan school, creating a fusion with European Baroque, that was carefully and successfully applied in the mosque of Nuru Osmaniye built in Istanbul in 1755.[2] In the late nineteenth century, however, a less discriminate absorption of European ideas produced a more syncretistic religious architecture. The uninhibited avidity for European fashion is best demonstrated in the art nouveau shrine of Shaykh al-Zafir in Istanbul.[3] These "excesses" of modernity were ultimately rejected in contemporary architecture in favor of a return to Sinan's traditions. Sinan was the chief architect and supervisor of the construction works under Suleyman the Magnificent, whose reign is considered to be the golden age of Ottoman history. Sinan lived long enough (1490s–1588) to work for two more sultans, Selim II and Murad III. Although Sinan, who is associated with an almost legendary number of monuments for members of the Ottoman court, used a great variety of ground plans and styles, it was the quatrefoil plan of his first royal monument, the mosque of Shahzade founded by Suleyman to commemorate his dead son, which was perpetuated in modern Turkish architecture.

In Egypt the Mamluk style of the thirteenth to the fifteenth centuries was revived in modern mosque architecture.[4] Under Mamluk rule (1250–1517) Cairo experienced a formidable religious and urban patronage that endowed the capital with an impressive number of great monuments, many of which have survived. [5] The overthrow of the Mamluk sultanate by the Ottomans in 1517 was followed by a long period of architectural provinciality, which lasted until the rule of Muhammad Ali Pasha (1805–1848). Thus by the first half of the nineteenth century Cairo's religious architecture had already taken a revivalist turn, while late-Ottoman Istanbul was still celebrating novelties from Europe.

The stylistic choices that brought about the revival of past architectural styles in Egypt and Turkey were made, however, without being accompanied by the intellectual discourse that Europe experienced during the eighteenth and nineteenth centuries, and without being consciously linked to current intellectual or literary movements. This lack of conceptualization of architecture was consistent with the absence of a theory of the visual arts in traditional Islamic culture. Due to different historical and intellectual experiences, European architectural styles had different connotations in Egypt and Turkey than in Europe itself. Rather than being linked to a complex combination of art-historical and ideological considerations, the European mode in Egyptian and Turkish architecture was essentially an expression of welcoming modernity and progress. This

chapter investigates some of the mechanisms behind stylistic choices in pre-modern Islamic architecture, focusing on Egypt as a case-study, and the evolution of the perception of style in the nineteenth century.

The Islamic Tradition

The two major centers from which Islamic classical civilization radiated were Damascus under the Umayyad caliphate (661–750) and Baghdad under the Abbasid caliphate (750–1258). With the foundation of the Dome of the Rock in Jerusalem in 691, the Umayyad caliph Abd al-Malik (685–705) inaugurated Islamic monumental architecture. With its location on the temple mount, its glass mosaics with Byzantine and Persian motifs in a novel combination, its extensive Koranic inscription inviting non-Muslims to join Islam, this monument emphasizes the religious appropriation of the past by the new Muslim rulers.[6]

The Great Mosque of Damascus, founded slightly later in 715 by the caliph al-Walid (705–15), rather emphasized political appropriation. Its interior, entirely covered with glass mosaics representing landscape with architecture, displayed the largest surface ever to be decorated in this Byzantine medium. The lavishness of its decoration expressed imperial continuity under a new Islamic identity. When al-Walid rebuilt the Prophet's mosque in Medina he again used glass mosaics for its decoration, doing away with its initial simplicity documented in Islamic tradition and cherished by Muslims to the present day. Historical accounts mention Byzantine craftsmen and materials used in this reconstruction, emphasizing the Umayyad appropriation of Byzantine paraphernalia.

With the foundation of Baghdad along the Tigris as the capital of the new Abbasid caliphate following the overthrow of the Umayyads of Damascus in the mid-eighth century, the centre of gravity of the Muslim Empire was transferred from the Byzantine East Mediterranean to Iraq. Mesopotamian and Iranian culture superseded Byzantine influences in the design of the round city of Baghdad founded by the caliph al-Mansur (754–75) and in the abstract decoration developed in the following century, which henceforth became a characteristic feature of Islamic art.[7] As Byzantium and Iran were the two great imperial powers defeated in the course of the Arab conquest, the appropriation of their arts, besides being a matter of convenience, proclaimed their submission to the Muslims.

Their arts and regalia, symbols of their power, became the trophy with which the conquerors glorified themselves.

The Case of Egypt

At the time of the Arab conquest in 642, Egypt was a province of the Byzantine Empire with Alexandria as its capital. Alexander's foundation, then a Christian city, was still glorious and is reported to have dazzled its Arab conquerors. Alexander, whom Muslim tradition identifies with the Dhu'l-Qarnayn of the Koran, is venerated in Islam as one of the pre-Islamic patriarchs, which partly explains the fascination with his city echoed in Arabic literature. It is reported that the general of the Arab armies and the first Muslim governor of Egypt, Amr Ibn al-As, would have chosen Alexandria as his capital, but the caliph in Medina preferred him to be closer and more accessible to the central authority. This led to the foundation of al-Fustat, the future Cairo, south of the Nile Delta, and eventually to the gradual decline of Alexandria.

In the initial phase of its history the new Egyptian capital reflected the garrison structure of its founders. Its congregation mosque was built on the plan, consisting of four arcades surrounding an open courtyard, that Muslim tradition associates with the house of the Prophet. With the exception of the Aqsa Mosque in Jerusalem, all congregational mosques built in the newly founded or conquered capitals followed this pattern. Jeremy Johns has negated the connection of early mosque architecture with the Prophet's house and rather attributes this plan to the decision of the second caliph Umar Ibn al-Khattab (634–44), who favored a universal plan based on late-antique traditions. This concept, which marked the new Islamic era, was dictated by the political considerations to create for the "conquest mosques" a standard architecture, rather than by any canonical religious guidelines.[8]

Notwithstanding the fact that Muslim tradition has associated this layout with the Prophet's house, it was never considered a taboo that should not be broken, and eventually mosques were built with various types of layout, including plans inspired from Christian architecture. The orientation toward Mecca is the only dictate which religion imposes on the layout of a mosque. The exclusion of figural representations, although it is not rooted in the Koran itself but in the Prophet's tradition, has been followed in religious architecture from the outset. With the expansion of

the Umayyad caliphate and the growth of al-Fustat, the mosque of Amr in Egypt was refurbished to acquire features inspired from the Great Mosque of Damascus, such as four minarets at the corners and glass mosaic decoration.[9]

In the course of the centrifugal movements of the ninth century, which challenged the power of the Abbasid caliphate, autonomous province governors began to build mosques in their own names. The governor of Egypt Ibn Tulun (868–84) declared his autonomy and founded a new ruling dynasty without, however, repudiating the caliph's supremacy. He founded a new city next to al-Fustat with a monumental mosque, which is well preserved to the present day (figure 4.1). Rather than distinguishing himself with a new architectural identity, Ibn Tulun adopted in this mosque the imperial Abbasid style of the new capital Samarra, albeit on a smaller scale.[10] The mosque's arcades were similarly built with rectangular brick piers rather than with columns, and it was decorated with the new abstract designs created in Samarra. The minaret, although built with a spiral exterior staircase following the imperial prototype, was constructed in stone instead of brick. The choice of stone might have been motivated simply by the potentials of the local masonry tradition.

Medieval chroniclers in Egypt, however, do not seem to have perceived the fact that Ibn Tulun's mosque was built in the style of Samarra. According to one interpretation, the architect built the mosque on piers instead of columns because he was a Christian who wished to prevent the spoliation of churches for their columns. Another anecdote explained the unusual form of the minaret as resulting from Ibn Tulun toying with a piece of paper around his finger, which eventually inspired him with the idea of a spiral tower. Both anecdotes suggest that if the Samarra style had been chosen to express any particular association with the imperial capital, the message failed to reach the audience. It is difficult to assess to what extent the association with Samarra architecture was a political statement, or simply a choice of convenience by which Ibn Tulun wished to build a mosque in the most "fashionable" style of the time. A premeditated association with the metropolitan style would imply that the Egyptian audience at the time was aware of what Samarra architecture looked like, which is rather doubtful, as the two anecdotes demonstrate.

In fact, Ibn Tulun had no alternative but to build in the Samarra style. Being himself a Central Asian recruit in the Abbasid army, he could not have had any motivation to return to the then dated Umayyad artistic traditions of Damascus, already used in the renovations of the mosque of

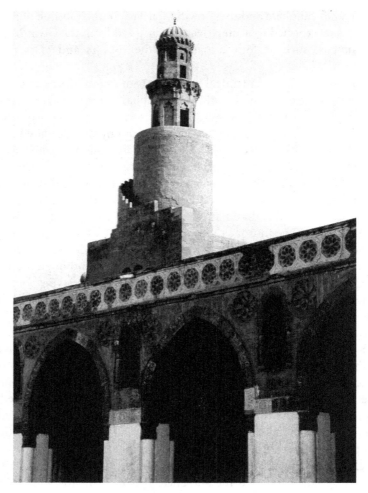

Figure 4.1 The Mosque of Ibn Tulun in Cairo. Photograph: Doris Behrens-Abouseif.

Amr. Nor could he have found an alternative in Coptic art, the art of Christian Egypt under Roman and Byzantine rule with no imperial architectural associations and therefore not comparable to the Persian and Byzantine traditions that could inspire a Muslim ruler.

Notwithstanding the fascination with ancient Egypt, which is echoed in Arabic medieval literature and in occult sciences, the visual arts of Islamic Egypt remained virtually untouched by Ancient Egyptian inspiration. The

presence in many medieval mosques of stone hieroglyph-inscribed blocks taken from ancient temples and used as thresholds probably for talismanic purposes, as well as the reuse of pre-Islamic columns and capitals in mosques, was not a matter of artistic inspiration or revivalism. Centuries earlier the Copts or Christian Egyptians had already turned their back on the arts of their pagan ancestors with their conversion to Christianity. While the Iranians never lost the connection with their immediate pre-Islamic past, which was a glorious period of their history under Sassanian rule, the immediate pre-Islamic past of the Egyptians was a period of Byzantine oppression, which promoted the cult of martyrs character-istic of Coptic devotion. This past could not have inspired nostalgic movements.

When the North African Fatimid dynasty (969–1171) established a new caliphate in Egypt, they founded a new capital, al-Qahira, in the northern vicinity of al-Fustat. Although the Fatimids, who adhered to the Shia faith, stood in antagonism to the orthodox Abbasid caliphate, their architecture did not break with Egypt's Abbasid aesthetics. The Fatimid caliph al-Hakim (996–1021) built his great mosque in the tradition of Ibn Tulun's architecture, while introducing some variations. By the end of Fatimid rule, the Egyptian capital, a fusion between al-Qahira and al-Fustat, had developed its own architectural and stylistic school, which continued to brand the monuments of the following Ayyubid (1169–1250) and Mamluk (1250–1517) periods.

Although Salah al-Din or Saladin, the founder of the Ayyubid dynasty, pursued the ideological goal of overthrowing the Fatimid caliphate and ending the Shia predominance in Egypt by reinstating orthodoxy – a goal which he ruthlessly pursued – Ayyubid architecture attests to continuity rather than rupture. To celebrate Egypt's return to orthodox Islam, the Ayyubid sultan al-Malik al-Kamil built a mausoleum for the scholar and saint Imam Shafei, which remained faithful to the artistic vocabulary created by the Fatimids, except for its scale, which surpassed that of their Shia shrines.

Equally, the transition from Ayyubid to Mamluk rule did not bring about a break in architectural traditions. Rather it was the new aspects of patronage which gradually produced a novel architecture. The unpreced-ented scale of building activity of the Mamluks in Cairo over a period of more than two and a half centuries created the architectural identity which inspired the revivalism of the late nineteenth century, and which prevails to the present day.

The glory of Egyptian Mamluk architecture came to an end with the Ottoman conquest in 1517. Reduced to the status of a provincial capital, Cairo was eclipsed by Istanbul as the greatest metropolis of the Muslim world. The new rulers introduced Ottoman architectural ideas which led to a stylistic fusion of Ottoman provincial and Mamluk "survival" features that characterizes most of the monuments of the following three centuries.

The Ottoman regime does not seem to have imposed its aesthetics on the Egyptians except in the case of the minaret. A reform in the style of minaret architecture immediately following the Ottoman conquest strongly suggests that it was a political statement dictated by the authorities rather than a matter of mere change of taste.[11] Instead of the elaborate three-storied sculptured minaret which characterized Cairo's skyline under the Mamluks, a new, much simpler structure, which can be described as a squat and provincial version of the Ottoman pencil-shaped minaret, prevailed in mosque architecture. This new minaret was not restricted to monuments built by Ottoman officials but was also adopted in the mosques of local dignitaries. The Ottoman-style minaret was adopted only in the capital, excluding the province. Such a stylistic mutation immediately following the conquest could not have been due to a spontaneous shift of taste. The fact that the Ottomans attached a political significance to the minaret is attested by their rule that multiple minarets were reserved for royal mosques.

Among the mosques built in Cairo between the sixteenth and the eighteenth centuries only one displays a minaret in the Mamluk style. It is the small sanctuary built by a Shaykh called al-Burdayni in 1616. Not only its minaret, but also its lavish decoration – exceptionally for that time – represent a revival of Mamluk aesthetics, although the proportions of the building are very modest.[12] Unfortunately, nothing is known about its founder or his intentions, except that he originated in an Egyptian provincial town, as indicated by his name, but his Mamluk minaret and decoration are too conspicuous not to be significant. Moreover, the location of the tiny building opposite the mosque founded slightly earlier by the Ottoman queen Safiyya, appears almost as a challenge. The Egyptian identity of the founder, who might have been a member of the religious establishment, is clearly legible in al-Burdayni's monument. One century after the Ottoman conquest, it emits a nostalgic message. Seen in the context of Cairene architecture, it would be the earliest documented association of architectural style with a political attitude.

In the eighteenth century Ottoman central authority was challenged by the growing power of local dignitaries and their aspirations for autonomy.

The Mamluk style of the minaret attached to the mosque of the emir Muhammad Bey Abu l-Dhahab built in 1774 might therefore not be accidental. It is a copy of the minaret of Sultan al-Ghawri who fell in battle fighting the Ottoman conquerors two and a half centuries earlier. Muhammad Bey Abu l-Dhahab was at the head of an emancipation movement, viewing himself as a successor of the Mamluks.

Egypt's Nineteenth Century

In the nineteenth century the rule of the Ottoman governor Muhammad Ali Pasha introduced radical changes in Egypt. Like Ibn Tulun nine centuries earlier, Muhammad Ali came as provincial governor, and he eventually emancipated himself by founding a new ruling dynasty, acknowledging Ottoman supremacy only to a certain extent. His intensive modernization program, which led to his being credited with founding modern Egypt, transformed its architecture.[13] The creation of new industry, the modernization of agriculture, and the reform of the legal, administrative, educational, and medical institutions required a new infrastructure for which new architectural categories and forms were necessary. Moreover, the massive influx of Europeans into Egypt imposed new requirements on the urban environment. Greeks and Armenians from various parts of the Ottoman Empire promoted a hybrid Mediterranean civil architecture, while Italians and French introduced a more stylish approach in the residences and palaces of Muhammad Ali and his dignitaries. However, when the Pasha began to plan the foundation of his great mosque, which was later to include his tomb, a different kind of choice regarding the style of its architecture had to be taken.

Although no explicit discourse concerning the choice of the mosque's style has been reported, the circumstances surrounding its foundation shed light on Muhammad Ali's views. Pascal Coste, a French architect and engineer hired by the pasha to work on new industrial and agricultural projects, had presented plans and elevations for a mosque in a neo-Mamluk style. Coste's fascination with Cairo's Mamluk architecture is documented in his album of drawings, which is the first ever to be exclusively dedicated to Cairo's Islamic monuments.[14] Judging from his eventual choice, which so obviously diverged from this proposal, Muhammad Ali could not have been pleased, to say the least, by Coste's proposal. His rejection of the neo-Mamluk style is significant and cannot be dissociated from his attitude

toward Egyptian culture, for which he had not the least affinity, viewing it rather as an obstacle to his vision of modernization. In order to pursue his reforms, Muhammad Ali had to eliminate the Mamluk aristocracy, which he did with their physical liquidation in 1811, when he invited hundreds of Mamluks to a party in the Citadel of Cairo to massacre them.

In 1830 he founded his monumental mosque in the Citadel (figure 4.2). Due to its prestigious location on top of the Muqattam hill, visible from

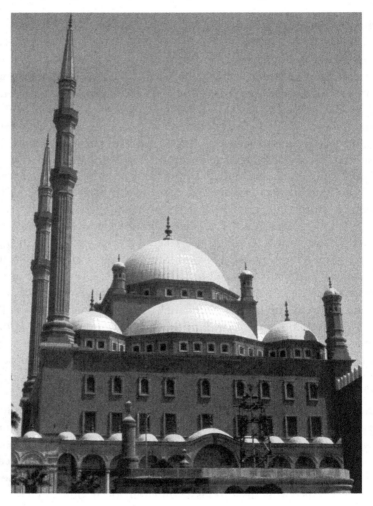

Figure 4.2　The Mosque of Muhammad Ali in Cairo. Photograph: Doris Behrens-Abouseif.

everywhere while overlooking the city, it became Cairo's landmark although it was the least Egyptian or rather the most "Turkish" mosque ever to be built in Cairo. Excluding all references to local architectural and decorative traditions, it also departed from the Mamluk–Ottoman fusion that had been practiced in the past three centuries. Like Ibn Tulun nine centuries earlier, Muhammad Ali opted for the imperial rather than the local style for the architecture of his mosque. His choice, however, might have had a different kind of motivation reflecting his radical intention to break with Egypt's past. Built on the site of a palace of the Mamluk sultans and next to the royal mosque founded by Sultan al-Nasir Muhammad in 1335, which it dwarfs, its message was assertive. Its slender and tall minarets, the highest in Cairo, match their royal homologues in Istanbul also in their twin configuration, which was a royal prerogative in Ottoman Turkey, reflecting Muhammad Ali's well-documented ambition to challenge the Ottoman sultan in the international political landscape.

Interestingly, however, Muhammad Ali, unlike Ibn Tulun, did not emulate the contemporary imperial style of architecture with its modernistic approach; rather he opted for a revival of the Ottoman classical style of the sixteenth and seventeenth centuries, anticipating this movement in Turkey itself. Instead of the modern compact single-dome structure, his mosque was built with the quatrefoil plan of a central dome flanked by four half-domes, as in the Shahzade Mosque built by Sinan and the mosque of Sultan Ahmed, the so-called Blue Mosque, completed in 1617.

This could be explained by a genuine intention to return to Ottoman classical aesthetics, or simply by the fact that being in Cairo, a provincial capital of the empire, he had no access to the court architects of Istanbul, who mastered contemporary designs. These architects, in particular the members of the Armenian Balyan family, represented a metropolitan elite who could travel to Europe. Other pious monuments founded by members of Muhammad Ali's family and his dignitaries fostered the new "modernistic" trend, in particular in the decoration of their mosques and public fountains.

Muhammad Ali's choice of the Ottoman style was eventually rejected in the second half of the nineteenth century by his successors, who rather embraced the neo-Mamluk style, thus marking Egypt's emancipation from its Turkish immediate past. Ironically, the Mamluk revivalism was the result of increasing European influence in Egypt, which Muhammad Ali himself was the first to promote. Like Pascal Coste earlier, European architects and experts could not fail to admire Cairo's medieval architecture and to plead

for its preservation.[15] As a result, in 1881 a committee with European and Egyptian members was founded for the preservation of Cairo's Islamic heritage. Political motivations might also have played a role in this appeal which aimed at representing Egypt, a British protectorate since 1882, as dissociated from the Ottoman Empire.

It is also ironic that, although the Mamluk style has been Egypt's brand of modern religious architecture, today the mosque of Muhammad Ali is the most photographed and advertised Islamic monument in Egyptian tourism publicity, rather than the medieval monumental masterpiece of Sultan Hasan (figure 4.3). The mosque of Muhammad Ali is popularly called the Citadel, being confused with the citadel of Salah al-Din within which it stands and which was built in the twelfth century! This is by no means an expression of revivalism but rather, as in the case of Ibn Tulun's mosque, the Egyptian "man on the street" did not recognize the

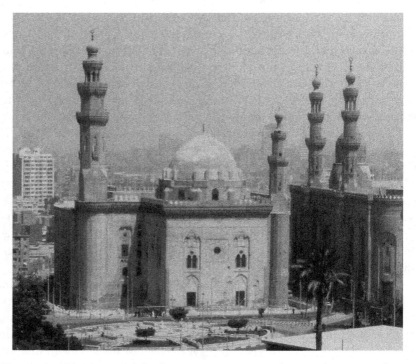

Figure 4.3 The Mosque of Sultan Hasan in Cairo. Photograph: Doris Behrens-Abouseif.

connection with the imperial prototype, which only the initiated would know. This aspect of art-historical ignorance is at the same time a testimony to the appropriation of the Turkish style.

Looking back at Egypt's medieval period, the approach to architectural style appears less conscious and premeditated than it became after the encounter with Europe. In absence of a theory of the visual arts in Islamic culture the issue of architectural style was a mere technical matter. The descriptions of buildings in foundation deeds of mosques contain stylistic categorizations on a "micro" level of individual elements, to define the configuration of a loggia or a staircase or a decorative pattern from the craftsman's point of view, rather than a global classification seen from the theoretician's perspective. In their descriptions of monuments Muslim medieval authors do not show any awareness of, or sensitivity toward, architectural styles. Nor do they make associations between style and ideology. Political changes, even when they implied serious ideological shifts, were not accompanied by radical artistic transformations. Things began to change, however, in the Ottoman period, which introduced a new perception of architectural style in Islamic culture, as is suggested by the Ottomanization of the minaret in Cairo. The Ottoman seventeenth-century bureaucrat and traveller, Evliya Celebi in his description of Cairo categorizes the mosques according to either their "Turkish" or their "old" style, using both a geographic and a chronological categorization.

The Ottoman association of style with political meanings, which might be a result of Ottoman interaction with Europe in the Renaissance and baroque periods, is a subject that still needs to be investigated. Nonetheless, Muhammad Ali's categorical rejection of Mamluk elements in his monuments departs from the more indifferent attitude of medieval patrons, who viewed architectural styles rather as a natural evolution, a matter of old and new, rather than of ideology. Historicist or revivalist tendencies had no role in mainstream architecture prior to the nineteenth century.

Rupture and Stylistic Split

The modernization of Egypt and other Muslim countries produced an aesthetic rupture and reduced the significance of religious architecture. Whereas many aspects of material culture, such as dress, architecture, and urbanism, were transformed in the nineteenth century to a point of no return, the mosque has remained fundamentally retrospective. The

mosque of Muhammad Ali in Cairo was the latest mosque to be built by a monarch in Egypt as a symbol of power. Muslim rulers turned to more modern and secular propagandistic media. While losing its political significance, the mosque acquired a retrospective character, epitomizing religious and cultural values rather than political power.

The dramatic European impact on the civil architecture of the Muslim world in the nineteenth century imposed a situation which required decisions to be taken and choices to be made for the development of mosque architecture. Facing the triumph of foreign architecture in their cities, the consensus of Muslims ultimately resisted the separation of the mosque from its history.

Notes

1 Gülru Necipoglu, "Challenging the past: Sinan and the competitive discourse of early modern Islamic architecture," *Muqarnas* 10 (1993), pp. 169–80; *idem*, *The Age of Sinan: Architectural Culture in the Ottoman Empire* (London: Reaktion, 2005); Godfrey Goodwin, *Sinan: Ottoman Architecture and its Value Today* (London: Saqi, 1993).

2 Maurice Cerasi, "Historicism and inventive innovation in Ottoman architecture – 1720–1820," in N. Akin, A. Batur, and S. Batur (eds.), *Seven Centuries of Ottoman Architecture: A "Supra-National Heritage"* (Istanbul: YEM Yayin, 1999), pp. 34–42.

3 Zeynep Çelik, *The Remaking of Istanbul: Portrait of an Ottoman City in the Nineteenth Century* (Seattle: University of Washington Press, 1986); Baha Tanman, "Nineteenth century Ottoman funerary architecture: from innovation to eclecticism," in Doris Behrens-Abouseif and Stephen Vernoit (eds.), *Islamic Art in the Nineteenth Century* (Boston: Leiden, 2006), pp. 37–56.

4 Mercedes Volait, "Appropriating orientalism? Saber Sabri's Mamluk revivals in late nineteenth century Cairo," in Behrens-Abouseif and Vernoit, *Islamic Art*, pp. 131–57.

5 Doris Behrens-Abouseif, "Mamluk art," in *Encyclopaedia of Islam (Supplement)*, 2nd ed. (Leiden: Brill, 2004), pp. 578–88.

6 Oleg Grabar, *The Shape of the Holy: Early Islamic Jerusalem* (Princeton, N.J.: Princeton University Press, 1996); *idem*, *The Formation of Islamic Art* (New Haven: Yale University Press, 1987).

7 Richard Ettinghausen and Oleg Grabar, *The Art and Architecture of Islam 650–1250* (Harmondsworth: Penguin, 1987), chs. 1 and 2.

8 Jeremy Johns, "'The house of the Prophet' and the concept of the mosque," in Julian Raby and Jeremy Johns (eds.), *Bayt al-Maqdis. Volume 2: Jerusalem and Early Islam*, Oxford Studies in Islamic Art 9 (Oxford: Oxford University Press, 1999), pp. 59–112.

9 The present mosque did not preserve any of its original features; only its location marks the beginning of Islamic history in Egypt. For an introduction to the mosque see D. Behrens-Abouseif, *Islamic Architecture in Cairo: an Introduction* (New York and Cologne: Leiden, 1989), pp. 47–8.

10 Ibid., pp. 51–2.

11 Behrens-Abouseif, *The Minarets of Cairo* (Cairo: American University in Cairo Press, 1985, repr. 1987), pp. 21–2; John Alden Williams, "The monuments of Ottoman Cairo," in *Colloque international sur l'histoire du Caire* (Cairo: American University in Cairo Press, 1972), pp. 453–65.

12 Behrens-Abouseif, *Islamic Architecture*, pp. 163–4.

13 Gaston Wiet, *Muhammad Ali et les Beaux-Arts* (Cairo: Dar al-Ma'arif, 1949), pp. 265–88; Muhammad al-Asad, "The mosque of Muhammad Ali in Cairo," *Muqarnas* 9 (1996), pp. 39–55.

14 Pascal Coste, *Architecture arabe, ou, Monuments du Kaire* (Paris, 1837). See also Pascal Coste's account of his experience in Egypt in Dominique Jacobi (ed.), *Pascal Coste, toutes les Egypte* (exhibition catalogue, Marseille: Parenthèses, 1998), pp. 31–48.

15 Philip Speiser, *Die Geschichte der Erhaltung der Baudenkmäler in Ägypten* (Heidelberg: Heidelberger Orientverlag, 2001), pp. 47–74; Donald Malcolm Reid, *Whose Pharaohs?* (Berkeley, Calif., and London: University of California Press, 2002), pp. 213–57.

5

Identifying the Body: Representing Self. Art, Ornamentation and the Body in Later Prehistoric Europe

Fay Stevens

The archaeological record of later prehistoric Europe presents societies in a complex narrative of fragmentation and flux, based on shifting economies and the construction and reconstruction of distinct cultural groups. The presentation of these societies orients itself around material culture in the form of highly decorative body ornaments that are either found in burials, represented in sculptural forms, or found in hoards. In his study of the decorative motifs found on these objects, Paul Jacobsthal[1] stated that the art had no genesis (i.e., that it had no discernible or gradual evolution), and was *"full of contrasts... full of paradoxes, restless, puzzlingly ambiguous."* More recently, this form of decoration has been seen as a potent factor in expressing cultural taste and human relations with the supernatural, which profoundly affect relations between people.[2] Given that the complex narratives of these societies is expressed, in part, through the body, it is not surprising that body ornamentation is seen to be embedded in the construction of identity in later prehistoric Europe.

Art of Later Prehistoric Europe: Setting the Scene

The body is a potent symbol in later prehistoric Europe. It is one of its defining characteristics and is evidenced by the presence of highly decorated ornaments in a variety of contexts. This decoration (generally considered to be an art form) is often referred to as "La Tène" or "Celtic." It is considered to be the legacy of an avant-garde group, regularly and consciously challenging the techniques or subject-matter of "established" art.[3] This is a legacy that refers more to a nineteenth-century product of the age of Romanticism with its associated nationalism and social values, and more contemporary conceptions of "Celtic art."[4] These conceptions are interesting in that they are associated in a contemporary context with a broad range of so-called minority groups and new-age spiritualism. Interpretations of the archaeological record are equally broad-ranging, suggesting that the people of later prehistoric Europe were formed of loosely knit cultural groupings, rather than single ethnic units. Definitions of these cultural groupings are considered to be linked more by religious and political beliefs than by economic or technological systems[5] to more recent and contrasting concepts of European ethnicity and political phenomena.[6] Thus, the presence of these highly ornamented material objects is associated with the identity of these so-called "Celts" and has recently been drawn upon to present a symbol of European unity as well as regional identity. Yet it is a concept that is inherently problematic and has been approached with criticism and skepticism in academic discourse.[7] The presence of highly ornamented material culture in later prehistoric Europe is deeply embedded within these complex "Celtic" conceptions, tied in with past and contemporary formations of the individual self and cultural identity.

The wearing of decorative ornamentation on the body presents a visual expression of self on an individual level and as an interplay between a collection of identifiable cultural groups. The aim of this chapter is to offer a lateral perspective to the construction of identity in later prehistoric Europe by considering these ornaments and their associated decoration as an integral component of the body and as an expression of self. The scope is not to extended current discourses on the problematic concept of the "Celts" and the construction of "Celtic society." I want to focus on various body states – physical (in the form of burial), representational (bodies depicted in sculptural form), and metaphorical (for example, hoards of

body ornaments) – as a route into exploring the construction of particular ideas of identity, whether that is expressed in life, death, or the other world. The material, social, and conceptual transformations of later prehistoric Europe are intwinned in the design, construction, and presentation of both ornamentation and the body. This being so, this chapter will explore how identity is created, negotiated, expressed and transformed within the interplay of these textural and social rhythms.

Creating Identity

This chapter situates identity not as a static inherent quality but as a dynamic and contingent aspect of people's being.[8] What I am interested in is how aspects of identity are conveyed, played out, perceived, and articulated. Body ornamentation provides an effective avenue of enquiry as we have evidence for both people and objects being highly mobile in this period. Because of this, we can consider the construction and expression of identity as viewed in the context of mobility.[9]

The biographical body

The biographical object and the biographical body are enrolled in the construction of particular ideas of identity and self in later prehistoric Europe. Ornamented objects associated with the body play out a range of multiple perspectives. Whether they were worn in life and accompanied burial, worn in life and not associated with a burial, or just made for burial, they indicate the presence of a body. In her study of jewelry and adornment of later prehistoric Europe, Champion noted that some rings, particularly certain solid neck rings, were introduced onto the body in childhood and must therefore have been carried in life into the grave.[10] Moreover, she considered evidence from some graves that certain items were made specifically for burial. These perspectives become multi-layered when we consider the inscription of ornamentation onto and within the objects. The decorative inscription of body ornaments in either context represents a series of complex relationships between the presence of a material body and an expression of personhood. I refer to personhood as it is substantiated through the maintenance of social relations. These relations, in the context of this chapter, are expressed and played out through the appropriation of body ornamentation. In this case, a person

wearing such ornamentation can be seen either as an individual, distinct from other individuals, or as composed of relationships and transactions between other persons. Multiple biographies can be seen to be in motion as people dip in and out of a number of cultural groups and the biographical body is enrolled in the construction of particular ideas of identity and self.

Creating social relations

Archaeologists consider the material culture of prehistoric societies as presenting a range of expressions of relations between individuals and groups. More recently they have considered the role of ornamentation and material culture in the process of cultural transmission.[11] It is important, however, to situate the role of ornamentation in relation to the concept of identity and the construction of self in prehistoric societies. The wearing of decorative body ornaments, whether on a physical, representational, or metaphorical body, is embedded in the display of social relations and is ingrained in the interplay of social practices. The practice of display requires some form of performance and can be accessed through consideration of the relationship between ornament, decoration, and bodily gestures and what those gestures might symbolize. Display facilitates a series of encounters that form negotiations between the viewer and the viewed, particularly in relation to shared and contrasting perspectives. All undergo a process of material and social transformation that is played out through the negotiation and expression of identities and self. Social relations can therefore be seen to be maintained and expressed through body ornamentation. The playing out of these relations requires display, encounter, and performance of self as a situating device.

The maintenance of social relations offers a key to understanding these preliterate complex societies in later prehistoric Europe. In his study of non-literate societies Goody has shown how people think and behave in some ways that are fundamentally different from literate groups. In non-literate societies memory is seen to play a much greater role in the preservation of cultural traditions.[12] The construction of these memories is embedded in the design and construction of material objects and is accessed through the process of interpretation, rather than that of recall. The design and reproduction of ornamentation plays an important role in the cementing and playing out of memories, for its value and ability to exhibit as public presentation is crucial to how it is received and valued on different planes.[13]

Thus ornamented designs of the later prehistoric societies of Europe present an interesting paradox to us when we consider the construction of identity and the establishment of social relations in these preliterate societies. The design of ornamental objects and the execution of decorative motifs associated with them communicate shared concepts, images, and patterns of behavior. Yet every object is unique and individual; no two are alike. Ornamentation acts as a mnemonic communicator; it is designed to aid the memory. The wearing of ornamentation on the body can be seen to function in two ways: memory of individual self and the interpretation of the individual as part of a wider network of social relations.

The concept of the self is part of what has been called a "grand narrative" of humanism and, by postmodernists, of "modernism."[14] Without an "other" there can be no self, and so all human action is considered to be understood within a context of an individual's perception of the self's identity. The concept of self presents a contradiction, for it is highly reflexive "stripping bare," "exposing," but at the same time it is "shelved" and removed from sight.[15] For the French philosopher Jacques Derrida, the idea that there is a real or true self is one of the "centralising agencies of meaning" in Western thought, which he sought to deconstruct.[16] Thus the construction of the self is a kind of "reflected or looking-glass self"[17] created out of what we imagine we are like in the minds of other people in society. This brings about the creation of a persona which can create a sense of self and identity through, for example, the wearing of body ornamentation. Concurrently the self can also present multiple personas that present a narrative of fluid cultural trends.

We draw upon fashions and trends (representative of a collective) to express a concept of "self" (aspects of the individual) and so present ourselves simultaneously as part of a whole and as unique. The construction of self, then, is seen as "in-process."[18] Damasio[19] suggests that the articulation of "self in-process" is associated with two different levels of consciousness, "core consciousness" and "extended consciousness," each giving rise to a different sense of self. *Core consciousness* is not fixed and is constantly undergoing change as a result of encounters with the environment. It is a "narrative without words"[20] taking place beneath the level of consciousness. This non-verbal narrative occurs when a person interacts with an object – encountering shapes, colors, and decoration. Thus, the interaction together with its emotional concomitants is experienced in the form of felt bodily images, bodily feelings and emotions that create a sense of "what it feels like to be ourselves in the moment." *Extended*

consciousness, as a direct, contrast has an ability to hold images active over time. It is associated with the construction of the autobiographical self and depends on core consciousness to enhance autobiographical memories and make them explicit as felt images.[21] The self in process is therefore presented, performed, and encountered on varying levels according to the needs, requirements, and social context of both the wearer and the viewer. Damasio's model helps us understand better the idea of reflexivity as a process of change and development, as reflexivity is an effect of extended consciousness brought about by the acquisition of memory.

I have mentioned how evidence from the archaeological record points to later prehistoric societies of Europe as being constantly in a process of flux. If this is the case, then how do societies manage to function if societies and identities are "in process"? Drawing on concepts outlined above, I want to focus on particular thematic avenues of enquiry that open up and expand discussions of the body and how ornamentation is embedded in the identification of the body and the representation of self. These are routes into defining certain aspects of identity as it is negotiated, expressed, or transformed. A number of interpretative perspectives will be considered: phantasmagoria, gesture, encounter, and performance.

Negotiating Identity: Phantasmagoria

Phantasmagoria is a concept that refers to a shifting series of real or imaginary images, perhaps as seen in a dream. It is also an optical device for rapidly varying the size of images and, as such, is an appearance of reality that tricks the senses through technological manipulation. The playing out of phantasmagoria is evident in the design of body ornaments in later prehistory. These ornaments comprise a wide range of varied and contrasting materials (including bronze, gold, coral, and enamel) that combine particular qualities of texture, color, density, and luminosity. Moreover, the decorative schemata on these objects, often fused together into one composite form, create optical illusions in the form of altering shapes, alluring and strange faces that seem to merge in and out of view, and decorative representations that are not always what they seem at first glance. This phantasmagorial world, presented in the form of decoration and worn on the body, presents a shifting series of real and imagined identities of the object, the wearer, and the viewer.

The use of color to play out the phantasmagorial experience is evident in the presence of objects that comprise a range of material forms. Artifacts comprising colored substances are said to have complex biographies.[22] The use of varied substances from spatially distant sources and the deployment of these substances to create artifacts of a composite nature means that many artifacts metaphorically speak of temporally extensive relationships among the living.[23] These relationships can be consolidated through the placement of multiple substances in burial contexts. This is particularly evident in the burial of a female at Vix, Côte d'Or, France, which comprised multiple substances brought together into a kaleidoscope of varying colors, textures, and material qualities. Studies of personal ornament have focused on gender, social status, and agreed regional difference, and have been approached through the examination of the evidence of patterns or ornament use, largely from inhumation cemeteries. Lorenz[24] has shown that detailed analysis of the way rings (arm, neck, ring, and finger) were worn in different parts of Europe allows the tentative identification of women who have moved from one group to another, perhaps demonstrating exogamy. The presence of exotic elements of gold, amber, and coral in burial assemblages is often viewed as an indication of the high status of the individual interred.[25] These assemblages create layers of meaning both of the individual and of the societies that individual was associated with. It is these qualities that can, in this case, be seen to refer to the identity of a person who represents broad-ranging contacts. Consequently, the presence of composite materials is a visual manifestation of composite identities that fuse into one identifiable individual identity. Configurations of textures can evoke reactions and feelings by arrangements of lines, colors, and movements. Thus color can be drawn upon to embody individual and social transformations.

The possible roles of these substances can be developed further to consider the role of color to the body. It can be viewed in the use of raw branches of coral in the late Halstatt and early La Tène periods, which have been explained as being apotropaic (supposedly having power to avert an evil influence or bad luck).[26] Substances can also be said to be imbued with the body and tied into the status and well-being of the wearer.[27] Merleau-Ponty[28] quotes Cézanne in his consideration of color, which is seen as "the place where our brain and the universe meet." Color can thus be seen to be drawn upon as a device that presents the body in certain states of being. The colorful qualities of artifacts deposited enable

memories to be recalled on their deposition[29] and are generative of memory when deployed in the context of mortuary rituals.

We can further draw upon this phantasmagorial world to portray the body, and in particular the face, as fluid and uncertain. There is evidence that imagery on ornaments worn on the body in this period presents a complex interplay of shape-shifting faces (both human and animal), vegetal motifs, and composite animal/human forms that phase in and out of view. The gold leaf fragment from a female grave in Bad Durkheim, Rhineland presents this interplay with a multi-layered perspective. The image is of a reversible face that can be seen either as an elderly male with a rather gloomy expression or as a young female with an expression of gladness, according to which way up it is viewed. Megaw refers to this type of image making as "shape-changing."[30] It is considered an important element in early La Tène art in which mutabilities are said to be of magical importance.[31] The dual fluidity of facial imagery is further evident in the popular Janus images, such as the twin-heads from a shrine at Roqueper-tuse, Bouches-en-Rhône, France and the stone Janus from Holzgerlingen, Germany. This focus on dual and fluid faces does not just present a single identity but perhaps is drawing upon phantasmagoria to play out multiple identities. The visuality of these identities is focused more on the reasons and motivations associated with the *viewing* of the imagery, through the physical act of encounter and the symbolism of visual encounter.

Another phantasmagorial aspect of the body is played upon by the use of asymmetry in the overall design of the ornament. Asymmetry is a recurrent theme that resonates in physical, representational, and meta-phorical body forms. The Vix burial has been noted for her particular asymmetrical face, a trend that is not uncommon in female burials of this period. The bodies of male statues can be seen to be strange and somewhat distorted with observable skewed proportions. The statue from Hirschlanden (figure 5.1) has exaggerated hips and muscular thighs and calves, visualizing an asymmetric "bottom-heavy" body, while the bronze figure from Bouray, France presents asymmetry in its exaggerated head and foreshortened and hoofed legs.

Ornaments such as the gold bracelet from a male secondary burial at Rodenbach, Germany also present asymmetrical perspectives. The Roden-bach ornament portrays a central abstracted face with a crown of inverted bottles and balusters that take the form of an open crest. On either side of the face are crouched, backward-looking ibexes/rams with folded legs. The body of the bracelet lacks symmetry, and presents a conscious optical

Figure 5.1 Statue from the top of a burial mound at Ditzingen-Hirschlanden, Germany. Sandstone figure, height 1.5m. Celtic, 6th century BC. Stuttgart, Wuerttembergisches Landesmuseum. Photograph: akg-images / Erich Lessing.

device that is said to make maximum use of light,[32] which causes the eye to constantly roam over the object. Similarly the gold armlet from Aurillac, Tarn, France (figure 5.2) is illusional in that at first glance it appears to comprise vegetal motifs of twigs, roots, and berries but in reality is an abstract design based on curls and bosses.

The overt depiction of asymmetry portrays a world in which things are not quite as they seem. Asymmetry facilitates the playing out of a complex interplay of layers and encounters. In the case of the armlet from Aurillac the wearer is aware that the design and imagery of the object is abstract; it

Figure 5.2 Gold armlet from Aurillac, Tarn, France. In L. Laing and J. Laing, *Art of the Celts* (London: Thames and Hudson, 1996).

is the viewer who is perhaps manipulated and deceived by their encounter and engagement with the object as worn on the body. Asymmetry is a device that is embedded in the design and concept of these ornaments. It is used to create an optical illusion of balance such that the ornament initially appears to be symmetrical, but on closer viewing is clearly not. Asymmetry thus becomes a way of visually presenting the balance of the person in an unbalanced and fluctuating world. Asymmetry is utilized perhaps to play out the expression of the social relations of the self within

society. Ornamentation as such presents varying visual boundaries that are drawn upon to play out social complexities.

The visuality of ornaments further extends the interplay of technological manipulation and the presentation of imagery. The contact between the physical human body surface and the body of an ornament draws both the viewer and the wearer further into the phantasmagorial world. A number of ornaments including the gold bracelet from Rodenbach and the gold armlet from Aurillac comprise considerable areas that would have been in view. What is interesting to note, however, is that the areas on view are three-dimensional and decorated, while undecorated areas are located at points where the object might have touched the body. The interface between object surface and human skin therefore is associated with smooth surfaces, whereas three-dimensional decorative motifs are visually evident to the viewer and have no direct body surface contact. This represents an interchange between the hidden and public perception of the body. It can be further drawn upon to consider the construction of identity, played out through the wearing of ornamentation, as having two objectives: the intimate inward-looking, hidden and associated with the individual identity of the wearer, and the expressive, overt and collective identity of both wearer and viewer. What is known and unknown is embedded in the relations played out between the wearer and the viewer of body ornaments. These relations can be both visual and hidden, and present codified and situated identities.

Negotiating Identity: Gesture

The notion of the archaeological study of gestures is a provocative one as it suggests we can access the bodily practices of peoples in the past.[33] For Merleau-Ponty it is the body which points out and which speaks; "the spoken word is a gesture and its meaning a world."[34] The visibility of physical and actual bodies is evident in later prehistoric Europe in the form of three-dimensional sculptural forms seen, for example, in the ithyphallic statue of Hirschlanden (figure 5.1). Sculptural forms such as this have symbolic significance inasmuch as the sculptural design relates to a body form, albeit abstracted and often asymmetrical. We can observe that physical bodies expressed in sculptural forms are articulated in particular ways. Many males are presented as naked except for the wearing of a torc around the neck, examples being the Hirschlanden statue and the statue of the dying Gaul from the Sanctuary of Athena. Gesture, in this

case, can be accessed through the shape, posture and facial expression of these represented bodies. They can be seen to express the interchange of anxiety and humility, visibly expressed through particular body postures. The asymmetrical composition of these sculptural forms can perhaps be seen to be a subtle expression of imbalance present in the expression of the self situated within a fluctuating world. Anxiety and humility are visible in the wounded Gaul from the Sanctuary of Athena, Italy, while the statue from Hirschlanden is contorted into a gesture of insecurity and protectiveness, indicated by hunched shoulders and crossed arms. Facial expressions range from aversion to bemusement. These kinds of gestures have been associated with a "century of crisis" in the old Halstatt areas.[35] There is a dichotomy in the representation of these images, however, for while the bodies themselves characterise asymmetry, anxiety and crisis, the wearing of the torc presents a contrasting perspective. Torcs have been characterized as status symbols, indicative of rank and prestige. They are presented in a broad range of sizes, shapes, and ornamented styles throughout later prehistory. As visual markers on the body, torcs distinctly separate the head from the body. This may been seen to further play out the dualism that is presented between individual power (the hidden mind) and social fluidity (the visual body), as gestured and played out through the wearing of body ornamentation.

The wearing of ornamentation is gestural in that it inscribes the body and signifies social practice. We need, however, to consider what gesture might be communicating. Gestures relate not just to the interactions of persons and artifacts in the sense of small portable objects, but also to the landscape, locations, places, and architecture that constitute the world in which people dwell.[36] Metaphorical bodies can be seen in the deposition of a number of hoards of body ornaments in later prehistoric Europe. These hoards act as mimetic devices where expressions of the body are communicated through bodily metaphors. The Erstfiled hoard, Switzerland, specifically located on an alpine mountain pass, presents metaphorical bodies as if they were in motion (as defined by the location) but also as markers of specific landscape locales that are inscribed by the body (as defined by the presence of body ornaments). Additionally, hoards of this period can be seen to comprise a broad range of object types in both complete and fragmented states. While the Erstfiled hoard is comprised of complete objects, the hoards from Snettisham, England, comprise more than a hundred torcs predominantly in a fragmented condition. The burial of these concealed metaphorical bodies, in the form of body ornaments, is defined by hoards that communicate complex states of non-visibility,

movement, access, and fragmentation. Complete and whole ornaments may act as expressions of self as a complete and whole body. Fragmented ornament hoards conversely may communicate fragmented bodies and a conception of self as if in flux. The composition, condition, and location of hoards of body ornaments can present iconographic displays of gesture in which sentiment, feelings, and emotions are structured.

Expressing Identity: Encounter

> *"what an incredible number of layers!*
> Don't we get to the heart of it soon?"[37]

Through the process of encountering art, we refer, and in the process of our reference we come to feel, a desire to penetrate more deeply.[38] Ornamentation contains multiple layers of visual stimuli and presents a fluid, often vivid, means of communication between people as individuals (sometimes eyeball to eyeball[39]), as groups or as institutions. The social body therefore can be seen to go through a series of encounters that are created, negotiated, and transformed.

We have seen how body ornamentation in the form of mobile objects acts as a social document where meaning is conveyed and identity is projected. Social relations and the identity of self are thus created through social encounters. These encounters are negotiated through, in part, body ornaments that present a range of overt and hidden decorative motifs. This creates visual impressions and expresses hidden identities and shared ideas in a self-reflexive expression of identity of what could be considered to be a "tailor-made" individual. The presence of body ornaments (whether it is a physical, representational, or metaphorical body) marks an event in space and time, and as such is an indication of moods and feelings. Encountering these ornamented bodies, whether through visual impact or the playing out of memory, plays out a series of transformations. These transformations visualize self, expressing social relations and so articulating identities.

Transforming Identity: Performance

The theme of performance presents a mode of cultural production: a kind of bodily engagement and a set of interactive contracts.[40] People create

their identities in relation to their interactions with others and this requires some degree of performance. Thus material objects play crucial roles as mnemonic devices to help performers remember and play out sequences of actions. In the construction of identity in later European prehistory, these performances are embedded in the context of changes people experienced in the social world in which they lived, and expressed through the way they perceived themselves in life and in death. Ornamenting the body is associated with public display that plays out a multitude of social personas. Visual body ornamentation therefore becomes a device for the playing out of social relations that expresses a sense of self both on an individual level and as part of a collective. It can be conscious and overt, but also hidden and concealed.

Performance plays out codified messages that are accessed and understood according to relationships that exist between the viewer and the viewed. For example, Jacobsthal's La Tène plastic style[41] is associated with bulbous bronze anklets, bronze and gold arm-rings, and specialized ornaments including complex girdle chains with enamel inlay. These body adornments have been interpreted as overt displays of elitism;[42] the distinctive decorative patterning is often to be found on the most visually prominent place on the ornament. Decoration, however, can often be placed in hidden, inaccessible parts of the ornament and this zonation of decoration raises questions as to the intention behind the making, wearing, and viewing of these complex ornament styles. This is said to be a visual projection of identity that presents multiple layers of codified messages. The wearing and display of decorative ornaments therefore presents a scripted drama and is associated with a performed event. The performance itself can be said to be a process of embodiment[43] that is taken on by the body and can be tied into the status and well-being of the wearer.[44] Thus performance negotiates identities of people and things on both an individual and a social level.

Conclusion

By referring to an image we communicate with it and consequently it is emotionally stimulating. The focus of this chapter has been to explore ways in which this reference might communicate a sense of identity in later prehistoric Europe. The ways in which bodily adornment figures in the relationship between the embodied self and social history leads us to

reconsider the implications of these body ornaments. The objects that people make and use can be understood as media of social action and, as such, play roles in the shaping of relations between people. Recognition of understandings of self, subject, and society lead to an explanation of the interconnections between people and their sense of self within societies, in which body ornaments act as mediators of complex and entangled biographical encounters.

We have seen through the study of the body as ornamented that identity is not fixed; rather it is fluid and dynamic. Moreover, identity represents a series of relationships between self and society, where identity is embedded in how people viewed their lives and their world, and how they interacted with others and went about their daily lives. The wearing of body ornamentation structures and shapes these self-reflexive identities. Thus body ornamentation can be seen to facilitate the acting out of permeable and fluid identities that are unfixed and constantly in process. This view offers an alternative perspective to the fixed, hierarchical, and fragmented individual that has often been presented to us in the study of later prehistoric Europe.

Acknowledgments

Personal thanks go to Samantha Cairns and Howard Lee.

Notes

1 Paul Jacobsthal, *Early Celtic Art* (Oxford: Oxford University Press, 1944).
2 Martyn Jope, "The social implications of Celtic art: 600 BC to AD 600," in M. Greed (ed.) *The Celtic World* (London: Routledge, 1995), p. 373.
3 Ruth Megaw and Vincent Megaw, *Celtic Art: From its Beginnings to the Book of Kells* (London: Thames and Hudson, 1989).
4 As defined by decorative curvilinear motifs or knotwork designs.
5 Megaw and Megaw, *Celtic Art*, p. 12.
6 John Collis, *The Celts: Origins, Myths and Inventions* (Stroud: Tempus, 2003), p. 197.
7 Nick Merriman, "Value and motivation in prehistory: the evidence for 'Celtic spirit,'" in I. Hodder (ed.), *The Archaeology of Contextual Meanings*, New Directions in Archaeology (Cambridge: Cambridge University Press, 1987), pp. 111–16.

8 Ibid.
9 Peter S. Wells, *Beyond Celts, Germans and Scythians* (London: Duckworth, 2001).
10 Sara Champion, "Jewellery and adornment," in M. Greed (ed.), *The Celtic World*, p. 411.
11 Stephen Shennan, *Genes, Memes and Human History* (London: Thames and Hudson, 2002).
12 *Beyond Celts*, p. 18.
13 Walter Benjamin, "The work of art in the age of mechanical reproduction," in H. Arendt (ed), *Illuminations. Walter Benjamin Essays and Reflections*, trans. H. Zohn (London: Fontana, 1992), p. 218.
14 Jean-François Lyotard, *The Postmodern Condition*, trans. G. Bennington and B. Masumi (Manchester: Manchester University Press, 2001).
15 Sue Roe, "Shelving the self," in S. Roe, S. Sellers, N. Ward Jouve with M. Roberts, *The Semi-Transparent Envelope* (London and New York: Marion Boyars, 1994), p. 51.
16 Jacques Derrida, *Of Grammatology*, trans. G. Spivak (Baltimore and London: Johns Hopkins University Press, 1976).
17 Charles H. Cooley, *Human Nature and the Social Order* (New York: Scribner's, 1902).
18 Antonio Damasio, *The Feeling of What Happens: Body, Emotion and the Making of Consciousness* (London: Vintage, 2000).
19 Ibid.
20 Ibid.
21 Ibid.
22 Andy Jones, "A biography of colour: colour, material histories and person-hood in the early Bronze Age of Britain and Ireland," in A. Jones and G. MacGregor (eds.), *Colouring the Past: The Significance of Colour in the Archaeological Record* (Oxford: Berg, 2002), p. 166.
23 Ibid.
24 Cited in Champion, "Jewellery and adornment."
25 George Eogan 1994, Piggott 1938, cited in Jones, "A biography of colour," p. 159.
26 Champion, "Jewellery and adornment," p. 415.
27 Alfred Gell, *Art and Agency: An Anthropological Theory* (Oxford: Clarendon Press, 1998), p. 86.
28 Maurice Merleau-Ponty, *The Primacy of Perception*, trans. J. Edie (Evanston, Ill.: Northwestern University Press, 1964), p. 180.
29 Jones, "A biography of colour," p. 170.
30 Vincent Megaw, cited in Lloyd Laing and Jennifer Laing, *Art of the Celts* (London: Thames and Hudson 1992), p. 16.
31 Laing and Laing, *Art of the Celts*, p. 16.

32 Ibid.

33 Steven Matthews, *An Archaeology of Gesture: Symposium Review* (www. semioticon.com/virtuals/archaeology/review.pdf, 2006), p. 1.

34 Maurice Merleau-Ponty, *Phenomenology of Perception*, trans. C. Smith (London: Routledge & Kegan Paul, 1962).

35 Vincent Megaw, cited in Laing and Laing, *Art of the Celts*, p. 45.

36 Fay Stevens, cited in Matthews, *An Archaeology of Gesture*, p. 6.

37 Henrik Ibsen, *Peer Gynt*, trans. P. Watts (Harmondsworth: Penguin, 1966), p. 191.

38 C. Davis, "Foreword," in *The Impossible Science of Being: Dialogues between Anthropology and Photography* (London: Photographers Gallery, 1995).

39 Jope, "The social implications."

40 Mike Pearson and Michael Shanks, *Theatre Archaeology* (London: Routledge, 2001), p. 150.

41 Paul Jacobsthal, *Early Celtic Art* (Oxford: Oxford University Press, 1944).

42 Megaw and Megaw, *Celtic Art*.

43 Pearson and Shanks, *Theatre Archaeology*, p. 15.

44 Alfred Gell, *Art and Agency*, p. 86.

Part III

Politics and Identity

Aristocratic Identity: Regency Furniture and the Egyptian Revival Style

Abigail Harrison-Moore

A history of the consumption of material culture can reveal ways in which the mass consumption of objects of commerce and high culture meets the psychological and cultural needs of dynamic social groups. This chapter will examine the use of the Egyptian Revival style in furniture making in early nineteenth-century England in light of political and social allegiances and class identity, and specifically as a signifier of an oppositionary interest in the material culture of France.

Dissemination of the Style

The Egyptian Revival style came into vogue at this time as a result of Napoleon's expedition to Syria and Egypt, 1798–1801. There had been a tradition of interest in Egypt or in mock-Egyptian culture in Europe since the Renaissance and motifs such as the anthemion, the palmette, the sphinx, the pyramid, and the obelisk were all familiar details in the history of ornament and decoration.[1] Because of the number of Egyptian relics looted after the fall of the Egyptian Empire, Rome also became a natural focus of attention for those interested in archaeological remains. The publication by the Comte de Caylus of seven volumes on classical antiquities, the *Recueil d'antiquités égyptiennes, étrusques et romaines*, from 1752

to 1757, disseminated knowledge of the national collections through Europe. Archaeologists and travellers, such as Volney (*Voyage en Egypte*, 1787), Norden (*Voyage d'Egypte et de Nubie*, 1795), and Grohmann (*Restes d'architecture égyptienne*, 1799) had led the way in the exploration of Egypt during the last years of the eighteenth century, and Piranesi had used Egyptian motifs in the designs which decorated the walls of the *Caffé degli Inglesi* in Rome, published in 1769 in *Diverse maniere d'adornare i cammini.* Yet the French vogue for Egyptiana evolved, in the most part, as a result of Napoleon's campaigns from 1798 onwards, specifically the work of his chief archaeologist Dominique-Vivant Denon and the publication of his work, *Voyage dans la Basse et la Haute Egypte* in 1802, described in England shortly after publication as having affected "many articles of interior decoration [which have become] the present prevailing fashion."[2] In 1808, George Smith, an English cabinet-maker,[3] claimed that he had attempted a direct interpretation of the spirit of antiquity as he found it in the best examples of Egyptian, Greek, and Roman styles.[4] We know, however, that much of his information on the Egyptian style was culled from Denon's *Voyage. Voyage* was an instantaneous success in both Paris and London, with some forty editions being published. Napoleon's Egyptian campaign and the archaeological surveys of buildings published by Denon began the serious, scholarly side of the revival and focused attention on Egypt in a supposedly scientific manner. It has been stated that *Voyage* and the work of the *Commission des sciences et arts d'Egypte* became for the Egyptian revival what Stuart and Revett's *Antiquities of Athens* was to the Greek revival.[5]

The effect of the expeditions and the accompanying publications on Egypt was to remind both cultured amateur of the arts and state-sanctioned designer that there was a far older culture and civilization than that of Greece, and one to which Greece owed a considerable debt. The pioneers of Egyptian Revival furniture design were Charles Percier and Pierre-François-Léonard Fontaine. In 1801, they published the *Recueil de décorations intérieures,* which acted as a pattern-book for those wishing to follow in Napoleon's wake and design furniture with Egyptian ornament.

> Si par exemple, des sphinx, des termes a l'égyptienne, peuvent convenir par la sévérité de leurs formes et par leur sens allégorique à tel ou tel emploi dans certains objets de l'architecture ou de l'ameublement, avant peu l'on verra toutes les enseignes, tous les dessus de portes a l'égyptienne.[6]

Thomas Hope was a friend of Percier and many of the pieces in *Household Furniture* bear a strong resemblance to the Frenchman's designs. Hope writes in the Preface to his text:

> I am flattered with hopes ... of producing in London a work comparable, in point of elegance of designs and excellence in execution, with that publication which at present appears in Paris, on a similar subject, directed by an artist of my acquaintance, Percier, who having devoted the first portion of his career to the study of Italian antiquities, now devotes his time to the superintendence of modern objects of decoration in France.[7]

Serge Grandjeau claims that the *Recueil* "was to acquire the status of a manifesto, not merely for national but indeed of a European significance."[8] It is most likely the relationship between its authors and designers and Napoleon that catapulted the work to European fame, as their designs in the Egyptian style took on semiological significance by representing the new power-base in France. Before 1801, they had already published one book based on their studies in Italy, the *Palais, maisons et autres édifices modernes dessinés à Rome* (1798), a work which revealed a joint interest in the Renaissance and classical antiquity. Their career as official architects, first to the Crown and then to the Republic, began with the preparation of designs for the furnishing of the Salle de la Convention at the Tuileries in 1793. During the Consulate, they began to restore the old royal palaces stripped bare by the Revolutionaries – residences which Napoleon would later occupy such as the Tuileries, the Elysée Palace, Saint-Cloud, the Trianon, Compiègne, and Fontainebleau. Josephine also used the architects to decorate her apartments at Malmaison, and three of the plates in the *Recueil de Decorations Interiéures* show some of their work for her.

The *Recueil de décorations intérieures comprenant tout ce qui a rapport à l'ameublement*, first published in 1801, was a folio volume comprising seventy-two engraved plates. Half of the designs were for pieces of furniture, either on their own or as part of an ensemble. The other plates showed architectural, carved, or painted decorations. The designs were mostly of a quality intended for state patronage, such as the designs for the King of Spain for his Palace at Aranjuez and, as such, were ideal for translation into the aristocratic homes and royal residences of England. In the list of plates, Percier and Fontaine indicated their debt to other cabinet-makers, "the fine finish and perfect workmanship demonstrate, these were made by M. Jacob," a reference evidently to Jacob-Desmalter,

the supplier of furniture to the French court, whose work featured in the French sales and was purchased by English collectors such as the Duke of Wellington.[9] While fearing revolution on their own shores and seeing France as a clear threat to the country's safety throughout the century, the leaders of England's artistic community coveted French fashion and style. The main instigator of this transference of cultural capital was the Prince of Wales, as he played a formative role in the development of the style of the royal residences and worked closely with Henry Holland and the architect's group of French assistants.

Political Allegiances: The Egyptian Revival Style in England

An interest in French culture and its objects aligned their owners in England with certain political groupings, predominantly associated with the Whig politics of Charles James Fox and the court of the Prince of Wales. Simultaneously it symbolized a move away from the majority who, led by the prime minister, Pitt the Younger, and George III, were concerned about French influence on English life at a time when France was perceived as the closest enemy and a threat to the safety of English society. While many fought to make England less permeable to French influence and commodification, the collecting practice of the Prince of Wales and his followers created a sense of opposition to the traditional structures of power, as "art and cultural consumption...fulfil[led] a social function of legitimating social differences."[10]

The allegiances of the Prince of Wales at this time were debated in the contemporary press and have been the subject of publications such as Linda Colley's *Britons* (1992), David Bindman's *The Shadow of the Guillotine* (1989), and a number of biographies and histories. For the purposes of this chapter, it is recognized that while the Prince was bound by his position to appear patriotic, he none the less demonstrated a significant admiration for France. This was reflected in his choice of designers and the interiors of both Carlton House and the Brighton Pavilion. Consumer habits that signified his opposition politics were particularly noticeable during his younger years, when, as Prince of Wales, he established a base of opposition ideology at Carlton House under the influence of the Foxite Whigs.

Concerns over French influence on English life preoccupied many sectors of society toward the end of the eighteenth century. These concerns

were brought together under the banner of the Anti-Gallican Association. The Association arose from a growing awareness of the influence of French ideas, particularly within the realm of culture. After the revocation of the Edict of Nantes in 1685, many Huguenot artists arrived in London. Imported designs, including the pattern-books of Daniel Marot and the work of Le Pautre, Rossi, Boucher, and Cuvilliés, were copied and published in translation. English furniture-makers increasingly used French-inspired styles to shape their own pieces. The fashion for the rococo, although never as widespread in Britain as on the Continent,[11] also bore witness to the influence that immigrant designers had on English design. The Association, founded in 1745, aimed to encourage English trade and "oppose the insidious arts of the French Nation."[12] Its intention was "to promote British manufactures, to extend the commerce of England and discourage the introduction of French models and oppose the importation of French commodities."[13] In 1802, the "pretentious Frenchifying" of the cabinet-maker's vocabulary was criticized by the *Gentleman's Magazine,* who complained that "Words entirely foreign have been greatly pressed into service, not by philologists and lexicographers, but by cabinet-makers and auctioneers, to give dignity to tables and chairs, to exalt cupboards and bracketts."[14]

Britain was at war with France almost continually between 1689 and 1713 and continued to go to battle against its most consistent enemy throughout the eighteenth century. As a result nationalistic sentiments were seen as vital to the continued strength of the country. After the Act of Union and the final failure of Jacobitism in 1745–6, the concept of nationalism was used as a tool to focus loyalty. Changes in eighteenth-century society began to erode localism, facilitate popular receptivity to state propaganda and encourage a national consciousness, including a much improved road and postal system, an expanding press network, metropolitan and urban growth, and an overall increase in levels of literacy.[15] A new sense of nationalism was also reflected in the country's trading links and in the establishment of societies with a specific agenda to improve commercial profitability in the light of an increase in imported goods and the rise of a British commercial identity. The Seven Years War added to this sense of patriotic duty, as the British victories and the resulting increase in colonial acquisitions boosted the trading portfolio of the country. In conjunction with this focus on commercial growth, society turned to cultural issues with the ambition of producing a hegemonic system that would reflect nationalistic ideas. An interest in art that

would honor Britain's heroes and rulers developed, ironically following the precedent set by the French royal family, particularly Louis XVI.

George III's desire to identify the monarchy with national achievement and visible images of this achievement was in evidence from the beginning of his reign. He drew symbolic capital from art and culture that codified a national identity, founded upon recognizable signs of victory and power. This focus on British cultural achievement contrasts greatly with the interests of his son, whose cultural capital was derived in the most part from recognizably French signs, which created an internalized code that would gain empathy and appreciation from his Whig peers.

After his victory over the Fox–North coalition in 1783–4, George III seemed, to many, to represent a reassuring stability in the midst of national flux and humiliation over the defeat in America. In the public mind, the King was aligned with Pitt the Younger against the dissident Whiggery. This was in direct opposition to the Prince of Wales's support of Fox. George III's popularity was nurtured by the unpopularity of his heir and reinforced by the French Revolution, which "gave almost every description of persons who have any influence on public opinion an interest to adhere to, and maintain inviolably, our established constitution and, above all, the Monarchy, as inseparably connected with, and maintaining everything valuable to the state."[16]

The French Revolution was the most serious challenge to the social and political structure of Britain since the Glorious Revolution. It threatened the country militarily (with the fear of an invasion by the French Revolutionary and Napoleonic armies), politically (bringing to Britain in its wake new reform movements and ideologies and the emergence of organized radicalism), and socially. Most Britons, however, reacted to the early events of the Revolution with approval. The summer of 1789 witnessed the fall of the Bastille, the abolition of feudalism, and the establishment of a constitutional government in France. Pitt's government welcomed the changes taking place on the other side of the Channel as they weakened a major competitor after many years of war between the two countries.[17] This was an ill-judged sentiment, however, as France proved herself rapidly capable of combining internal discord with external military triumph. Most of the Whig opposition, including the Foxite supporters, which had close links with liberal aristocratic opinion in France, welcomed the events of 1789 as a portent that political change could take place in England as well.[18]

The Radicals saw events in France as part of a wider pattern of the progressive overthrow of privilege. Activities taking place on the other side

of the Channel were used to corroborate the critical analyses of the church and the state located in the writings of Priestley, Paine, Spence, and Price. Between 1788 and 1792, Britain saw the most sustained radical and reformist activity since the Civil Wars of the seventeenth century. Radical clubs and associations were set up in nearly seventy towns and the success of Paine's *Rights of Man*, published in two parts in 1791–2 and proposing a complete reorganization of British society, ensured the unprecedented exposure of radical political ideas.[19] Included in this group of radical clubs was the London Corresponding Society, composed of men who did not have the vote and were calling for universal manhood suffrage. In November 1792, congratulatory addresses were taken to the New National Convention in France, proclaiming, "Frenchmen...you are already free, but the Britons are preparing to be so."[20]

These radical movements were greeted with fear and anxiety by Pitt's government and the majority of the aristocracy, as they appeared to threaten England's internal and external security. Their fears were confirmed by the ferocity of Edmund Burke's diatribe against the changes taking place in France, *Reflections on the Revolution in France* (1790). Burke identified events on the Continent as a new sort of revolution and he predicted its violence and energy, using the predicament of the French royal family as his most potent image.[21] At the beginning of December 1792, a fear of insurrection in England, exacerbated by reports of French agents in the country for "wicked purposes"[22] and of subsidies to opposition newspapers, led Pitt's government to call for fortifications of the Tower of London to be strengthened, troops to be brought into the metropolis, and a substantial part of the militia to be called out, an action which necessitated the recalling of parliament. A bill was passed authorizing the ejection of "undesirable aliens" from the country and the export of grain to France was halted.

The renewal of conflict between France and Britain in 1793 was marked by a propaganda campaign that demonized and dehumanized the enemy.[23] The pro-Government press made venomous attacks on the French. *The Times* maintained that British families should not be allowed to employ French servants and also suggested that French milliners should be repatriated for "taking the bread from the mouths of English women."[24] Fearful of French spies and saboteurs, Pitt's government introduced the Alien Act and the Traitorous Correspondence Bill in 1793. These were designed to prevent British subjects from assisting the French war effort. It became an offence to travel to or from France without a

licence or passport granted by the Crown, an act that limited the supply of French goods to England, and, perhaps ironically, increased their desirability due to their forbidden, and thus increased, status.

At the same time, there was growth in opposition to the war with France and demonstration of sympathy for France from the popular societies. The government's fear of these groups stemmed from a perceptible identification of the lower orders of English society with the ideology of the revolutionary enemy. The fervour Fox and his allies expressed for France could be tolerated because this group came from the social class of the ruling elite, but the popular societies consisted of men who, traditionally, had no voice in government and who came from the same social milieu as the *sans-culottes* of the Paris section.[25] The London Corresponding Society assumed leadership of the popular movement and demonstrated its new enthusiasm and strength with open-air meetings in the metropolis. After their second meeting on the October 26, 1793, George III was mobbed by crowds as he rode in state to open Parliament. Many loyalists believed that an attempt on the King's life had been made and Pitt's government reacted with a so-called "Reign of Terror."[26] A suspension of habeas corpus led to the threat of imprisonment for sedition. In many towns, Church and King Clubs and Loyalist Associations were active in the systematic intimidation of radicals and their sympathizers. Regiments of volunteers, manned chiefly by the propertied classes, acted as domestic military police, coordinated by government officials at the recently created Home Office.

According to Bindman, one effect of the fear amongst the propertied classes and the higher orders of a popular uprising and the influence of the French Revolution was "a horror of every kind of innovation."[27] Objects that celebrated nationality and tradition, and reinforced the *status quo*, were sought by those who wished to demonstrate their allegiance to the state. English makers who worked within the recognizable stylistic idioms of the eighteenth century were sought and patronized by those classes that feared change within the social hierarchy. Objects became emblems of patriotism and demonstrated support of the hegemonic milieu. Members of the ruling order were encouraged to seek out new forms of cultural expression that were unquestionably British. They remained as concerned as ever to stress what distinguished them from their lesser countrymen, but in ways that were indigenous to themselves, not borrowed from abroad.[28]

In contemporary language, "abroad" essentially meant France and those who adopted the French style were severely criticized in the public

arena. To avoid contact with the enemy, many Britons looked to the ancient past of Greece and Rome, not as previous generations had done, but with more certainty that they were creating a "new" form of cultural expression. "The societies they celebrated were emphatically dead. Consequently, they could inspire without being in any way threatening."[29] The artists most celebrated by a determinedly conservative society were those supported by Sir Joshua Reynolds and the Royal Academy. Society sought out ways to commemorate national heroes and used patriotism and jingoistic themes to usurp the cultural threat from the Continent. Contemporaneously, however, a new fashion was gathering favor, centered upon the figure of the heir to the throne. Rejecting society's fear of the French, he gathered together a group of supporters who embraced the style and culture of the Continent and celebrated it within the decoration of their homes.

The pattern of difference between heirs to the throne and their fathers did not originate with George III and his eldest son. Frank O'Gorman highlights a cycle of opposition and the tendency of successive heirs to the throne to act as the focus of political groups opposed to the existing administration in the eighteenth century.[30] The Prince of Wales was continually drawn to the Whig opposition, particularly the reactionary figure of Charles James Fox. George III regarded Fox and his supporter, the Duke of Portland (both later leaders of the Rockingham Whigs), as evil and ambitious men, who were hungry for office. The Prince of Wales, in direct opposition to his father's wishes, established a court at Carlton House that became a focus for radical political ideas. The oppositionary nature of this second court was emphasized by the differing responses to the French. Loyalist prints "frenchified" the Whig politicians and, after 1789, Fox and his allies were depicted as vulgar and French and were clearly identified in the public's mind as supporters of England's oldest enemy. Already, in 1782, the King was anxious about the increasing intimacy between the Prince of Wales and Fox. Fox, a Member of Parliament from the age of nineteen, had come to prominence during the American War of Independence when he roundly condemned what he perceived to be the mismanagement of the war effort under the Tory administration of Lord North, forcing North to resign in March 1782. At the age of thirty-three, Fox accepted office as one of the Secretaries of State in the new government led by the Whig, Lord Rockingham. In the following year, he became Foreign Secretary in the coalition government under the nominal leadership of the Duke of Portland.[31]

The Furnishing of Carlton House and Brighton Pavilion

The Prince courted the friendship of Fox from his new home, Carlton House. He had been given the empty building in 1783, on reaching his majority, plus sixty thousand pounds for refurbishment; "His enthusiastic interest in architecture and interiors was matched by his willingness to spend as much money as possible on settings which he considered suitable for his position."[32] The Prince's consumption constituted an authentic language and, through its focus on France, became a new means of individual and collective expression.[33] The heir to the throne became enmeshed ideologically in the politics of opposition and difference through his adoption of the stylistic regime of the Continental enemy. "Consumption is a system which assures the regulation of signs and the integration of the group: it is simultaneously a morality (a sign of ideological values), and a system of communication."[34] The objects consumed by the Prince of Wales and his followers acted as a system of meaning, a language that would determine and define them socially as distinct and, through distinction, as powerful. After refurbishment, Carlton House was to signify an oppositional power base. Its interiors spoke the language of a new cultural superiority.

From the beginning, the project had a markedly Gallic flavour. Guillaume Gaubert's appointment as the Clerk of Works in 1783 emphasized the Prince's interest in all things French, as did his close contact with influential French courtiers exiled in England, such as the Duc d'Orléans. Deliberately, the Prince of Wales aligned himself in opposition to his father's focus on patriotic patronage. Semiologically, he was reacting against the previous generation's cultural aims:

> Taste...functions as a sort of social orientation, "a sense of one's place", guiding the occupants of a given place in the social space towards the social positions adjusted to their properties and towards the practices or goods which befit the occupants of that position. It implies a practical anticipation of what the social meaning and value of the chosen practice or thing will probably be, given their distribution in social space and the practical knowledge the other agents have of the correspondence between goods and groups.[35]

In choosing the French idiom to voice his resistance, he was ensuring public awareness of his political allegiance. By the last quarter of the eighteenth century, the aping and acquisition of anything considered

foreign[36] was seen by many as cultural treason. Whether the neo-classical style fitted within this notion of "foreign" was open to much debate throughout the eighteenth century. When there was a call for a new national style of architecture at the beginning of the century, the architects had turned to the Italianate designs of Andrea Palladio, justifing their choice by proclaiming that their work was also inspired by the designs of Inigo Jones, Surveyor to the King's Works in the seventeenth century and the celebrated architect of royal buildings such as the Queen's House in Greenwich. Pattern-books, such as Colen Campbell's *Vitruvius Britannicus,* had celebrated the classical form, and the majority of both architectural and furniture treatises began with a consideration of the five orders of architecture. The neo-classical style, therefore, was considered inherently noble and nationalistic throughout much of the eighteenth century.

When George III moved from his residence in London to Windsor Castle, finally completed in 1789, he chose to decorate the castle with art that was a celebration of the indigenous styles of Britain. He commissioned a set of wall-paintings eulogizing Britain's history, both real and mythical, to decorate the new site of royal power. The refurbished state apartments at Windsor looked to a gothic past, evocative of chivalry, hierarchy, and a prehistory when the monarchy was assured of its position in the nation.[37]

Such displays of patriotic fervor clashed with the celebration of all things French and foreign that dominated the Prince of Wales's homes. "Taste is an acquired disposition to 'differentiate' and 'appreciate'... in other words, to establish and mark differences by a process of distinction."[38] The new style, referred to later as the "Regency" style,[39] also celebrated the feared ideology of the new, marking a clear, paradigmatic shift away from the traditional. The early nineteenth-century desire for innovation necessitated the constant production of new types of furniture, reflecting a popular reaction to objects celebrated by the then Prince Regent. Robert Southey noted in 1807 that:

> This is the newest fashion, and fashions change so often in these things, as well as in everything else, that it is easy to know how long it is since a house has been fitted up, by the shape of the furniture. An upholder just now advertises Commodes, Console-tables, Ottomans, Chaiselonges and Chiffoniers; – what are all these? you ask. I asked the same question and could find no person in the house who could answer me; but they are all articles of the newest fashion, and no doubt all will soon be thought indispensably necessary in every well furnished house.[40]

In the 1790s, however, such flouting of convention and dismissal of conservative norms was perceived to be ideologically dangerous and symbolic of a worrying counter-culture of opposition. William Pitt the Younger openly admitted that the war with France represented a desperate struggle to defend rank and, above all, property against the "example of successful pillage" set by the revolutionaries of 1789. Imagine, Edmund Burke asked his fellow Members of Parliament one year later, what it would be like

> To have mansions pulled down and pillaged, their persons abused, insulted and destroyed, their title-deeds brought out and burned before their faces, and themselves and their families driven to seek refuge in every nation throughout Europe, for no other reason than this, that, without any fault of theirs, they were born gentlemen and men of property, and were suspected of a desire to preserve their consideration and their estates.[41]

The landowners and aristocratic classes looked to France with fear and trepidation, and, even during the reign of Napoleon Bonaparte, witnessed the rise of men who had no landed background or ancient lineage to positions of power after the Revolution. The vision of a meritocracy so close at hand strengthened the resolve to celebrate the past glories of Britain and led to a distrust of those who surrounded themselves with objects that seemed to engage in a cultural dialogue out of which social change threatened to emerge.

In much of the scholarship that deals with the refurbishment of Carlton House, the furniture has been seen as autonomous from external determinants. Instead, focus has been placed on the commercial and stylistic value of the objects themselves. In articles by Geoffrey de Bellaigue, and in Frances Collard's *Regency Furniture*, the objects are questioned individually and, for the most part, are isolated from the commodification process, seen as representatives of a specific style or as defined by the "facts" of the archive. Aesthetic value, however, is contingent on a complex and constantly changing set of circumstances involving multiple social and institutional factors. Furniture does not exist independently of the complex institutional framework that authorizes, enables, empowers, and legitimizes it and, as such, the refurbishment of Carlton House needs to be positioned within this wider context.[42] Furniture history's strictly internal analysis – which views the objects as isolated texts – removes the object from the complex network of social relations that made the text's existence possible in the first place.

By isolating texts [objects] from the social conditions of their production, circulation and consumption, formalist analysis eliminates from consideration the social agent as producer [for example, the maker], ignores the objective social relations in which literary practice [furniture making] occurs and avoids the questions of what precisely constitutes a work of art at a given historical moment and of the "value"of the work.[43]

To be fully understood, objects must be reinserted into the system of social relations that sustained them. This does not imply a rejection of the aesthetic or formal qualities, but rather promotes an analysis which positions these qualities within a wider framework of "taste," consumption, and commodification.

The major phase of furnishing Carlton House began after Parliament agreed to settle the Prince's debts in 1787, and produced another sixty thousand pounds in order to complete the furnishing of the interiors. Gaubert was replaced by another Frenchman, Dominique Daguerre, at the request of the designer and architect of the house, Henry Holland. Holland apparently visited France in 1787, a visit which resulted in the dominant French aspects of the project.[44] After 1793, the unrest in France caused problems for Holland as Daguerre could not have found it easy to commission pieces directly from the Parisian workshops. Although French furniture could be obtained in London, the pieces were mainly from the pre-Revolutionary period, being sold either by the French government who had seized them from royal and aristocratic collections or by émigrés desperate for money. Relentlessly, without regard for cost and in defiance of the King's known wishes, more and more splendors were added to Carlton House. Craftsmen, decorators, cabinet-makers, metalworkers and woodcarvers were brought over from France until Carlton House could be compared with Versailles,[45] underlining the fact that there was contemporary understanding of the Prince's French influences. Whenever a cessation of fighting allowed it, the Prince's friends and relations went to France to buy furniture and *objets d'art*, including clocks, girandoles, looking-glasses, bronzes, Sèvres porcelain, Gobelin tapestries, and Boulle-work furniture. The salerooms and dealers' shops of London were similarly scoured for the most comprehensive collection of French works of art ever assembled by an English monarch – cabinets, chests and tables by Riesener, Weisweiler, Jacob, and Carlin, marble busts by Coysevox, bronzes by Keller, candelabra by Thomire, and pictures by Pater, Vernet, Greuze, Le Main, and Claude.[46]

The Prince of Wales's taste for all things French highlighted the clear cultural distinctions between himself and his father's generation and

supporters, while simultaneously indicating the vast distance between himself and the populace, even the radicalism of the popular societies. Linda Colley posits that the Prince chose pre-Revolutionary items specifically to champion the old France against the principles and the ruling personnel of the new.[47] This is questionable as Frances Collard makes it clear that, despite the evidence of a multiplicity of objects from the Louis XVI period, Henry Holland and Daguerre had both been in Paris to commission new furniture after the Revolution. Geoffrey de Bellaigue, in his study of Carlton House, also supports this claim, arguing that a number of pieces commissioned by the Prince of Wales's designers were actually made in Paris.[48] Thus, we can see that the Prince demonstrated an interest in both pre- and post-Revolutionary French style.

Obviously the heir to the British throne would have been wary of revolutionary forces on the Continent, and the Prince of Wales spoke out against the changes that he saw taking place politically and socially, particularly after he had assumed the role of Regent. His collecting activity, particularly from 1790 to 1805, however, tells a different tale. His support of Fox during the most radical of the latter's political years leads us to question how much the Prince really fought the changes taking place on the Continent, particularly under the rule of Napoleon. The Prince deeply admired the appearance of the new Napoleonic palaces. The decoration and furnishing of the Brighton Pavilion attest to this in their incorporation of the Egyptian style after the work of Percier and Fontaine and Denon in their grand designs for spaces such as the Tuileries.

The Prince's "marine pavilion" in Brighton, named in imitation of the Comte d'Artois's Parisian Pavilion de Bagatelle, continued his interest in the French style, including the use of scagliola columns and complementary colors.[49] After he was presented with some Chinese wallpapers in 1802, the Prince ordered that a Chinese Gallery be constructed, resulting in a move toward the oriental and the decision to convert the whole house to that style. This move has been linked to the Prince's realization of the unpopularity of his Gallic interest:

> ...the Prince says he had it so because at that time there was such a cry against French things etc.... and he was afraid of his furniture being accus'd of Jacobinism.[50]

The use of an Eastern style, however, did not preclude the Egyptian and Chinese styles that often originated in France, merely the removal of the

overtly French style of the eighteenth-century furniture that had dominated the Prince's purchases for Carlton House. The Pavilion contained a number of items with Egyptian motifs and there was a room described as an "Egyptian Gallery," probably dating from 1802, although no accurate descriptions of the room appear to have survived. Thomas Attree's *Topography of Brighton* (1809) describes the room as an "Egyptian Gallery ... the walls of which are covered with historical paper."[51] It is thought to have occupied the site of the present North Dressing Room. Egyptian Revival furniture still present at the Pavilion includes a couch in the form of a papyrus river-boat. The Prince of Wales purchased a number of items from Daguerre and Lignereux's shop including a pair of girandoles with the figure of an Egyptian woman and two cabinets with gilt-bronze Egyptianizing figure enrichments. In 1811 the Prince brought a centrepiece described as a large "Egyptian Temple or incense burner with figures supporting branches for eight lights."[52]

Furniture, Revivalism, and Identity

Chartier asserts that the nobility have used history to "provide them [selves] with a base for their particular culture, rooting their aristocratic ambitions in the past and justifying them."[53] Thus, what history was to mean, which history was to be remembered, and how it was to be written and transmitted came to be a vital part of the contest for power in the eighteenth century.[54] The French Revolution, while not permanently eradicating monarchical regimes in France, eliminated the possibility of an absolute monarchy and simultaneously broke the dynamic of the absolutist stylistic regime. That said, successive imperial and monarchical governments attempted, with varying degrees of success, to sustain a clear relationship between style and power, fashion and control. The rapidity of political change and the gap between the political and cultural transformation during the 1790s did not allow a fundamental redesign of the structures of furniture, which continued to reflect the neo-classical style. In terms of surface decoration, however, the early years of the Revolution witnessed the employment of self-consciously republican iconography, including scenes of the taking of the Bastille, clasped hands to show fraternity, and triangles with an eye in the middle which embodied reason. Thus the structures of the *ancien régime* were used but were given a republican skin.[55] The Directoire style continued this trend, although

designers increasingly turned to archaeological finds and the pattern-
books of classical architecture and design in order to copy objects directly.
This is the moment when Egypt began to be recognized as an alternative
source of historically sanctioned symbols of power, when Denon's *Voyage*
provided designers with the illustrations of ancient architecture (figure
6.1).[56] This literal version of historicism was fueled by a desire to recreate
the objects of the past. There was a sense that by rejecting the previous
revivalist forms that represented the control of the *ancien régime* in favor
of an informed, archaeologically sanctioned style, one could create a new
aesthetic for the new political regime. This is a questionable idea, as every
object, whether copied or styled in the spirit of the past, represents a re-
creation, but it also represents a deliberate attempt to use design to
distance Napoleonic society from the monarchical courts.

Napoleon shared with previous monarchs a belief in the importance of
the symbolic of the everyday. A new style agenda, figured within the
designs of Percier and Fontaine and Denon, recognized the symbolic
importance of revivalism but looked to a new foundation in history, that
of Egypt. The resulting objects were hybrids – utilizing Egyptian motifs
that celebrated Napoleon's campaigns in the East, but still based upon
classical forms borrowed from Louis XVI. As such, they celebrated the new
hierarchy of Napoleonic rule, while recognizing the post-Revolutionary
need to differentiate between the ruler and his subjects in a way similar to
absolutist control.

Todd Porterfield has posited that there was "no place for Egypt" in the
history of art, progress, and civilization under Napoleonic rule.[57] He
supports this argument by citing the fact that, in 1795, Egyptian artifacts
were kept in the medals department of the Bibliothèque Nationale along-
side other curiosities, that the Musée des Antiquités du Louvre of 1800
displayed only a few Egyptian objects of dubious origins, and that the spoils
of the Egyptian campaign were forcibly surrendered to Britain in 1801. This
has led Porterfield to conclude that it was not until the Restoration that
Egypt came to the fore as a stylistic idiom. Porterfield concentrates on the
impact of Egypt upon fine art and memorial sculpture and as a result he
underestimates the impact that Egypt had upon the style of other objects
produced during Napoleon's regime. Denon, publishing in 1802, instigated
a vogue for Egypt. Fastnedge confirms that, on Denon's return, "Egyptian
motifs were at once introduced in furniture made for Napoleon's private
apartments at the Tuilleries," designed by his appointed architects, Percier
and Fontaine.[58] Porterfield credits Champollion with the inception in 1829

Ruins of the Temple of Hermopolis

Figure 6.1 Dominique-Vivant Denon, *Ruins of the Temple of Hermopolis.* Plate XIV from *Voyage.* Reproduced by kind permission of the Earl and Countess of Harewood and the Trustees of Harewood House Trust.

of the belief that "the arts began in Greece as a servile imitation of the arts of Egypt ... without Egypt, Greece would probably have not at all become the classic land of the fine arts,"[59] and yet Denon discussed Egypt as the stylistic predecessor of Greece and Rome as early as 1802. Stylistic revivals can often be seen to impact upon the material culture of a new political regime long before they infiltrate fine art circles.

> Everything now must be Egyptian: the ladies wear crocodile ornaments, and you sit upon a sphinx in a room hung round with mummies, and with the long lean-armed, long-nosed hieroglyphical men, who are enough to make the children afraid to go to bed.[60]

The Egyptian Revival style, used in an eclectic mix with many others, came into vogue in Britain in the late 1790s, influenced by Denon and Percier and Fontaine. The English adaptation of the style often amounted to no more than the addition of a crocodile, serpent or sphinx-head to pieces of otherwise Greek Revival form. It was a superficial revival in the first instance, but its effect was to discriminate between the fashion for Egyptian motifs and the past, purer forms of the Graeco-Roman style.

Sheraton's Encyclopedia[61] of 1804–7 was the first pattern-book in England to use Egyptian motifs, although rather indiscriminately, such as by adding sphinx-heads to a classical bookcase or canopy bed.[62] Such items, however, were combined with politically indicative images to highlight the links between the Egyptian campaigns and Egyptian detail, such as a bookcase of c.1810 which is based on Sheraton's design but features the busts of Charles James Fox, William Pitt, and Admirals Nelson and Duncan in the place of the sphinx-heads, combined with typical Egyptian ornamental motifs. Thomas Chippendale the Younger used similar Egyptian designs for the furniture that he supplied to Richard Colt-Hoare for the library at Stourhead (1804–5), where a pedestal desk with both Egyptian and classical heads, a writing-table, six armchairs, and two single chairs all have sphinx-heads incorporated into their design.[63] At Stowe, there was an Egyptian Hall by 1805 and a bedroom which, in August 1805, had been "fitted up for the Duke of Clarence ... in the Egyptian style."[64] Goodwood contained a dining-room furnished in the Egyptian style between 1803 and 1806, "said to have been suggested by the works of Mons. Denon, particularly his description of the Temple and Palace discovered at Tintyra."[65] This is a useful indication of the impact that Denon's *Voyage* had on English cabinet design after its publication in 1802.

The influence of the Egyptian style and Denon's work was not universally celebrated, however, and a divergence between scholarly and popular interest led to C. A. Busby's comment in 1808 that

> Of all the vanities which a sickly fashion has produced, the Egyptian style in modern architecture appears the most absurd; a style which, for domestic buildings, borders on the monstrous. Its massy members and barbarous ornaments are a reproach to the taste of Its admirers; and the travels of DENON have produced more evil than the elegance of the engravings and the splendour of his publication, can be allowed to have compensated.[66]

The Egyptians were also criticized by Richard Brown who declared that,

> By the adoption of the pyramidal form, [they] seem to have intended their works to outlast all record; but their productions are more to be admired for their sublimity than true elegance and are more appropriate to monumental purposes than to furniture for apartments.[67]

Brown did include the Egyptian in his list of styles recommended for the fitting up of a room with appropriate furniture and upholstery so as to present "an accordance of ornament," and he criticized Sheraton for confusing the Egyptian and Roman styles.

For Craven Cottage in Fulham (1805–6), Walsh Porter designed one of the most elaborate Egyptian interiors of the Regency period. Porter was to become the Prince of Wales's advisor on the redecoration of Carlton House in 1802, after royal approval of his own fantastic interiors which included an Egyptian Hall, an exact copy from one of the plates in Denon's travels in Egypt,[68]

> with columns covered in hieroglyphics holding up the ceiling, palm trees in the corners, bronze figures and furniture which included a lion's skin for a hearth-rug, for a sofa the back of a tiger, the supports of tables in most instances were four twisted serpents or hydras.[69]

After Holland withdrew from royal service. Farington commented in his diary in May 1806:

> Lyscus said the Prince of Wales is incurring vast expenses. Although Carlton House as finished by Holland was in a complete and new state – he has ordered the whole to be done again under the direction of Walsh Porter who has destroyed all that Holland has done and is substituting a finishing in a most extensive and motley taste.[70]

The Egyptian style was fast becoming a fashion translated through the French designs of Denon and Percier and Fontaine, rather than one of English extraction. The Prince of Wales replaced the Holland/C. H. Tatham interiors with Walsh Porter's designs extracted directly from *Voyage*. Denon's illustrations were vital for anyone within the Prince of Wales's circle who wished to appear culturally aware. In 1801, Gaetano Landi published *Architectural Decorations: A Periodical Work of Original Designs invented from the English, the Greek, the Roman, the Etruscan, the Attic, the Gothic etc. For Exterior and Interior Decoration of Galleries, Halls, Apartments etc.*, including a design for "Lion" chairs probably taken from Denon.[71] The lion motif became symbolic of the influence of Egypt translated through Napoleonic France.

Thomas Hope mentions Denon's *Voyage* in the list of works most useful to him in *Household Furniture*.[72] Hope states that one of his intentions in using such texts is to give the "different pieces of furniture . . . an appropriate meaning." Even at this early date, he was acknowledging that objects are signs of appropriate cultural capital; they carry with them "meaning" as a distinct set of signifiers, including those associated with revivalism. The Dutch-born Hope had been a Francophile from youth. His family fled to England at the approach of the French armies invading Holland in 1795. The Hopes had lived in *ancien régime* splendor in Amsterdam, where Baron de Fremilly wrote that they "prided themselves on being frenchified, spoke only French and lived entirely *à la Française*."[73] The Duchess Street House, purchased in 1799 from Lady Warwick, must have appealed to Hope's Francophile tastes as it was set behind a screen and around a courtyard in the manner of a Parisian *"hôtel particulier."*[74] Unusually, Hope's Grand Tour, which lasted eight years, included a sojourn in Egypt, and this was reflected in the Egyptian Room at Duchess Street, which he filled with Egyptian antiquities including a mummy in a glass case. The walls were painted with a processional frieze of hieroglyphic figures and the furnishings were executed in black and gold with Egyptian motifs. *Household Furniture and Interior Decoration* was produced in conscious emulation of Percier and Fontaine's *Recueil*,[75] and Hope states that he hopes that his work is comparable to Percier's publication, in its invention and design of furniture, cabinet-work, and plate and his etching style and descriptions.[76] Hope warned the "young artist" against lightly undertaking the Egyptian style, as "the hieroglyphic figures, so universally employed by Egyptians, can afford us little pleasure on account of their meaning since this is seldom intelligible."[77] Hope also

created an Egyptian room at his country house, The Deepdene in Surrey, where in 1819, Maria Edgeworth saw a bed, "made exactly after the model of Denon's Egyptian bed."[78]

George Smith popularized the Egyptian style in his 1808 *Collection of Designs for Household Furniture and Interior Decoration*. The author was advertised as the "upholder extraordinary to his Royal Highness the Prince of Wales," although this fact has been questioned and may simply be an acknowledgment of the importance of royal patronage as a marketing tool. The introduction to his 1826 *Cabinet-Maker's and Upholsterer's Guide* declares Smith's debt to Denon's *Voyage* in his attempt to "interpret the spirit of antiquity as found in the best examples of the Egyptian, Greek and Roman styles."[79] This later pattern-book also contains a description for a complete library in the Egyptian taste.

The Egyptian Revival style was short-lived in England. As early as August 1809, Rudolph Ackermann commented that

> It cannot but be highly gratifying to every person of genuine taste, to observe the revolution which has, within these few years, taken place in the furniture and decorations of the apartments of people of fashion. In consequence of this revolution, effected principally by the study of the antique, and the refined notions of beauty derived from that source, that barberous Egyptian style, which a few years since prevailed, is succeeded by the classical elegance which characterised the most polished ages of Greece and Rome.[80]

Material culture provides the means by which social relations are visualized, and, as such, is the frame through which people communicate identities. In England, in the early nineteenth century, a material culture derived from France, incorporating a symbolism that looked to the power of a mighty Egyptian civilization, furnished its designers and owners with the ability to express certain social and political allegiances, and to mark their opposition to the status quo.

Notes

1 See N. Pevsner and S. Lang, "The Egyptian Revival," *Architectural Review* 119 (1956), pp. 243–54. See also Alois Riegl's *Stilfragen* (1893), where Egyptian ornament is used to develop a history of style.

2 James Randall, *A Collection of Architectural Designs for Mansions* (London, 1806).

3 Joseph Farington, *The Farington Diary*, ed. K. Garlick and A. Macintyre (New Haven and London: Yale University Press, 1978), p. 1778. In January, 1802, Farington reported that "G Smith has been in Paris seven months and is returned extremely disgusted with the state of society. No morals – no integrity. Characters of the lowest kind abounding in wealth which they expend in a licentious way. There appears to be an indifference to everything except pleasure. No principle remains...The government may be said to resemble that of the Praetorian bands in Ancient Rome...He thinks a person may live in Paris at half the expense of England."

4 George Smith, *A Collection of Designs for Household Furniture* (1808), cited in R. Fastnedge, *English Furniture Styles, 1500–1830* (Harmondsworth: Penguin 1962), p. 261.

5 J. S. Curl, *Egyptomania: The Egyptian Revival* (Manchester: Manchester University Press, 1994), p. 8.

6 Percier and Fontaine, *Recueil de décorations intérieures* (Westmead: Gregg International Publishers, 1971), p. 11.

7 Thomas Hope, *Household Furniture and Interior Decoration* (New York: Dover Publications, 1971), pp. 13–14. See also R.W. Symonds, "Thomas Hope and the Greek Revival," *Connoisseur* 140 (1957), pp. 226–30.

8 Serge Grandjeau, *Empire Furniture* (London: Faber and Faber, 1966), p. 24.

9 Percier and Fontaine, p. 35. See also Frances Collard, *Regency Furniture* (Woodbridge: Antique Collectors Club, 1985), p. 132.

10 Pierre Bourdieu, *Distinction: A Social Critique of the Judgement of Taste* (London: Routledge, 1979), p. 2.

11 Unlike on the Continent, where the rococo was incorporated into all aspects of interior and sometimes exterior design, in England this style was often used to complement substantially neo-classical rooms, and only featured in pieces such as girandoles and pier-glasses. For a short time it was fashionable for cabinet-makers to produce all types of designs featuring rococo scrolls, serpentine lines, and naturalistic patterning. The first edition of Chippendale's *Director* (1754) was overwhelmingly rococo in style, a fact which is often used to account for the rapid succession of editions. The second edition of 1762 featured mainly neo-classical designs.

12 See C. Alister, "The Anti-Gallicans," *Transactions of the Greenwich and Lewisham Antiquarian Society 7* (1970), pp. 211–17, and E. Mew, "Battersea Enamels and the Anti-Gallican Society," *Apollo* VII (1928), pp. 216–22.

13 G. Wills, *English Furniture, 1760–1900* (London: Guinness Superlatives, 1969), p. 37, quoted in Clive D. Edwards, *Eighteenth Century Furniture* (Manchester and New York: Manchester University Press, 1996), p. 157.

14 *Gentleman's Magazine*, September, 1802, quoted in Geoffrey de Bellaigue, "English Marquetry's debt to France," *Country Life*, June 13, 1968, pp. 1594–8.

15 L. Colley, "The apotheosis of George III: loyalty, royalty and the British nation, 1760–1820," *Past and Present* 102 (1984), p. 98. See also J. Brewer, *Party, Ideology and Popular Politics at the Accession of George III* (Cambridge: Cambridge University Press, 1973) and J. Brewer, N. McKendrick, and J. B. Plumb, *The Birth of a Consumer Society: The Commercialisation of Eighteenth Century England* (London: Europa, 1982), pp. 172–262.

16 S. Romilly, *Memoirs of the Life of Sir Samuel Romilly*, vol. 2 (London: 1840), pp. 300–1, quoted in Linda Colley, "The apotheosis," p. 105.

17 Frank O'Gorman, *The Long Eighteenth Century: British Political and Social History, 1688–1832* (London: Arnold, 1977), pp. 233–4.

18 In my discussion of the influence of the revolution in England, I follow the excellent arguments made by David Bindman, *The Shadow of the Guillotine: Britain and the French Revolution* (London: British Museum Publications, 1989), p. 12.

19 Ibid., p.14.

20 *London Chronicle*, November12, 1792, quoted in C. Emsley, *British Society and the French Wars, 1793–1815* (London and Basingstoke: Macmillan, 1979), p. 14.

21 John Brewer points out that Burke's denunciation of the Revolution must be seen in light of his political career. By 1789 he was having problems as his mentor, the Marquis of Rockingham, had died and his influence on other Whig political leaders, especially Charles James Fox and the Prince of Wales, had declined. His wrath was directed as much at English Radical dissenters as it was toward France (Bindman, *Shadow of the Guillotine*, p. 32).

22 Clive Emsley, *British Society and the French Wars*, 1793–1815 (London and Basingstoke: Macmillan, 1979), p. 15.

23 See Ian Germani, "Combat and culture: imagining the Battle of the Nile, *The Northern Mariner* 10(1), January (2000), pp. 53–72.

24 Emsley, p. 17.

25 Ibid., p. 25.

26 Bindman, *Shadow of the Guillotine*, p. 18.

27 Ibid., p. 19.

28 Linda Colley, *Britons: Forging a Nation, 1707–1835* (London: Vintage, 1996), Introduction and p. 222.

29 Colley, *Britons*, p. 181.

30 O'Gorman, p. 214.

31 Christopher Hibbert, *George IV* (London and Harmondsworth: Penguin, 1988), p. 50.

32 Collard, *Regency Furniture*, p. 13.

33 See Jean Baudrillard, "The system of objects," *Selected Writings*, ed. M. Poster (Cambridge: Polity, 1988).

34 Ibid., p. 46.

35 Bourdieu, *Distinction*, pp. 466–7.
36 See John Summerson, *Architecture in Britain*, 1530–1830 (New Haven and London: Yale University Press, 1993).
37 Mark Girouard, *The Return to Camelot: Chivalry and the English Gentleman* (New Haven and London: Yale University Press, 1984), pp. 19–25, and Colley, *Britons*, p. 227.
38 Bourdieu, *Distinction*, p. 466.
39 "Margaret Jourdain first used the word ["Regency"] in the title of her book [on English interiors] in 1923. The term was used at an early date by Sir Albert Richardson, who collected articles of the period in his house at Ampthill and it was given further currency by Edward Knoblock, who had collections of furniture, both French and English, including articles designed by Thomas Hope, in his house at Clifton Terrace, Brighton ... The age of Regency furniture may be said to have begun when the Prince of Wales appointed Henry Holland to rebuild and refurbish Carlton House (August 1783)," Clifford Musgrave *Regency Furniture, 1800–1830* (London: Faber and Faber, 1961), pp. 28–9.
40 Robert Southey, *Letters from England by Don Manuel Espiriella* (London: 1807), vol. 1, pp. 154–5.
41 G. Fasel, *Edmund Burke* (Boston: Twayne's Publishers, 1983), quoted in Colley, *Britons*, p. 159.
42 This reading has been influenced by Pierre Bourdieu's *The Field of Cultural Production; Essays on Art and Literature*, ed. Randal Johnson (Cambridge: Polity, 1993).
43 Ibid., p. 7.
44 Collard, *Regency Furniture*, p. 33.
45 Novelist Robert Plumer Ward quoted in Christopher Hibbert, *George IV* (London and Harmondsworth: Penguin, 1988), p. 57.
46 Hibbert, p. 58.
47 Colley, *Britons*, p. 228.
48 Geoffrey de Bellaigue, "The furnishings of the Chinese drawing room, Carlton House," *Burlington Magazine* 109(774), September (1967), pp. 518–30.
49 M. H. Port, "The homes of George IV," in Dana Arnold (ed.), *Squanderous and Lavish Profusion: George IV, his Image and Patronage of the Arts* (London: Georgian Group, 1995), p. 26.
50 Earl Granville Leveson Gower, *Lord Granville Leveson Gower, first Earl Granville: Private Correspondence*, 1781 to 1821, ed. Castalia Countess Granville, vol. 2, p. 120, letter dated October 9, 1805.
51 Curl, *Egyptomania*, p. 143.
52 Ibid., p. 144.
53 R. Chartier, *The Cultural Uses of Print in Early Modern France*, trans. L. G. Cochrane (Princeton, N.J.: Princeton University Press, 1987), pp. 194–5.

54 Leora Auslander, *Taste and Power: Furnishing Modern France* (Berkeley: University of California Press, 1996), p. 53.
55 Ibid., p. 151.
56 Abigail Harrison Moore, "Denon and the transference of images of Egypt," *Art History* 25(4), September (2002), pp. 531–49.
57 Todd Porterfield, *The Allure of the Empire: Art in the Service of French Imperialism, 1798–1836* (Princeton, N.J.: Princeton University Press, 1998), p. 91.
58 Fastnedge, *English Furniture Styles*, p. 261.
59 J. Champollion, *Lettres et journaux écrits pendant le voyage d'Egypte*, pp. 335–6, quoted in Porterfield, *Allure of the Empire*, p. 92.
60 Southey, *Letters from England*, vol. 3, p. 305.
61 Thomas Sheraton, *The Cabinet-Maker, Upholsterer and General Artist's Encyclopedia* (London: 1804–7).
62 See ibid., plate 2, Canopy Bed with Egyptian Figures.
63 See J. Kenworthy-Brown, "Notes on the furniture by Chippendale the Younger at Stourhead," in *The National Trust Year Book* (London: National Trust Publishing, 1975–6), pp. 93–102.
64 A. Fremantle (ed.), *The Wynne Diaries* (London: Oxford University Press, 1940), vol. 3, p. 187. I am indebted to Frances Collard for her detailed research and knowledge of Regency furniture.
65 D. Jacques, *A Visit to Goodwood* (Chichester and London: 1822), p. 21. In *Regency Furniture*, Collard states (p. 215) that the decoration and furniture in the Egyptian style at Kenwood were removed in 1904, leaving only a few pieces of furniture, including two sidetables with lion monopedia legs made of lead.
66 C. A. Busby, *A Series of Designs for Villas and Country Houses* (London: 1808), pp. 11–12.
67 R. Brown, *The Rudiments of Drawing Cabinet and Upholstery Furniture* (London: 1822), p. ix.
68 T. Faulkner, *An Historical and Topographical Account of Fulham* (London: 1813), p. 432; see Collard, *Regency Furniture*, p. 218.
69 T. C. Croker, *A Walk from London to Fulham* (London: W. Tegg, 1860), pp. 190–1.
70 Farington, *Diary*, p. 214.
71 Collard, *Regency Furniture*, p. 220.
72 Thomas Hope, *Household Furniture and Interior Decoration* (New York: Dover Publications, 1971), p. 140: "I shall conclude by subjoining a list of works, either representing actual remains of antiquity, or modern compositions in the antique style, which have been of most use to me in my attempt to animate the different pieces of furniture here described, and to give each peculiar countenance and character, a pleasing outline, and an appropriate

meaning." Hope then goes on to list Denon's *Egypt* as one of the items of "most use to me."

73 M. Chapman, "Thomas Hope's Vase and Alexis Decaix," *V and A Album* 4 (1985), p. 220. For further discussion of Thomas Hope, see David Watkin, *Thomas Hope 1769–1831 and the Neo-classical Idea* (London: Murray, 1968).

74 Chapman, "Thomas Hope's Vase," p. 220.

75 Hope, *Household Furniture*, p. viii.

76 Ibid., p. 14.

77 Ibid., p. 36.

78 Christina Colvin (ed.), *Maria Edgeworth: Letters from England*, 1813–44 (Oxford: Clarendon Press, 1971), p. 197.

79 Ralph Fastnedge, *English Furniture Styles*, p. 260.

80 R. Ackermann, *The Repository of Arts* (London: 1809), August, vol. 2, p. 132.

Architecture, Power, and Politics: The Forum-Basilica in Roman Britain

Louise Revell

Monumental architecture is perhaps one of the most instantly recognizable remains of the Roman period because of its privileged position in the history of classical archaeology and the canon of post-Roman architecture. When we look at a temple or an amphitheatre, we make an almost instinctive association between such places and the spread of the Roman Empire, an association which is not entirely inaccurate, but which can obscure the way in which power relations operated on a daily level. We see the appearance of Roman towns in the Western Empire as somehow inevitable, and that these should naturally include a range of monumental buildings. The forum-basilica symbolizes the power of Rome throughout the Mediterranean region and north-western Europe, but we can be less than thorough in our examination of how meaning accrues to such material remains. We become overawed by the grandeur and the opulence of these buildings, measuring the provincial examples against an ideal type and constructing a narrative which ignores the daily use of such spaces.

The central issue, which I shall discuss in this chapter, is how the fora of Roman Britain serve to place "Rome" and the power of the imperial system in the daily lives of the inhabitants of the provinces. However, in answering this question, we are immediately confronted with the problem

of how we should deal with Roman buildings, and in particular, those within the provinces. It is, in part, a problem of disciplinary meta-narrative: the dominance of style within the art-historical tradition.[1] For the Roman period, this has resulted in the formulation of a Roman canon based largely upon two elements: the descriptions of Vitruvius and the architecture of the city of Rome itself. When dealing with the public architecture of the provinces, this leads to two distinct disciplinary approaches. The first, which we might call the art-historical approach, is to construct a narrative of architectural change from the early Republic through to the Late Imperial periods based upon examples from Rome; the architecture of the provinces is then set against this by geographical region. The second, the archaeological approach, is to tie it into a narrative of Romanization, embedding the ideal type within a discourse of acceptance or resistance of Roman power and a Roman cultural norm.[2] Both of these approaches rest upon the idea of a canonical style, and concentrate upon the moment of construction. It is possible to critique this approach from a number of angles: from a disquiet concerning the importance this attaches to the works of Vitruvius to a more fundamental questioning of the whole notion of style as a theoretical approach.

Furthermore, when trying to pick apart the structures of empire, such an approach proves inadequate for the location and exploration of unequal power relations; we might acknowledge that they are embedded within the proliferation of such public buildings, but we assume that the detail is unproblematic. Within the Roman Empire, hierarchies of power existed on two levels: firstly, the global or Empire-wide level; and secondly, the local. The temptation is to deal with these as distinct entities, rather than as a complex interrelationship, based upon similar criteria and similar practices. My aim in this chapter is to explore how these relationships operate as part of the everyday experience and reality of the people of the provinces. Central to this is the idea of performance: the political spaces of the provincial towns provide the setting for a series of meaningful and repeated practices through which these relationships were negotiated. However, the danger with this is that in trying to reconstruct such practices, we build up a normative picture of a single experience: that of the elite, adult male. In the Roman period, the formulation of the architectural space served to privilege and mark out this particular identity; therefore, we need to be aware of the inherent rhetoric within the architecture and see past it. We need to acknowledge the multivocality of architectural space. As the roles in the everyday routines differ, so

experiences differ, with some marked out as more privileged, leading to the construction of power hierarchies. The materiality of the architecture was used to differentiate the users of such buildings, and so provides a framework through which we can reconstruct how such experiences differ. Rather than looking for every possible experience of a building, this allows us to identify the points at which a commonality of experience breaks down and privileged readings are built up.

The Forum-Basilica in Roman Politics

The importance of the forum lies in its association with political activity on the part of the social elite and the popular masses. It is hard to overestimate the importance of politics within the social structures of the city of Rome from the early Republic onwards. Social status was gained through a combination of wealth, birth, and political magistracies.[3] These magistracies were decided through the popular vote, but eligibility to stand was restricted to those meeting a property qualification of 400,000 sesterces, later raised to one million, typically inherited. There was a series of annual magistracies (culminating in the position of consul) which were decided by the votes of the (adult, male) citizen body. Elections were undoubtedly won through bribery, but they were contested through the idea of *virtus*, loosely, although somewhat misleadingly, translated as virtue. Authors such as Cicero and Quintilian stress the importance of the moral worth of a man in his ability to serve the state, and this formed part of the rhetoric of political competition. To question an opponent's morality was to question his suitability for office, and ultimately his membership of this political and social elite, and this idea forms the backdrop to much of the political writing of the time (for example, Cicero, *ad Quintum fratrem* 1.1). *Virtus* was acquired through both the deeds of the individual, and from his ancestors.[4] In a face-to-face society, the routines of political activity became the arena through which individual morality was demonstrated and judged by competitors and the citizen body as a whole.

The ancient forum in Rome, the Forum Romanum, was the center of political activity: as the venue for the assemblies of the people, as the setting for the platform from which the magistrates addressed them, and as the location of the senate-house (or curia) where the magistrates met. The forum was given its social importance through its connection with the

political activities of assemblies, speeches, and voting which lay at the heart of the Roman social and political structures, and, to a certain extent, defined what it was to be a Roman. Thus architecture became infused with a political meaning, but also with a tension: social position was not an automatic given, but had to be demonstrated repeatedly within the spatial location. In this way the forum becomes an arena for the demonstration of *virtus*, masculinity, and power.[5] As Rome increased its control initially into the rest of Italy, and then throughout the Mediterranean basin and north-western Europe, the same structures were exported into the conquered provinces through the foundation of towns in the image of Rome itself. Extant urban charters demonstrate the extension of a town council or ordo and elected magistrates.[6] Once again, eligibility rested on a property qualification, this time of 10,000 sesterces. Permeability between Rome and the provinces meant that an elite family from one of the provinces could become a member of the Roman senate, and ultimately consul, and this became increasingly common from the first century AD onwards.[7] The extension of Roman power through the newly conquered territories was accompanied by the extension of this socio-political system, with or without Roman citizenship. The reliance of this system upon rank through magistracy and popular participation through voting ensured that the forum went hand in hand with it.

However, it would be inaccurate to think of the forum as a static entity: changes in its form responded to the growing importance of monumental architecture, symbolized by the increase in ostentatious decoration such as imported marbles. For example, at Cosa the town was founded as a colonia in 273 BC, with the forum as the central point in the street grid.[8] The architecture of the first phase contained the most basic buildings necessary for political activity: an assembly place (comitium) and senate-house (curia) allowed for assemblies of the citizens and provided a meeting-hall for the senate, and an open courtyard formed a space where the population as a whole could vote. However, even by the second century BC, this space retained a mixed public-domestic use with atrium houses constructed around the sides of the forum. Areas were gradually demarcated for specific activities, with one block of housing removed to make way for a temple, and an open area potentially for commercial activities (the so-called forum piscarium); the demolition of a number of houses to allow for the extension of the curia and basilica points to the increasing importance attached to the public areas in preference to the domestic. The gradual elaboration of this space was further enhanced by

the construction of a series of porticoes around three sides of the forum, giving the space a more uniform and monumental appearance.

The key change in the configuration of the political space at Rome comes in the latter half of the first century BC with the construction of the Forum Iulium by Julius Caesar, and the Forum Augustum by Augustus.[9] In contrast to the earlier Forum Romanum, crossed by the processional route of the Sacra Via, these changes distanced the internal space of the forum from the rest of the urban networks. Both imperial fora comprised an open courtyard surrounded by porticoes (the so-called closed form), dominated by ideas of one or multiple axes governing the reading of the space and, as far as possible, a symmetrical layout. The Forum Iulium, supposedly an extension to the Forum Romanum, was in effect separated from it, fundamentally altering the way in which the inhabitants of the city would interact with and experience their space. In addition, the combination of the closed form and the axial temple to Venus Genetrix gave it an additional meaning of temple precinct, substantially altering the reading of the label "forum." This new style was repeated by Augustus with the construction of a second new forum adjoining the Forum Iulium. Paul Zanker has described the Forum Augustum as the expression of "a new national mythology":[10] the decoration of the area reinforced the glorious past and present of Rome through the divine family of Augustus. It served to reinforce the position of the new emperor and the new political regime, but also reiterated the criteria for leadership and elite status. The sides of the forum comprised two rows of porticoes, each lined with a series of statues depicting the glorious heroes of Rome's past, both real and mythical. Beneath each statue was a plaque giving the man's name, his magisterial career, and a description of his service to the state. Such decoration served to reinforce this reinterpretation of the history of the state, but also the new political power of the emperor.

These changes in the layout of the forum were not confined to Rome, but can be seen in the fora of Italy and the provinces. Those of the Iberian peninsular and France largely date from the time of Augustus onwards, and were modeled on the closed tripartite form of northern Italy.[11] They incorporated the monumental temple and open courtyard of the imperial fora at Rome, but also contained a large basilica as part of a unified scheme. However, this was not only the adoption of an architectural form: the association of the forum with the new political power of the emperor is also evident through the new iconographic representations of the emperor and the imperial family, inscriptions dedicated to the person

of the emperor, and the cult of the deified former emperors.[12] At Pompeii, temples to the imperial cult were constructed along the east side of the forum, dominating the space, with a group of monumental bases at the south end possibly for statues of the imperial family.[13] Other monuments were dedicated by the local elites, demonstrating their fitness for power through the reiteration of their magistracies and their good deeds to the community. Outside Italy, similar changes can be seen at Tarraco, where the colonial forum was transformed by an arch decorated with the iconography of captives and weapons, and a later temple to the deified Augustus. A new basilica was constructed with a shrine to the imperial cult, again later further elaborated with statues of Augustus and the imperial family.[14] By the middle of the first century AD, the forum was the setting for these twin levels of magisterial power, of both the local magistrates and the emperor. This was recalled through the political activities carried out within the buildings and through the statues and inscriptions which adorned the space.

The Introduction of the Forum to Roman Britain

As previously stated, the forum has long been considered emblematic of the spread of Roman architecture. However, those of Britannia are too often seen as the poor relation of those elsewhere in the Empire. Attempts to account for this have focused on two avenues of thought: the question of who instigated their construction and who physically built the structures. This has resulted from two pieces of evidence being given undue prominence: the lack of a significant pre-Roman tradition of public architecture in the province, and the reading of the highly ambiguous passage in Tacitus's biography of the provincial governor, Agricola.[15] Debates concerning the relationship between the civilian forum and the military principia in Britain have raged since the publication of the Wroxeter forum by Atkinson in 1942, and have concerned either the architectural style or the military personnel, or both.[16] The involvement of military architects and masons has been put in doubt by the work of Thomas Blagg, whose detailed study of the architectural sculpture has demonstrated the existence of distinct military and civilian styles.[17]

The fora of Britain date from the second half of the first century AD onwards, and the typical layout can be seen at Silchester (figure 7.1), where the forum lay at the heart of the town. Its closed form consisted

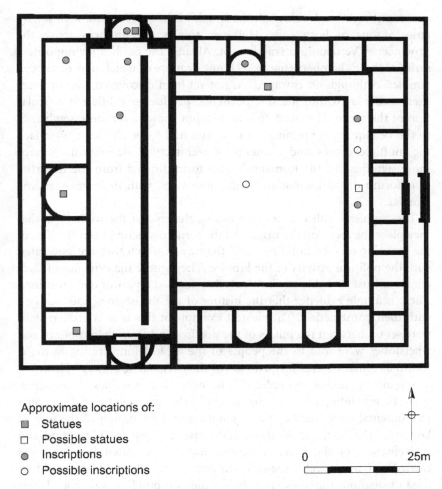

Approximate locations of:

■ Statues
□ Possible statues
● Inscriptions
○ Possible inscriptions

0 25m

Figure 7.1 Silchester forum and basilica showing approximate location of inscriptions and statues. After Raphael M. J. Isserlin, "A spirit of improvement? Marble and the culture of Roman Britain," in Ray Laurence and Joanne Berry, *Cultural Identity and the Roman Empire* (London: Routledge, 1998), figure 9.1.

of a large courtyard, surrounded by ranges of porticoed rooms or shops on three sides, and a cross-ways basilica with rear offices closing the fourth. The space was dominated by one axis which takes in the entrance to the forum, the entrance to the basilica and an open room at the centre of the rear offices, which is usually interpreted as a shrine. A secondary

· axis ran at right angles through the length of the basilica hall, with square apses at one or both ends. However, this is not uniform across the province: at Verulamium (modern St. Albans) the basilica lay opposite a series of three chambers (figure 7.2), one or more of which may have been temples. Although no entrance has not yet been discovered, one or more presumably lay within the side porticoes, producing a different articulation of the space. The most common layout shows a certain resemblance to the headquarters buildings of fortresses and forts, although these lack the multiple rooms and elements of architectural decoration. Perhaps more significantly, the Romano-British form differed from the tripartite style forum of the Iberian and Gallic provinces, with their free-standing temples.

The problem with debates concerning the role of the military is that they place the focus on the origins of the form, detracting from the idea of the meaning of such buildings, and the way in which they are associated with the political activity of the Empire. They ignore the evidence of their continued use and the way in which they formed a part of daily routines. There is ample evidence that the history of the British fora does not end with their construction. The clearest example of this is at Wroxeter: stalls were set up between the pillars of the portico, and from them pottery and whetstones were sold to the people of the area, demonstrating how the forum as a market area formed part of their regular routines.[18] However, this is not a unique example. All the excavated examples demonstrate sporadic rebuilding and reconfiguration of the space. Some of this is on a monumental scale, such as the demolition and rebuilding of the fora of London, Silchester, Verulamium, and Caistor.[19] Detailed excavation and re-evaluation of the London basilica has demonstrated how this was carried out in a careful sequence to ensure that the building could be used throughout the work. The site for the new building was much larger than the original structure, and the new forum was built around it, starting with the basilica itself and continuing with the side wings. Only once the new building was substantially completed was the old one demolished and the front portico and entrance added.[20] Less spectacular are the smaller alterations: at Exeter the entranceway to the forum was blocked in the mid-second century, and rooms were inserted in the south-eastern portico of the forum; and at Leicester two rooms in one of the side wings were joined and decorated with mosaic flooring. Hypocausts also seems to have been a popular addition, for example at Exeter and Caerwent.[21]

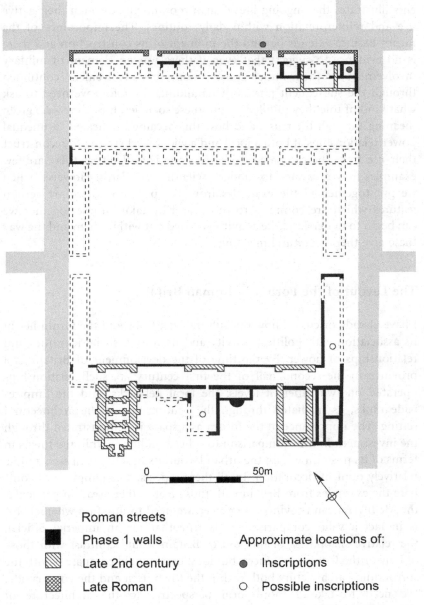

Figure 7.2 Verulamium forum and basilica showing approximate location of inscriptions and statues. After Rosalind Niblett, *Verulamium: The Roman City of St Albans* (Stroud: Tempus, 2001), figure 35.

Roman streets

Phase 1 walls

Late 2nd century

Late Roman

Approximate locations of:

● Inscriptions

○ Possible inscriptions

0 50m

This continued reworking of space and renewal of the decorative elements illustrates the ongoing life of such monuments through their active use and reinterpretation within daily routines. The importance of the forum-basilica extends beyond the moment of its construction and there is no evidence to suggest that even if there was an element of military involvement in their initial construction, this involvement continued through the subsequent phases of rebuilding. Therefore we need to ask what kind of role they fulfilled within these societies, how they were given meaning through their use, and how this became implicated in unequal power relationships at both a local and a wider level. Trying to reconstruct their use from the excavated evidence alone is difficult, as there are few examples fully excavated to modern scientific standards. However, when we put together all the examples from the province, there are certain features which are common to most, and by taking these together we can begin to understand the activities carried out within them and the way these give them a cultural meaning.

The Layout of the Forum in Roman Britain

I have already discussed how the cultural significance of the forum lies in its association with political activity and its role in social identities and relationships of power. By the time of the development of Britain as a province in the second half of the first century AD, such relationships operated on two different levels: the local networks, and the Empire-wide ranks, as mediated through the routine use of the architectural setting. The importance of the forum as a space is demonstrated through the investment in it in comparison to other buildings within the towns in terms of its position within the urban layout, its monumental size, and its relatively opulent decoration. In all these aspects, it is tempting to compare the examples from Britain with those from other areas, in particular the Mediterranean provinces. However, we need to question whether this is in fact a valid comparison. It is true that for an imperial official, the relative shabbiness of the fora of Britain would contrast with those of Italy or the Iberian provinces, but local users would compare it with the surrounding architecture both within the town itself and the countryside. We need to take a more local perspective to the architecture of the province: how the forum was invested in by the community, and the way in which certain areas were highlighted through a more elaborate

decoration, or through the way they were accessed (or not) both physically and visually.

Within British towns, the forum lay at the heart of the street grid, usually occupying a whole insula. At Caerwent, a town with a stereotypical planned grid, it lay at the point where the two major routes through the town crossed.[22] Elsewhere, towns with Iron Age predecessors were less regular in plan, but still the forum lay at a pivotal point within them. At Verulamium, the forum was constructed on the side of the Late Iron Age central enclosure, which has been interpreted as either a mint within a "royal" enclosure, or a ceremonial or religious precinct.[23] It occupied the central insula at the meeting of the roads through three main gates. The prestige of these buildings, like other public architecture in the province, was emphasized through investment in the building materials and their decoration. Imported marbles and ornate Corinthian capitals have been found on a number of sites, suggesting that the forum was considered worth the cost, time, and skilled workmanship involved in the transportation of the materials and the carving of the decoration.[24] They were not small buildings tucked out of the way, but dominated the townscape at key locations within passages of movement. Furthermore, the prominence of, and investment in, these buildings stressed the importance of their meaning and made it a part of the conceptual mindsets of the people inhabiting these towns.

In the rest of this chapter I will explore the way in which these buildings were given meaning. I have already argued that at Rome this meaning was connected with political activity and the reproduction of the power of the social elite through magisterial activity. The problem is that the meaning of the architecture, like that of any other form of material culture, is not fixed and stable, but is written onto and read off the space through the performance of routine activities within it. Therefore, the question we need to address is whether the fora of Britain were imbued with similar meanings, or whether they were used in a different way. If the meaning of the forum lay in its connection with power through political activity, can we detect it in these examples? The areas associated with the performance of magisterial power were the tribunal and the council chamber (the curia). The separation of those with political power from those without it was negotiated through who had access to these areas, how the movement of people through the spaces was controlled, and any differentiation through their decoration.

The tribunal formed a platform for use by magistrates; it was not a necessary part of the forum, and the position was variable.[25] However, in the fora of Roman Britain, it was invariably placed within the basilica at one or both ends of the central nave. The basilica at London seems to have had a single tribunal at the eastern end: this was a raised platform set within a circular apse with an antechamber separating it from the main part of the nave.[26] Brigham has suggested that there was possibly a "triumphal arch" highlighting the area; this precise terminology seems unlikely, as a triumphal arch was a very specific monument. Nevertheless, parallels at Caerwent (see below) would suggest this to be the general accentuating of the area through the use of columns and pilasters. The reconstruction of the decoration based upon the contexts of fragments of wall-painting indicates that the more elaborate decoration concentrated on the antechamber. The most ornate of the sequence dates from the second century and saw the antechamber richly decorated with a scheme of red panels with borders of green and yellow pennants and a second border of narrow white bands. The red panels, some bordered with blue, were decorated with designs of spiraling green stalks and colored flowers, and a robed figure of some kind. There is no firm evidence for the decoration of the apse, although traces of plaques in the plastered wall suggest that it was lined with marble veneer. The rhetoric of the architectural decoration served to highlight this area, and consequently the people who had access to this area.

A similar vocabulary can be seen at Silchester (figure 7.1).[27] Here, a tribunal was located at either end of the basilica nave and the decoration of the one at the north end again suggests a zoning from the rest of the nave. The nave itself shows a preponderance of white wall-painting with some red bands, while the apse was decorated in yellow and red, with some decorative elements, and very little white. However, there is an intriguing problem with this example: during the second-century rebuild the basilica was planned with circular apses at either end of the basilica, and construction on them was started. At some point before completion, it was decide to remove the circular apses, replacing them with square-ended tribunals. The excavators have argued that the decorative scheme described above was from this apse, and removed during the conversion. Nevertheless, this rhetoric of spatial decoration seems to have been repeated in the new arrangement, only this time the tribunal was faced with thin slabs of Purbeck marble. This emphasis on the tribunal at the end of the basilica nave is repeated elsewhere in the province, although the evidence is less

complete. At Cirencester, the west end of the basilica was dominated by a large circular apse; within the rubble excavated from here were fragments of architectural moldings and a piece of imported marble, tentatively identified by the Victorian excavator as cipollino from Italy.[28] At Caerwent the square-ended tribunal was accentuated with an engaged column and possibly a balustrade, and again was decorated with more than one phase of wall-painting.[29]

The second area associated with the performance of magisterial duty was the curia, a formal meeting space for the ordo or town council. The requirement was for the meeting to be held in a templum or ritually demarcated space, and the Curia at Rome seems to have been modeled on the architectural form of a temple.[30] They were part of the forum, but activities within them were physically or visually demarcated from the more public area. Internally, they usually seem to have had rows of stepped benches for the members along two facing sides, with a small tribunal for the presiding magistrate between. There are two main types of curia in the north-western provinces: a freestanding structure in the form of a temple, and a large room associated with the basilica. However, trying to identify these buildings within the fora of Britain has proved frustratingly difficult. The only securely identified example is that from Caerwent.[31] Here, one of the rooms in the basilica showed evidence of a small platform at the end opposite the entrance, with benches along the two sides. The decoration of the room points to its importance: the walls were painted with panels separated by columns in red, pink, and buff, and the floor was later covered with a mosaic. The curia was distanced from the open spaces of the basilica by an antechamber through which lay the only entrance.

The curias in other towns have proved more difficult to identify. Balty uses identification of benches, architectural form, position, and internal decoration as criteria. Using these, there are a number of possible candidates, although none is certain. The only probable example of the freestanding temple form is at Verulamium where three abutting buildings lie at the southern end of the forum, opposite the basilica (figure 7.2).[32] Each of these adjoined the ambulatory, but was prefaced by a monumental façade of some form, of which only the foundations remain. It is impossible to be certain which was a curia and which temples: the excavators tentatively suggested that room C was a curia, but more recent authors have argued for the central room B or room A. The central room does seem the most likely candidate, as it was an appropriate size, with side

chambers for either magistrates or administrative clerks, which would be unusual in a shrine. The architectural façade emphasized the importance of the space, of the activities carried out within it, and of the people who participated in them. Other examples are even less certain. At Caistor, Frere argued that the curia lay to the south end of the basilica nave, based on its position and its size (9.91m × 9.14m).[33] The other potential candidate (room 2) lies behind the basilica, and its position, hypocaust, and antechamber suggest it might be a curia, but at approximately twenty-eight square meters it seems too small for the ordo. At Leicester, the room in a similar position at the end of the basilica nave has also been identified as the curia, in part through analogy with Caistor, and again, alternatives seem too small.[34] At Silchester (figure 7.1), the earliest commentators argued that the central room in the western range of the basilica was the curia, but it seems more likely that this was a shrine.[35] The alternative is the most northerly of the rooms in this range, which is the largest and similar in position to that at Caerwent.

In addition to the curia and the tribunal, other areas contributed to the political meaning of the forum. Documentary sources and archaeological parallels both point to other functions for the spaces. We might expect there to be record offices, treasuries, offices for guilds or collegia to meet in, possibly even a prison. These spaces are difficult to identify with certainty, but there are hints of them: a possible treasury at Caerwent, a record office at Wroxeter.[36] Similarly, the marking out of certain rooms with hypocausts (Caistor), apses (Silchester), or mosaics (Leicester) suggests that they were used for more important activities. Epigraphic evidence records the imperial officials who carried out the Empire-wide census, such as Munatius Bassus who carried out the census of the Roman citizens at Colchester.[37] At Rome, the census took place in the public spaces of the town, the forum and the Campus Martius, and it seems likely that in the provincial towns it was similarly held in public spaces. In Britain, which lacked the multiple political areas of elsewhere in the Empire, the forum would seem a plausible location All such activities gave the forum a political meaning overall, confirming politics and political participation as important parts of the post-conquest social reorganization. Within this, there was a series of roles to enact: imperial official, urban magistrate, local citizen, and the excluded (women, children, and slaves). The use of the space within the forum served as a way to differentiate between these positions: ability to access, to participate, or to view allowed multiple experiences and multiple ways of fitting into the

Roman system. The ways in which people negotiated these spaces created a hierarchy based on political power. The rhetoric of the space, produced in part through the layout and decoration of particular areas, privileged the persona of the magistrate through his visible access to the tribunal and his non-visible use of the curia. The public nature of some of the activities, coupled with the ideology of the elected magistrate, produced moments of uncertainty. It formed the arena where he demonstrated his authority (*auctoritas*) and moral rectitude (*virtus*); he might affirm his power, or he could be judged as lacking in ability. Political power was contingent on the continued demonstration of fitness for position.

A Way to Remember Those Absent

However, there were two elements of stress within the political system. The first was that the political activities centered on both the tribunal and the curia were essentially ephemeral, requiring a more long-lasting affirmation. The second was the presencing of the power and position of the emperor. In an age where most of the inhabitants of the Empire would never see him in person, how was his image to be part of their mental landscape, and so part of their social knowledge? The decorative elements of the forum formed one solution to both of these problems. Statuary and inscriptions recorded transient acts of service and donation, and provided a visible reminder of those who were absent.[38] The political statues and monumental inscriptions on stone form a frequent part of the archaeological record elsewhere in the Empire, but an initial review of the evidence suggests that they are less frequent in Britain. However, a more thorough examination of the architectural space demonstrates that they may have been more frequent than we might suppose.

The forum at Silchester was decorated with a series of statues and inscriptions (figure 7.1). In the northern apse of the basilica traces of statue bases were found, and nearby a fragment of a larger-than-life-size statue of a military commander, probably an emperor.[39] A bronze eagle was found in the room adjoining the southern tribunal, a stone female head, argued to represent the tutela of the town, was found in the central apsed room and there were another four fragments of human figures without firm location, at least one of which may be of an emperor. Further statue bases were excavated in the northern range and the eastern ambulatory of the forum. A number of inscriptions have also been found

which have been tentatively placed in the basilica, and in the ambulatories and courtyard of the forum. Although the majority are very fragmentary, a dedication to the god Hercules by Titus Tammonius Vitalis almost certainly contains the phrase OB HONOREM (RIB 67), usually used when a leading person was given some form of public honor, or during his time as a magistrate. Another two inscriptions were monumental in size, and probably formed part of the architecture of the basilica (RIB 84 and 85).

Although no other forum has quite the wealth of evidence of Silchester, other examples provide tantalizing glimpses. At Caistor, there was a podium for statues beside the central room of the basilica,[40] and the fragment of an inscription found beside a road adjoining the forum probably originated within the building (RIB 214). At Cirencester, a fragment of a bronze statue was found in the rubble from the apse of the basilica, and fragments of an inscription were found unstratified on the site of the forum which referred to the Res Publica, or community of the town (RIB 114).[41] At Gloucester, a substantial base (approximately 4.1m ×3m) was uncovered at the area just in front of the basilica, with bronze fragments discovered around it; this may have been a bronze equestrian statue of a second-century emperor.[42] A similar bronze equestrian statue may have adorned the forum at Lincoln, and from the first phase there is evidence for at least two statue bases within the internal colonnade.[43] At Wroxeter, two large bases probably flanked the entrance to the basilica, and fragments of bronze found around them point to one or more human statues.[44] Finally, at Leicester a statue base was discovered during the nineteenth-century excavations.[45] Evidence for inscriptions is less frequent: at Verulamium (figure 7.2), the excavations in 1898–1901 produced five fragments of inscriptions from in or around buildings A and C and the basilica (RIB 222, 226–9) and a further one was found in 1935 in a rear room of the basilica (RIB 224). Furthermore, excavations in 1955 produced a group of fragments from the dedicatory inscription of the forum, similar to the forum dedication at Wroxeter.[46] Both of these inscriptions would have dominated the entrances to the fora, and record dedications to the current emperor in the names of the town's people. At Wroxeter, a second fragmentary inscription found in the vicinity may also have originated in the forum (RIB 286).

Taken individually, each of these examples may seem somewhat slight compared to the evidence from elsewhere in the Empire. However, it is noticeable that in the majority of fora in Britain which have been subjected

to systematic excavation, there is some evidence for the presence of inscriptions and statues. Their fragmentary nature makes it impossible to be certain in many cases of the message being conveyed. Larger-than-life-size statues were almost certainly of the emperor or another member of the imperial family. However, for the other fragments of statues and inscriptions, and the cases where we have only bases, we can only surmise that these were being used to make a public statement which related to the social and political power structures being enacted within these spaces. Nevertheless, while we must be mindful of these caveats, it is clear that the forum-basilica was considered an appropriate location for the positioning of statues and inscriptions, reinforcing the importance of these spaces, and also the message being conveyed through them. As people used the forum, they viewed such material, internalizing the statements of political power with respect to their own less powerful positions. These items served to familiarize them with the emperor and his position as supreme authority within the Empire. They also reiterated the local social hierarchies, and the connection of the forum in their display.

Any discussion of the emperor brings us necessarily to the question of the imperial cult, or more particularly, of temples to the deified emperors and their connection with political space. This relationship originated with the temple to Divus Julius, the deified Julius Caesar, built on the site of his funeral pyre in the Forum Romanum, and Vitruvius records incorporating a temple of Augustus within the basilica at Fanum (Vitruvius, 5.1.7). In Britain, a number of basilicas provide evidence for an open room placed at the farthest end of the dominant axis. At Silchester, in the pre-forum timber building, an open-fronted building was aligned with an altar in the open courtyard in front. The excavators interpreted this as a precursor to the basilica, but the alternative suggestion that it was an early temple is appealing.[47] This axis is preserved in the later basilica, although the altar was removed: the central room of the rear range was open and raised up by two steps along its entire front. It was decorated with thin slabs of white marble, and the original excavator commented that it "appears to have been more richly ornamented than any other part of the building."[48] The ritual significance of the space is suggested by the statue of the tutela discovered within it (see above). This idea of the raised, open room on the dominant axis is reproduced at both Caistor and Caerwent;[49] these contrast with the closed frontages of the other rooms within the forum. However, the association between these rooms and the imperial cult is problematic. It is based on analogy with the temples

to the imperial cult within the fora in other provinces, and the Shrine of the Standards in the corresponding position in the military headquarters. Picking apart this evidence suggests that the identification is less than secure. The argument for the dedication of temples within the forum to the imperial cult is essentially a circular argument: most such temples are in fact of unknown dedication. Similarly, the direct equation of a military headquarters with the forum is based upon architectural form at its broadest: functionally and symbolically these spaces had quite different meanings. Nevertheless, in spite of these caveats, these spaces were clearly marked out as special areas and probably as shrines. Their association with the imperial cult, although not exclusively as the statue of the tutela at Silchester suggests, is plausible. In this case, viewing these spaces, possibly adorned with images of past and present members of the imperial family, would serve to invoke the person of the emperor and his political position.

The Magistrate in Roman Britain

Thus far I have presented an unproblematic picture of the elite of Britannia adopting the role of magistrate as a new way of maintaining their status, and using political performance as a means to negotiate their position in relation to their imperial masters and the local populace.[50] In reality, however, the evidence is more nuanced, and there are certain problems with the assumption that the new province witnessed a linear transformation into Roman customs. When we begin to look for concrete evidence of named magistrates from the local community, there are very few examples. The epigraphic record of other provinces allows us to build up a picture of named magistracies and those who held them. In contrast, if we search the epigraphic corpus from Britain, there is a noticeable scarcity, although not complete absence, of equivalent examples. This absence is further accentuated by the lack of iconographic representation of the British elites wearing togas or in the act of delivering a speech. Reinforcing this is the analysis carried out by Tom Blagg on the incidence of munificence in Britain.[51] The construction of public architecture in the Roman Empire was carried out by leading members of the elite using their own resources; they then celebrated this act of donation to the community through inscriptions recording this. Thus, in other provinces we can see the magistrate taking an active lead. In contrast, Blagg has demonstrated that in Britain, munificence was more likely to be funded by collective

bodies, such as the group as a whole (for example, Civitas Cornoviourm) or a guild (Collegium Peregrinorum at Silchester).[52]

There are two possible (but not mutually exclusive) explanations for this: that there was a lack of competition for elite office, and so consequently less need for the inscriptions and iconography to preserve the deeds of a magistrate; or that there was a more deep-seated rejection of the idea of the magistrate within the differentiation of social status. Returning to the attested magistracies on the inscriptions from the province, it is noticeable that the majority of the individual magistracies mentioned are religious: sevirs or Augustales, both connected with the imperial cult.[53] The only individual political magistracy mentioned is the aedile Marcus Ulpius Januarius, who paid for a new stage for the theater at Brough-on-Humber. However, there are more attested members of the town councils, the decurions: at York and Gloucester, for example.[54] The tombstone of Volusia Faustina names her as a citizen of Lincoln, and gives her husband's title of decurion, and there is a possible second example of a decurion, although the text is fragmentary. Furthermore, inscriptions from York and Caerwent refer to political decisions or actions on the part of the ordo.[55] All this suggests the adoption of political activity as a means of mediating status, but not the element of competition for the more prestigious annual magistracies.

Therefore we are left with a somewhat nuanced picture of political activity in the province. The forum was clearly a significant part of the mental landscape and daily routines of the people using the towns of Roman Britain. The continued investment through to the end of the third century AD demonstrates that they were not an imperial imposition ignored by the local populations. They were an important symbol for the community. The forum, incorporating the basilica, was imbued with a meaning of political power and, by extension, social position. It served to legitimize the authority of certain people through political activity, separating them from those who lacked this authority. This was carried out through routine activities connected with the administration of the local area by the magistrates: the dignity of council meeting and trials was enhanced through the prominence invested in the areas where they were conducted, and this served to reaffirm the importance of the magistrate. The forum was preferentially used as a location for the more permanent display of this power through the statues and inscriptions located within it, and these also provided a way to fix the more abstract persona of the emperor within the social understanding of his subjects. We must

remember, however, that the performance and renewal of these hierarchies did not rely on the powerful alone: their continued position rested upon the acceptance of the rest of the population through their acts of participation and viewing. Thus the forum was a zone of possibilities, where the political elite could be challenged and found wanting: here the relative social positions of the community as a whole were continually renewed through the performance of political activity.

Acknowledgments

My thanks to Peter Guest and Martin Millett who read and commented on drafts of the text; also to Penny Copeland who redrew the images. Any errors remain my own.

Notes

1 This is discussed in Dana Arnold, *Reading Architectural History* (London: Routledge, 2002), ch. 3.
2 Examples of the traditional approach to architectural style: Frank Sear, *Roman Architecture* (London: Batsford, 1982); John B. Ward-Perkins, *Roman Imperial Architecture* (Harmondsworth: Penguin, 1981). For examples of the Romanization/resistance interpretation see Thomas F. C. Blagg, "First-century Roman houses in Gaul and Britain," in Thomas F. C. Blagg and Martin Millett, *The Early Roman Empire in the West* (Oxford: Oxbow, 1990), pp. 194–209; Colin Haselgrove, "Social and symbolic order in the origins and layout of Roman villas in Northern Gaul," in Jeannot Metzler, Martin Millett, Nico Roymans, and Jan Slofstra, *Integration in the Early Roman West: The Role of Culture and Ideology* (Luxembourg: Dossier d'Archéologie du Musée National d'Histoire et d'Art IV, 1995), pp. 65–75.
3 Details of the Roman political system are summarized in Peter Garnsey and Richard P. Saller, *The Roman Empire: Economy, Society and Culture* (London: Duckworth, 1987).
4 See John R. Patterson, *Political Life in the City of Rome* (Bristol: Bristol Classical Press, 2000).
5 See for example Amy Richlin, "Gender and rhetoric: producing manhood in the schools," in William J. Dominik, *Roman Eloquence: Rhetoric in Society and Literature* (London: Routledge, 1997), pp. 90–110.
6 The best examples of these are from Spain: the *lex coloniae Genetivae* and the *lex Irnitana*, the latter the municipal law given to a number of towns in

Baetica by Vespasian. For the texts of these see Michael Crawford (ed.), *Roman Statutes*, Bulletin of the Institute of Classical Studies Supplement 16 (London: Institute of Classical Studies, 1996), and Julián González, "The lex Irnitana: a new copy of the Flavian municipal law," *Journal of Roman Studies* 76 (1986), pp. 147–243.

7 For detailed studies of the epigraphic evidence for senatorial class and the consuls see Mason Hammond, "Composition of the senate, AD 68–225," *Journal of Roman Studies* 47 (1957), pp. 74–81; Géza Alföldy, "Consuls and consulars under the Antonines," *Ancient Society* 7 (1976), pp. 263–99.

8 The earliest excavations were synthesized with a discussion of the development of Cosa and its buildings in Frank E. Brown, *The Making of a Roman Town* (Ann Arbor: Michigan University Press, 1980). This has been deconstructed in light of more recent work in Elizabeth Fentress, "Introduction: Frank Brown, Cosa, and the idea of a Roman city," in *Romanization and the City: Creation, Transformations and Failures. Proceedings of a conference held at the American Academy in Rome to celebrate the 50th anniversary of the excavations at Cosa, 14–16 May, 1998* (Portsmouth, R.I.: Journal of Roman Archaeology Supplementary Series 38, 2000), pp. 11–24. See also Elizabeth Fentress, *Cosa V: an Intermittent Town. Excavations 1991–1997.* Memoirs of the American Academy in Rome Supplementary Volume II (Ann Arbor: University of Michigan Press, 2004).

9 The imperial fora are discussed in James C. Anderson, *The Historical Topography of the Imperial Fora* (Brussels: Latomus, 1984). The best interpretation of the iconographic importance of the Forum Augustum is Paul Zanker, *The Power of Images in the Age of Augustus* (Ann Arbor: University of Michigan Press, 1988).

10 Zanker, *Power of Images*, p. 195.

11 As demonstrated in John B. Ward-Perkins, "From Republic to Empire: reflections on the early provincial architecture of the Roman west," *Journal of Roman Studies* 60 (1970), pp. 1–19. See also Roland Martin, "Agora et forum," *Mélanges de l'Ecole Française à Rome* 84 (1972), pp. 903–33.

12 As discussed in Zanker, *Power of Images*, pp. 297–333; for more detailed case-studies from the Iberian peninsular, see W. Trillmich and Paul Zanker (eds.), *Stadtbild und Ideologie. Die Monumentalisierung hispanischer Städte zwischen Republik und Kaiserzeit. Kolloquium in Madrid vom 19. bis 23. Oktober 1987* (Munich: Verlag der Bayerischen Akademie der Wissenschaften, 1990).

13 For Pompeii see Paul Zanker, *Pompeii: Public and Private Life* (Cambridge, Mass.: Harvard University Press, 1998), pp. 81–102 and figs. 37 and 51. Also Ray Laurence, *Roman Pompeii: Space and Society* (London: Routledge, 1994), fig. 2.3.

14 Simon J. Keay, "Innovation and adaption: the contribution of Rome to urbanism in Iberia," in Barry W. Cunliffe and Simon J. Keay, *Social*

Complexity and the Development of Towns in Iberia (London: Proceedings of the British Academy 86, 1995), pp. 291–337.

15 The passage in question is chapter 21, with debate centering on the precise interpretation of the phrase *hortari privatim, adiuvare publice*; for a detailed discussion of this see Thomas F. C. Blagg, "An examination of the connexions between military and civilian architecture in Roman Britain," in Thomas F. C. Blagg and Anthony C. King (eds.), *Military and Civilian in Roman Britain: Cultural Relationships in a Frontier Province* British Archaeological Reports British Series 136 (Oxford: B.A.R., 1984), pp. 249–63.

16 The argument was proposed by Donald Atkinson in *Report on Excavations at Wroxeter (the Roman City of Viroconium) in the County of Salop, 1923–1927* (Oxford: Oxford University Press, 1942). The key contributions since are: Richard G. Goodchild, "The origins of the Romano-British forum," *Antiquity* 20 (1946), pp. 70–7; Ward-Perkins, "From republic to empire"; Sheppard S. Frere, "The forum and baths at Caistor by Norwich," *Britannia* 2 (1971), pp. 1–26.

17 Thomas F. C. Blagg, *Roman Architectural Ornament in Britain*, British Archaeological Reports British Series 329 (Oxford: Archaeopress, 2002).

18 Atkinson, *Excavations at Wroxeter*; see also Louise Revell, "Constructing romanitas: Roman public architecture and the archaeology of practice," in Patricia Baker, Colin Forcey, Sophie Jundi, and Robert Witcher (eds.), *TRAC98: Proceedings of the Eighth Annual Theoretical Roman Archaeology Conference, Leicester 1998* (Oxford: Oxbow, 1999), pp. 52–8.

19 Trevor Brigham, "Civic centre redevelopment: forum and basilica reassessed," in G. Milne, *From Roman Basilica to Medieval Market* (London: HMSO, 1992), pp. 81–95; Silchester: Michael Fulford and Jane Timby, *Late Iron Age and Roman Silchester: Excavations on the Site of the Forum-Basilica 1977, 1980–86*, Britannia Monograph Series 15 (London: Society for the Promotion of Roman Studies, 2000); Verulamium: Rosalind Niblett, *Verulamium: The Roman City of St Albans* (Stroud: Tempus, 2001); Caistor: Frere, "Forum and baths."

20 Brigham, "Civic centre redevelopment," pp. 81–3, figs. 31–2.

21 Exeter: Paul T. Bidwell, *The Legionary Bath-house and Basilica and Forum at Exeter* (Exeter: Exeter City Council, University of Exeter, 1979); Leicester: Max Hebditch and Jean Mellor, "The forum and basilica of Roman Leicester," *Britannia* 4 (1973), pp. 1–83; Caerwent: Sheppard S. Frere, "Roman Britain in 1987. 1. Sites explored," *Britannia* 19 (1988), pp. 416–84.

22 Richard J. Brewer, "Caerwent – Venta Silurum: a civitas capital," in Stephen J. Greep (ed.), *Roman Towns: The Wheeler Inheritance. A Review of Fifty Years' Research* (York: Council for British Archaeology Research Report 93, 1993), pp. 56–65.

23 The argument for this is presented in Niblett, *Verulamium*, pp. 42–3 and fig. 43.

24 The key research on these distributions is presented in Raphael M. J. Isserlin, "A spirit of improvement? Marble and the culture of Roman Britain," in Ray Laurence and Joanne Berry, *Cultural Identity and the Roman Empire* (London: Routledge, 1998), and Blagg, *Roman Architectural Ornament.*

25 For a full discussion of the basilica and the tribunal see Pierre Gros, *L'Architecture romaine: du début du IIIe siècle av. J.-C. à la fin du Haut-Empire,* Manuels d'Art et d'Archéologie Antiques (Paris: Picard, 1996), vol. 1, pp. 235–60.

26 Brigham, "Civic centre redevelopment."

27 See Fulford and Timby, *Late Iron Age,* and in particular the section by Bird on the wall-plaster. For the nineteenth-century excavations: James G. Joyce, "Third account of excavations at Silchester," *Archaeologia* 46 (1881), pp. 344–65, George E. Fox and W. H. St John Hope, "Excavations on the site of the Roman city at Silchester, Hants, in 1892," *Archaeologia* 53.2 (1893), pp. 539–73, at p. 557.

28 A. T. Martin, "Notes on the Roman basilica at Cirencester, lately delivered by Wilfred J. Cripps Esq., C.B.," *Transactions of the Bristol and Gloucestershire Archaeological Society* 21 (1898), pp. 70–8.

29 Sheppard S. Frere, "Roman Britain in 1990. 1. Sites explored," *Britannia* 22 (1991), pp. 222–92.

30 The most important discussion of the curia throughout the Empire is Jean Ch. Balty, *Curia ordinis: recherches d'architecture et d'urbanisme antiques sur les curies provinciales du monde romain,* Mémoires de la Classe des beaux-arts, vol. 15, fascicule 2 (Brussels: Académie royale de Belgique, 1991).

31 Thomas Ashby, "Excavations at Caerwent, Monmouthshire, on the site of the Romano-British city of Venta Silurum, in the year 1905," *Archaeologia* 60.1 (1906), pp. 111–30; Sheppard S. Frere, "Roman Britain in 1988. 1. Sites explored," *Britannia* 20 (1989), pp. 258–326; Brewer, "Caerwent – Venta Silurum," pp. 56–65.

32 The excavations are published in M. Aylwin Cotton and R. E. Mortimer Wheeler, "Verulamium 1949," *Transactions of the St. Albans and Hertfordshire Architectural and Archaeological Society* (1953), pp. 13–97; for alternative interpretations see Balty, *Curia ordinis*; John S. Wacher, *The Towns of Roman Britain* (London: Batsford, 1995), and Niblett, *Verulamium.*

33 Frere, "The forum and baths at Caistor by Norwich," p. 15.

34 Hebditch and Mellor, "The forum and basilica of Roman Leicester," especially p. 38.

35 James G. Joyce, "The excavations at Silchester," *Archaeological Journal* 30 (1873), pp. 10–27; Fulford and Timby, *Late Iron Age.*

36 Caerwent: Brewer, "Caerwent – Venta Silurum," p. 63; Wroxeter: Atkinson, *Report on Excavations at Wroxeter,* pp. 101–3.

37 The inscription is published in *Corpus Inscriptionum Latinarum*, vol. 14.3955; it is discussed in Anthony R. Birley, *The Fasti of Roman Britain* (Oxford: Clarendon Press, 1991), pp. 303–4. For a full description of the census at Rome see Claude Nicolet, *The World of the Citizen in Republican Rome* (London: Batsford, 1980), pp. 60–7.

38 For a discussion of the motivation for such donations, see Nicola Mackie, "Urban munificence and the growth of urban consciousness in Roman Spain," in Thomas F. C. Blagg and Martin Millett, *The Early Roman Empire in the West* (Oxford: Oxbow, 1990), pp. 179–91.

39 The sculpture from the Roman Empire is collected in the various volumes of the *Corpus Signorum Imperii Romani*, the inscriptions in Robin G. Collingwood and Richard P. Wright, *The Roman Inscriptions of Britain. Volume 1: Inscriptions on Stone* (Oxford: Clarendon Press, 1965), abbreviated as *RIB*. For the Silchester examples, see Barry W. Cunliffe and Michael Fulford, *Bath and the Rest of Wessex, Corpus Signorum Imperii Romani*, vol. 1.2 (Oxford: Oxford University Press, 1982). Also Fulford and Timby, *Late Iron Age*; Joyce, pp. 10–27; George C. Boon, "Serapis and Tutela: a Silchester coincidence," *Britannia* 4 (1973), pp. 107–11; George E. Fox & W. H. St. John Hope, "Excavations on the site of the Roman city at Silchester, Hants, in 1892," *Archaeologia* 53.2 (1893), pp. 539–73. The possible locations of the inscriptions are given in Isserlin, "A spirit of improvement?" especially fig. 9.1.

40 Frere, "The forum and baths," p. 7.

41 Martin, "Roman basilica at Cirencester," p. 78.

42 H. Hurst, "Excavations at Gloucestershire, 1968–71: first interim report," *Antiquaries Journal* 52 (1972), pp. 24–69; Martin Henig, *Roman Sculpture from the Cotswold Region, with Devon and Cornwall, Corpus Signorum Imperi Romani*, vol. 1.7 (Oxford: Oxford University Press, 1993), no. 177.

43 Michael Jones, David Stocker, and Alan Vince, *The City by the Pool: Assessing the Archaeology of the City of Lincoln*, Lincoln Archaeological Studies 10 (Oxford: Oxbow, 2003), especially pp. 69–70, figs. 7.17 and 7.19.

44 Atkinson, *Report on Excavations at Wroxeter*, pp. 82–94; Martin Henig, *Roman Sculpture from the North West Midlands. Corpus Signorum Imperi Romani*, vol. 1.9 (Oxford: Oxford University Press, 2004), no. 184.

45 Hebditch and Mellor, "The forum and basilica of Roman Leicester," p. 5.

46 For Verulamium: Sheppard S. Frere, *Verulamium Excavations II* (London: Society of Antiquaries of London, 1983), pp. 69–72; for Wroxeter: Atkinson, *Report on Excavations at Wroxeter*, pp. 177–84, *RIB* 288.

47 Fulford and Timby, *Late Iron Age*; the alternative interpretation is discussed in Martin Millett, "Review of Fulford and Timby," *Archaeological Journal* 158 (2001), pp. 394–5.

48 James G. Joyce, "Third account of excavations at Silchester," p. 361.

49 Frere, "The forum and baths at Caistor by Norwich"; Brewer, "Caerwent – Venta Silurum," pp. 56–65.

50 For a fuller discussion of this model: Martin Millett, *The Romanization of Britain: An Essay in Archaeological Interpretation* (Cambridge: Cambridge University Press, 1990).

51 Thomas F. C. Blagg, "Architectural munificence in Britain: the evidence of the inscriptions," *Britannia* 21 (1990), pp. 13–31.

52 Civitas Cornoviorum: *RIB* 288; Collegium Peregrinorum: *RIB* 69–71.

53 Sevir: *RIB* 678 from York; Augustalis: *RIB* 154 from Bath.

54 The inscriptions are as follows: York, *RIB* 673, Mark W. C. Hassall and Roger S. O. Tomlin, "Roman Britain in 1986. II. The Inscriptions," *Britannia* 18 (1987), pp. 360–77, nos. 5 and 18; Gloucester, *RIB* 161; Lincoln, *RIB* 250, Mark W. C. Hassall and Roger S. O. Tomlin, "Roman Britain in 1976. II. The inscriptions," *Britannia* 8 (1977), pp. 425–49, no. 9.

55 York: Hassall and Tomlin, "Roman Britain in 1976," pp. 425–49, no. 16; Caerwent, *RIB* 311.

Bibliography

Adamson, J. W. (ed.) (1922). *The Educational Writings of John Locke*. Cambridge: Cambridge University Press.

Akin, N., Batur, A., and Batur, S. (eds) (1999). *Seven Centuries of Ottoman Architecture: A "Supra-National Heritage."* Istanbul: YEM Yayin.

al-Asad, M. (1996). The mosque of Muhammad Ali in Cairo. *Muqarnas* 9: 39–55.

Alden Williams, J. (1972). The monuments of Ottoman Cairo, in *Colloque International sur L'Histoire du Caire*. Cairo: American University in Cairo Press, pp. 453–65.

Alfoldy, G. (1976). Consuls and consulars under the Antonines. *Ancient Society* 7: 263–99.

Alister, C. (1970). The Anti-Gallicans. *Transactions of the Greenwich and Lewisham Antiquarian Society* 7: 211–17.

Anderson, J. C. (1984). *The Historical Topography of the Imperial Fora*. Brussels: Latomus.

Arnold, D. (2002). *Reading Architectural History*. London: Routledge.

Ashby, T. (1906). Excavations at Caerwent, Monmouthshire, on the site of the Romano-British city of Venta Silurum, in the year 1905. *Archaeologia* 60.1: 111–30.

Atkinson, D. (1942). *Report on Excavations at Wroxeter (the Roman City of Viroconium) in the County of Salop, 1923–1927*. Oxford: Oxford University Press.

Auslander, L. (1996). *Taste and Power: Furnishing Modern France*. Berkeley: University of California Press.

Avery, C. (1997). *Bernini: Genius of the Baroque.* London: Thames and Hudson.

Baker, P., Forcey, C., Jundi, S., and Witcher, R. (eds.) (1999). *TRAC 98: Proceedings of the Eighth Annual Theoretical Roman Archaeology Conference, Leicester 1998*. Oxford: Oxbow.

Balty, J. C. (1991). *Curia ordinis: recherches d'architecture et d'urbanisme antiques sur les curies provinciales du monde romain.* Mémoires de la Classe des beaux-arts, vol. 15, fascicule 2. Brussels: Académie royale de Belgique.

Banks, Sir J. (1745–1820). Things intended for Omai manuscript list. National Library of Australia MS9/14.

Bann, S. (1989). *The True Vine: On Visual Representation and the Western Tradition.* Cambridge: Cambridge University Press.

Barocchi, P. (ed.) (1973). *Scritti d'arte del Cinquecento.* Milan and Naples: Riccardo Ricciardi.

Barrell, J. (ed.) (1992). *Painting and the Politics of Culture.* Oxford: Oxford University Press.

Baudrillard, J. (1988). *Selected Writings,* ed. M. Poster. Cambridge: Polity.

Beazley, J. D. (1963). *Attic Red-Figure Vase-Painters,* 2nd ed. Oxford: Oxford University Press.

Behrens-Abouseif, D. (1989). *Islamic Architecture in Cairo: An Introduction.* New York and Cologne: Leiden.

Behrens-Abouseif, D. (2004). "Mamluk Art," in *Encyclopaedia of Islam (Supplement),* 2nd ed. Leiden: Brill.

Behrens-Abouseif, D. and Vernoit, S. (eds) (2006). *Islamic Art in the Nineteenth Century.* Boston: Leiden.

Bhabha, H. (1990). *Nation and Narration.* London: Routledge.

Bhabha, H. (1994). *The Location of Culture.* London: Routledge.

Bidwell, P. T. (1979). *The Legionary Bath-House and Basilica and Forum at Exeter.* Exeter: Exeter City Council, University of Exeter.

Bindman, D. (1989). *The Shadow of the Guillotine: Britain and the French Revolution.* London: British Museum Publications.

Birley, A. R. (1991). *The Fasti of Roman Britain.* Oxford: Clarendon Press.

Blagg, T. F. C. (1990). Architectural munificence in Britain: the evidence of the inscriptions. *Britannia* 21: 13–31.

Blagg, T. F. C. (2002). *Roman Architectural Ornament in Britain.* British Archaeological Reports British Series 329. Oxford: Archaeopress.

Blagg, T. F. C. and King, A. C. (eds.) (1984). *Military and Civilian in Roman Britain. Cultural Relationships in a Frontier Province.* British Archaeological Reports British Series 136. Oxford: B.A.R.

Blagg, T. F. C. and Millett, M. (eds.) (1990). *The Early Roman Empire in the West.* Oxford: Oxbow.

Boardman, J. (1976). A curious eye-cup. *Archäologischer Anzeiger:* 282–90.

Boon, G. C. (1973). Serapis and Tutela: a Silchester coincidence. *Britannia* 4: 107–14.

Boselli, O. (1994). *Osservazioni sulla scultura antica,* ed.. Antonio P. Torresi. Ferrara: Liberty House.

Bourdieu, P. (1979). *Distinction: A Social Critique of the Judgement of Taste.* London: Routledge.

Bourdieu, P. (1993). *The Field of Cultural Production: Essays on Art and Literature.* Cambridge: Polity.

Bourdieu, P. and Passeron, J.-C. (1977). *Reproduction in Education, Society and Culture*, trans. Richard Nice. London: Sage.

Brewer, J. (1973). *Party, Ideology and Popular Politics at the Accession of George III.* Cambridge: Cambridge University Press.

Brewer, J., McKendrick, N., and Plumb, J. B. (1982). *The Birth of a Consumer Society: The Commercialisation of Eighteenth Century England.* London: Europa.

Brown, F. E. (1980). *The Making of a Roman Town.* Ann Arbor: Michigan University Press.

Brown, R. (1822). *The Rudiments of Drawing Cabinet and Upholstery Furniture.* London.

Busby, C. A. (1808). *A Series of Designs for Villas and Country Houses.* London.

Butler, J. (1993). *Bodies that Matter: On the Discursive Limits of Sex.* New York: Routledge.

Carter, P. (2001). *Men and the Emergence of Polite Society in Britain 1660–1800.* Harlow: Pearson Education.

Çelik, Z. (1986). *The Remaking of Istanbul: Portrait of an Ottoman City in the Nineteenth Century.* Seattle: University of Washington Press.

Cellini, B. (1564). *Due trattati, uno intorno alle otto principali arti dell'oreficeria, l'altro in materia dell'arte della scultura* Florence: Velente Panizzij and Marco Peri. (anastatic reprint, Modena: Edizioni Aldine, 1983).

Champollion, J.-F. (1998). *Lettres et journaux écrits pendant le voyage d'Egypte.* Paris: C. Bourgois.

Chapman, M. (1985). "Thomas Hope's Vase and Alexis Decaix," V and A Album 4: 216–28.

Chartier, R. (1987). *The Cultural Uses of Print in Early Modern France,* trans. L. G. Cochrane. Princeton, N.J.: Princeton University Press.

Cole, M. (2002). *Cellini and the Principles of Sculpture.* Cambridge: Cambridge University Press.

Coliva, A. (ed.) (2002.) *Bernini scultore: la tecnica esecutiva.* Rome: De Luca.

Coliva, A. and Schütze, S. (eds.) (1998). *Bernini scultore: la nascita del barocco in casa Borghese.* Rome: Edizioni de Luca.

Collard, F. (1985). *Regency Furniture.* Woodbridge: Antique Collectors Club.

Colley, L. (1984). The apotheosis of George III: loyalty, royalty and the British nation, 1760–1820. *Past and Present* 102: 94–129.

Colley, L. (1996). *Britons: Forging a Nation, 1707–1835.* London: Vintage.

Collingwood, R. G. and Wright, R. P. (1965). *The Roman Inscriptions of Britain. Volume 1: Inscriptions on Stone.* Oxford: Clarendon Press.

Collis, J. (2003). *The Celts: Origins, Myths and Inventions.* Stroud: Tempus.

Colvin, C. (ed.) (1971). *Maria Edgeworth: Letters from England, 1813–44*. Oxford: Clarendon.

Connerton, P. (1989). *How Societies Remember*. Cambridge: Cambridge University Press.

Cook, J. (1784). *A Voyage to the Pacific Ocean: undertaken by the command of his Majesty, for making discoveries in the Northern hemisphere* (3 vols., vols. 1 and 2 written by J. Cook), vol. 1. London: W. & A. Strahan.

Cook, J. (1961). *The Journal of Captain James Cook on his Voyages of Discovery. Volume 2: The Voyage of the Resolution and Adventure, 1772–75*, ed. J. C. Beaglehole. Cambridge: Hakluyt Society.

Cook, J. (1967). *The Journals of Captain James Cook on his Voyages of Discovery. Volume 3: The Voyage of the Resolution and Discovery, 1776–80, Part 2*, ed. J. C. Beaglehole. Cambridge: Hakluyt Society.

Cooley, C. H. (1983). Human Nature and the Social Order. New York: Scribner's.

Coste, P. (1837). *Architecture arabe, ou, Monuments du Kaire*. Paris.

Cotton, M. A. and Wheeler, R. E. M. (1953). Verulamium 1949. *Transactions of the St. Albans and Hertfordshire Architectural and Archaeological Society*: 13–97.

Crawford, M. (ed.). (1996). *Roman Statutes*. Bulletin of the Institute of Classical Studies, Supplement 64. London: Institute of Classical Studies, University of London.

Croker, T. C. (1860). *A Walk from London to Fulham*. London: W. Tegg.

Cunliffe, B. W. and Fulford, M. (1982). *Bath and the Rest of Wessex: Corpus Signorum Imperii Romani* vol. 1.2. Oxford: Oxford University Press.

Cunliffe, B. W. and Keay, S. J. (eds.) (1995). *Social Complexity and the Development of Towns in Iberia*. London: Proceedings of the British Academy 86.

Curl, J. S. (1994). *Egyptomania: The Egyptian Revival*. Manchester: Manchester University Press.

Damasio, A. (2000). *The Feeling of What Happens: Body, Emotion and the Making of Consciousness*. London: Vintage.

Davidson, J. (1997). *Courtesans and Fishcakes. The Consuming Passions of Classical Athens*. London: HarperCollins.

Davis, C. (1995). Foreword, in R. Charity (ed.), *The Impossible Science of Being: Dialogues between Anthropology and Photography*. London: The Photographers Gallery.

de Bellaigue, G. (1967). The furnishings of the Chinese drawing room, Carlton House. *Burlington Magazine* 109: 518–30.

de Bellaigue, G. (1968). English marquetry's debt to France. *Country Life*, June 13, 1968: 1594–8.

de Bolla, P. (2001). *Art Matters*. Cambridge, Mass.: Harvard University Press.

de Bougainville, L-A. (1772). *A Voyage Round the World: Performed by Order of His Most Christian Majesty, in the Years 1766, 1767, 1768, and 1769 by Lewis de*

Bougainville... Commodore of the Expedition in the Frigate La Boudeuse, and the Store-ship L'Etoile. Trans. John Reinhold Forster. London.

Delavaud-Roux, H. (1995). L'énigme des danseurs barbus au parasol et les vases "des Lénéennes." *Revue Archéologique:* 227–64.

DeMarrais, E., Gosden, C., and Renfrew C. (eds.) (2004). *Rethinking Materiality: The Engagement of Mind with the Material World.* McDonald Institute Monographs Cambridge: McDonald Institute.

Derrida, J. (1976). *Of Grammatology*, trans. G. Spivak. Baltimore and London: Johns Hopkins University Press.

Dombrowski, D. (1997). *Giuliano Finelli: Bildhauer zwischen Neapel und Rom.* Frankfurt am Main: Peter Lang.

Dominik, W. J. (ed.) (1997). *Roman Eloquence: Rhetoric in Society and Literature.* London: Routledge.

Edwards, C. D. (1996). *Eighteenth Century Furniture.* Manchester and New York: Manchester University Press.

Emsley, C. (1979). *British Society and the French Wars, 1793–1815.* London and Basingstoke: Macmillan.

Ettinghausen, R. and Grabar, O. (1987). *The Art and Architecture of Islam 650–1250.* Harmondsworth: Penguin.

Farington, J. (1978). *The Farington Diary*, ed. K. Garlick and A Macintyre. New Haven and London: Yale University Press.

Fasel, G. (1983). *Edmund Burke.* Boston: Twayne's Publishers.

Fastnedge, R. (1962). *English Furniture Styles, 1500–1830.* Harmondsworth: Penguin.

Faulkner, T. (1813). *An Historical and Topographical Account of Fulham.* London.

Fehrenbach, F. (2005). Bernini's light. *Art History* 28: 1–42.

Fentress, E. (ed.) (2000). *Romanization and the City: Creation, Transformations and Failures. Proceedings of a conference held at the American Academy in Rome to celebrate the 50th anniversary of the excavations at Cosa, 14–16 May, 1998.* Journal of Roman Archaeology Supplementary Series 38. Portsmouth, R.I.: Journal of Roman Archaeology.

Fentress, E. (2004). *Cosa V: An Intermittent Town, Excavations 1991–1997.* Memoirs of the American Academy in Rome Supplementary Volume II. Ann Arbor: University of Michigan Press.

Ferrari, G. (2002). *Figures of Speech: Men and Maidens in Ancient Greece.* Chicago: Chicago University Press.

Fox, G. E. and Hope, W. H. St. J. (1893). Excavations on the site of the Roman city at Silchester, Hants, in 1892. *Archaeologia* 53.2: 539–73.

Fremantle, A. (ed.) (1940). *The Wynne Diaries, vol.* 3. London: Oxford University Press.

Frere, S. S. (1971). The forum and baths at Caistor by Norwich. *Britannia* 2: 1–26.

Frere, S. S. (1988). Roman Britain in 1987. 1. Sites explored. *Britannia* 19: 416–84.

Frere, S. S. (1989). Roman Britain in 1988. 1. Sites explored. *Britannia* 20: 258–326.

Frere, S. S. (1991). Roman Britain in 1990. 1. Sites explored. *Britannia* 22: 222–92.

Frere, S. S. (1983). *Verulamium Excavations II*. London: Society of Antiquaries of London.

Frontisi-Ducroux, F. (1995). *Du masque au visage : aspects de l'identité en Grèce ancienne*. Paris: Flammarion.

Fulford, M. and Timby, J. (2000). *Late Iron Age and Roman Silchester: Excavations on the Site of the Forum-Basilica 1977, 1980–86*. Britannia Monograph Series 15. London: Society for the Promotion of Roman Studies.

Garnsey, P. and Saller, R. P. (1987). *The Roman Empire: Economy, Society and Culture*. London: Duckworth.

Gell, A. (1998). *Art and Agency: An Anthropological Theory*. Oxford: Clarendon Press.

Germani, I. (2000). Combat and culture: imagining the Battle of the Nile. *The Northern Mariner* 10(1): 53–72.

Girouard, M. (1984). *The Return to Camelot: Chivalry and the English Gentleman*. New Haven and London: Yale University Press.

González, J. (1986). The lex Irnitana: a new copy of the Flavian municipal law. *Journal of Roman Studies* 76: 147–243.

Goodchild, R. G. (1946). The origins of the Romano-British forum. *Antiquity* 20: 70–7.

Goodwin, G. (1993). *Sinan: Ottoman Architecture and its Value Today*. London: Saqi.

Gosden, C. (2001). Making sense: archaeology and aesthetics. *World Archaeology* 33(2): 163–7.

Grandjeau, S. (1966). *Empire Furniture*. London: Faber and Faber.

Granville Leveson Gower, Earl (1916). *Lord Granville Leveson Gower, first Earl Granville: Private Correspondence, 1781 to 1821*, ed. Castalia Countess Granville, vol. 2. London: John Murray.

Greed, M. (ed.) (1995). *The Celtic World*. London: Routledge.

Greep, S. J. (ed.) (1993). *Roman Towns: the Wheeler Inheritance. A Review of Fifty Years' Research*. Council for British Archaeology Research Report 93. York: Council for British Archaeology.

Gros, P. (1996). *L'Architecture romaine: du début du IIIe siècle av. J.-C. à la fin du Haut-Empire*. Les Manuels d'Art et d'Archéologie Antiques. Paris: Picard.

Halperin, D. M., Winkler, J. J., and Zeitlin, F. I. (eds.) (1990). *Before Sexuality: the Construction of Erotic Experience in the Ancient World*. Princeton, N.J.: Princeton University Press.

Hammond, M. (1957). Composition of the senate, AD 68–225. *Journal of Roman Studies* 47: 74–81.

Hassall, M. W. C. and Tomlin, R. S. O. (1977). Roman Britain in 1976. II. The inscriptions. *Britannia* 8: 425–49.

Hassall, M. W. C. and Tomlin, R. S. O. (1987). Roman Britain in 1986. II. The inscriptions. *Britannia* 18: 360–77.

Hawkesworth, J. (1773). *An Account of the Voyages Undertaken by the Order of His Present Majesty, for Making Discoveries in the Southern Hemisphere.* London.

Hebditch, M. and Mellor, J. (1973). The forum and basilica of Roman Leicester. *Britannia* 4: 1–83.

Henig, M. (1993). *Roman Sculpture from the Cotswold Region, with Devon and Cornwall: Corpus Signorum Imperi Romani* vol. 1.7. Oxford: Oxford University Press.

Henig, M. (2004). *Roman Sculpture from the North West Midlands. Corpus Signorum Imperi Romani* vol. 1.9. Oxford: Oxford University Press.

Herrmann Fiore, K. (ed.) (1997). *Apollo e Dafne del Bernini nella Galleria Borghese.* Milan: Silvana.

Hibbard, H. (1982). *Bernini.* New York: Penguin.

Hibbert, C. (1988). *George IV.* London and Harmondsworth: Penguin.

Hodder, I. (ed.) (1987). *The Archaeology of Contextual Meanings.* Cambridge: Cambridge University Press.

Hope, H. (1971). *Household Furniture and Interior Decoration.* New York: Dover Publications.

Hurst, H. (1972). Excavations at Gloucester, 1968–71: first interim report. *Antiquaries Journal* 52: 24–69.

Ibsen, H. (1966). *Peer Gynt*, trans. P. Watts. Harmondsworth: Penguin.

Jacobi, Dominique (ed.) (1998). *Pascal Coste, Toutes les Egypte.* Exhibition catalogue. Marseille: Parenthèses.

Jacobsthal, P. (1944). *Early Celtic Art.* Oxford: Oxford University Press.

Jacques, D. (1822). *A Visit to Goodwood.* Chichester and London.

Jones, A. and MacGregor, G. (eds.) (2002). *Colouring the Past: The Significance of Colour in the Archaeological Record.* Oxford: Berg.

Jones, M., Stocker, D., and Vince, A. (2003). *The City by the Pool: Assessing the Archaeology of the City of Lincoln.* Lincoln Archaeological Studies 10. Oxford: Oxbow.

Joyce, J. G. (1873). The excavations at Silchester. *Archaeological Journal* 30: 10–27.

Joyce, J. G. (1881). Third account of excavations at Silchester. *Archaeologia* 46: 344–65.

Kenworthy-Brown, J. (1975–6). Notes on the furniture by Chippendale the Younger at Stourhead. *The National Trust Year Book.* London: National Trust Publishing: 93–102.

Klein, L. (1994). *Shaftesbury and the Culture of Politeness: Moral Discourse and Cultural Politics in Early Eighteenth-Century England.* Cambridge: Cambridge University Press.

Korshak, Y. (1987). *Frontal Faces in Attic Vase Painting of the Archaic Period.* Chicago: Ares Publishers.

Laing, L. and Laing, J. (1992). *Art of the Celts.* London: Thames and Hudson.

Latour, B. (1991). *We Have Never Been Modern,* trans. Catherine Porter. Cambridge, Mass.: Harvard University Press.

Laurence, R. (1994). *Roman Pompeii: Space and Society* (London: Routledge).

Laurence, R. and Berry, J. (eds.) (1998). *Cultural Identity and the Roman Empire.* London: Routledge.

Lavin, I. (1977–8). The sculptor's "last will and testament." *Allen Memorial Art Museum Bulletin* 35: 4–39.

Lavin, I. (ed.) (1985). *Bernini: New Aspects of his Art and Thought.* University Park: Pennsylvania State University Press.

Lissarrague, F. (1989). *L'Autre Guerrier: archers, peltastes, cavaliers dans l'imagerie attique.* Paris: La Découverte.

Lissarrague, F. (1990). *The Aesthetics of the Greek Banquet: Images of Wine and Ritual.* Princeton, N.J.: Princeton University Press.

Lissarrague, F. (2001). *Greek Vases: The Athenians and their Images.* New York: Riverside Book Company.

Lyotard, J.-F. (2001). *The Postmodern Condition,* trans. G. Bennington and B. Masumi. Manchester: Manchester University Press.

Maas, M. and McIntosh Snyder, J. (1989). *Stringed Instruments of Ancient Greece.* New Haven and London: Yale University Press.

Marconi, C. (ed.) (2004). *Greek Vases, Images and Controversies.* Columbia Studies in the Classical Tradition. Leiden: Brill.

Martin, A. T. (1898). Notes on the roman basilica at Cirencester, lately delivered by Wilfred J. Cripps Esq., C.B. *Transactions of the Bristol and Gloucestershire Archaeological Society* 21: 70–8.

Martin, R. (1972). Agora et forum. *Mélanges de l'Ecole Française à Rome,* 84: 903–33.

Matthews, S. (2006). *An Archaeology of Gesture: Symposium Review.* (www. semioticon.com/virtuals/archaeology/review.pdf): 1.

McCormick, E. H. (1977). *Omai: Pacific Envoy.* Auckland: Auckland University Press.

Megaw, R. and Megaw, V. (1989). *Celtic Art: From its Beginnings to the Book of Kells.* London: Thames and Hudson.

Merleau-Ponty, M. (1964). *The Primacy of Perception,* trans. J. Edie. Evanston, Ill.: Northwestern University Press.

Meskell, L. (ed.) (2005). *Archaeologies of Materiality.* Oxford: Blackwell.

Metzler, J., Millett, M., Roymans, N. and Slofstra, J. (1995). *Integration in the Early Roman West: The Role of Culture and Ideology.* Luxembourg: Dossier d'Archéologie du Musée National d'Histoire et d'Art IV.

Mew, E. (1928). Battersea Enamels and the Anti-Gallican Society. *Apollo* 7: 216–22.

Meyer, M. (1988). Männer mit Geld. *Jahrbuch des deutsches archäologisches Instituts* 103: 87–125.

Miller, M. (1992). The parasol: an oriental status-symbol in late archaic and classical Athens. *Journal of Hellenic Studies* 112: 91–105.

Millett, M. (1990). *The Romanization of Britain: An Essay in Archaeological Interpretation.* Cambridge: Cambridge University Press.

Millett, M. (2001). Review of Fulford and Timby. *Archaeological Journal,* 158: 394–5.

Milne, G. (ed.) (1992). *From Roman Basilica to Medieval Market.* London: HMSO.

Montagu, J. (1989). *Roman Baroque Sculpture: The Industry of Art.* New Haven: Yale University Press.

Moore, A. Harrison (2002). *Voyage:* Dominique-Vivant Denon and the transference of images of Egypt. *Art History* 25(4) (September): 531–49.

Musgrave, M. (1961). *Regency Furniture, 1800*–1830. London: Faber and Faber.

National Library of Australia (2001). *Cook and Omai: The Cult of the South Seas.* Exhibition catalogue. Canberra: National Library of Australia.

Necipoglu, G. (1993). Challenging the past: Sinan and the competitive discourse of early modern Islamic architecture. *Muqarnas* 10: 169–80.

Necipoglu, G. (2005). *The Age of Sinan: Architectural Culture in the Ottoman Empire.* London: Reaktion.

Niblett, R. (2001). *Verulamium: The Roman City of St Albans.* Stroud: Tempus.

Nicolet, C. (1980). *The World of the Citizen in Republican Rome.* London: Batsford.

O'Gorman, F. (1977). *The Long Eighteenth Century: British Political and Social History 1688–1832.* London: Arnold.

Osborne, R. (1998). *Archaic and Classical Greek Art.* Oxford: Oxford University Press.

Patterson, J. (2000). *Political Life in the City of Rome.* Bristol: Bristol Classical Press.

Pearson, M. and Shanks, M. (2001). *Theatre Archaeology.* London: Routledge.

Percier, C. and Fontaine, P. F. L. (1971). *Recueil de Décorations Intérieures.* Westmead: Gregg International Publishers.

Pevsner, N. and Lang, S. (1956). The Egyptian Revival. *Architectural Review* 104: 243–54.

Port, M. H. (1995). The homes of George IV. In D. Arnold (ed.), *Squanderous and Lavish Profusion: George IV, his Image and Patronage of the Arts.* London: Georgian Group.

Porterfield, T. (1998). *The Allure of the Empire: Art in the Service of French Imperialism, 1798*–1836. Princeton, N.J.: Princeton University Press.

Raby, J. and Johns, J. (ed.) (1999). *Bayt al-Maqdis: Jerusalem in Early Islam. Volume 2: Jerusalem and Early Islam.* Oxford Studies in Islamic Art 9. Oxford: Oxford University Press.

Reid, D. M. (2002). *Whose Pharaohs?* Berkeley: University of California Press.

Renfrew, C. (2003). *Figuring it Out: What Are We? Where Do We Come From? The Parallel Visions of Artists and Archaeologists.* London: Thames and Hudson.

Renfrew, C., Gosden, C., and DeMarrais, E. (eds.) (2004). *Substance, Memory, Display: Archaeology and Art.* McDonald Institute Monographs. Cambridge: McDonald Institute for Archaeological Research.

Rickman, J. (1781). *Journal of Captain Cook's Last Voyage to the Pacific Ocean.* London: E. Newbery.

Riegl, A. (1893). *Stilfragen.* Berlin.

Roe, S., Sellars, S., Ward Jouve, N., and Roberts, M. (1994). *The Semi-Transparent Envelope.* London and New York: Marion Boyars.

Romilly, S. (1840). *Memoirs of the Life of Sir Samuel Romilly,* vol. 2. London.

Schäfer, A. (1997). *Unterhaltung beim griechischen Symposion.* Mainz: Philipp von Zabern.

Schiff, R. (2005). Something is happening. *Art History* 28(5): 752–82.

Scholten, F. (ed.) (1998). *Adriaen de Vries, 1556–1626.* Exhibition catalogue. Amsterdam: Rijksmuseum.

Sear, F. (1982). *Roman Architecture.* London: Batsford.

Shennan, S. (2002). *Genes, Memes and Human History.* London: Thames and Hudson.

Sheraton, T. (1804–7). *The Cabinet Maker, Upholsterer and General Artist's Encyclopaedia.* London.

Smith, G. (1808). *A Collection of Designs for Household Furniture.* London.

Southey, R. (1807). *Letters from England, by Don Manuel Espiriella,* vols. 1 and 3. London.

Speiser, P. (2001). *Die Geschichte der Erhaltung der arabischer Baudenkmäler in Ägypten.* Heidelberg: Heidelberger Orientverlag.

Summerson, J. (1993). *Architecture in Britain, 1530–1830.* New Haven and London: Yale University Press.

Symonds, R. W. (1957). Thomas Hope and the Greek Revival. *Connoisseur* 140: 226–30.

Tarlton, J. and McCormick, E. H. (1977). *The Two Worlds of Omai.* Exhibition catalogue. Auckland: Auckland City Art Gallery.

Thomas, N. (1991). *Entangled Objects: Exchange, Material Culture and Colonialism in the Pacific.* Cambridge, Mass., and London: Harvard University Press.

Thomas, N. and Berghof, O. (eds) (2000). *George Forster: A Voyage Round the World,* 2 vols. Honolulu: Hawaii University Press.

Trillmich, W. and Zanker, P. (eds.) (1990). *Stadtbild und Ideologie. Die Monumentalisierung hispanischer Städte zwischen Republik und Kaiserzeit. Kolloquium in Madrid vom 19. bis 23. Oktober 1987.* Munich: Verlag der Bayerischen Akademie der Wissenschaften.

Troide, L. E. (ed.) (1988). *The Early Journals and Letters of Fanny Burney. Volume II: 1774–7.* Letter, December 1, 1774. New York: Clarendon Press.

Vos, M. F. (1963). *Scythian Archers in Archaic Attic Vase-painting.* Groningen: J. B. Wolters.

Wacher, J. S. (1995). *The Towns of Roman Britain.* London: Batsford.

Ward-Perkins, J. B. (1970). From Republic to Empire: reflections on the early provincial architecture of the Roman west. *Journal of Roman Studies* 60: 1–19.

Ward-Perkins, J. B. (1981). *Roman Imperial Architecture.* Harmondsworth: Penguin.

Warner, M. (2002). *Publics and Counterpublics.* New York: Zone Books.

Watkin, W. (1968). *Thomas Hope 1769–1831 and the Neo-Classical Idea.* London: Murray.

Wells, P. S. (2001). *Beyond Celts, Germans and Scythians.* London: Duckworth.

Wiet, G. (1949). *Muhammad Ali et les beaux-arts.* Cairo: Dar al-Ma'arif.

Williams, D. (1993). *Corpus Vasorum Antiquorum: Great Britain, Fascicule 17; The British Museum, Fascicule 9.* London: British Museum Press.

Wills, G. (1969). *English Furniture, 1760–1900.* London: Guinness Superlatives.

Wilson, K. (ed.) (2004). *A New Imperial History: Culture, Identity and Modernity in Britain and the Empire 1660–1840.* Cambridge: Cambridge University Press.

Winner, M., Andreae, B., and Pietrangeli, C. (eds) (1998). *Il cortile delle statue. Der Statuenhof des Belvedere im Vatikan.* Mainz am Rhein: Philipp von Zabern.

Zanker, P. (1988). *The Power of Images in the Age of Augustus.* Ann Arbor: University of Michigan Press.

Zanker, P. (1998). *Pompeii: Public and Private Life.* Cambridge, Mass. Harvard University Press.

Index

Note: Page numbers in italics denote illustrations

Abbasid style 69, 71, 73
Abd al-Malik 69
abstract decoration 69–71
Achilles 47
Ackermann, R. 121
Agariste 50
age/beards 45–6, 47, *48*, 49
Agricola 132
Ahmed, Sultan 77
Alessandro, P. 57
Alexandria 70
Alien Act 107
American War of Independence 106,
 109
Amr mosque 71, 72
Anacreon 37
Andrews, Dr. 23
andron (symposion room) 31, 36, 49
Anti-Gallican Association 105
Apollo and Daphne (Bernini) 55, *56*
 drillwork 60
 metamorphosis 63
 struts 60–1, *62*, 63–4
 transformation 5–6, 57
apotropaic functions 88

appropriation
 body ornaments 84–5
 colonialism 29–30n24
 indigenous/European 17, 27
archaeology 88, 101, 102
architecture
 civil/religious 67
 Ibn Tulun 73
 Islamic 6
 modernity 68–9
 monumental 127, 130
 multivocality 128–9
 national style 111
 politics 7
 see also forum-basilica; mosques
aristocracy 112
 see also elites
armlet, golden 90, *91*, 92
art nouveau shrine 68
Ashby Painter 35–6
Ashmolean cup 44–5
asymmetry 89–90, *91*–2
Athenaios
 Deiphnosophistai 31–2
Atkinson, D. 132

Attree, T. 115
auctoritas 141
aulos 32, *33*
Aurillac burial site 90–1
Avery, C. 55
Ayyubid period 73

Bad Durkheim burial site 89
Baghdad 69
Balty, J. Ch. 139
Bandinelli, B. 57
Banks, Sir J. 17
Bann, S. 2, 8n2
barbitos (stringed instrument) 32, *33*
Bartelozzi, F. 21–2
basilicas 7, 138–9
 see also forum-basilica
Baylan architects 77
beards/age 45–6, 47, *48*, 49
Beazley, D. 39
Behrens-Abouseif, D. 5, 6, *72, 76, 78*
Bellaigue, G. de 112, 114
Bernini, G.
 Aeneas 62
 Clement X 64
 Constantine 64
 David 55, 57, 58, 62
 developing career 63–4
 illusion 62
 Pluto and Proserpina 58
 repairs to sculptures 60
 St. Jerome 64
 St. Longinus 57
 struts 60–1, 62, 63–4
 transformation 5–6, 57, 63
 Urban VIII 63
 see also Apollo and Daphne
Bernini, P. 60
Bernini Scultorei exhibition 57
Bey Abu 'l-Dhahab, Muhammad 75
Bhabha, H. 20
Bindman, D. 104, 108

Blagg, T. 132, 144–5
Blue Mosque 77
body 83–5
body decoration
 asymmetric 89–90
 color 88–9
 elitism 95
 gestures 92, 93
 identity 82, 95–6
body ornaments
 appropriation 84–5
 burials 82
 mobility 84
 phantasmagoria 6–7, 87–92
 social relations 85
Bomford Cup 36–8
Borghese, Cardinal 55, 57, 58
Boucher, F. 105
Bougainville, L. A. de 17
Bourdieu, P. 8–9n7
bracelet, golden 89–90, 92
breeding 19
bribery in elections 129
Brigham, T. 138
Brighton Pavilion 104, 114–15
Briseis Painter 46, *48*
Britain
 Act of Union 105
 Egyptian Revival style 104–9, 118
 French imports 108
 French influence 104–5, 110–11,
 113–14
 French residents 107
 French Revolution 106
 Home Office 108
 national style of architecture 111
 patriotism 105–6
 Radicals 106–7
 see also Roman Britain
British Museum cup 42, *43*, 44, 45
Brown, R. 119
al-Burdayni, Shaykh 74

burials 82, 84, 93
 see also individual sites
Burke, E. 107, 112, 123n21
Burney, F.
 diary 19–20
 gentlemanliness 17–18
 imitation 22–3
 Mai 15, 16, 17–18
 sensibility 29n10
Busby, C. A. 119
Byzantine influence 69–70
Byzantium 69

cabinet-makers: *see* furniture-making
Caerwent forum 134, 137, 138, 139,
 140, 143
Caesar, Julius 143
Cairo 68, 70, 74
Caistor forum 134, 140, 142, 143
Campbell, C. 111
Carlton House
 politics of opposition 104, 109
 redecoration 119
 refurbishment 110, 112, 114–15
 see also Holland, H.; Porter, W.
Caylus, Comte de 101–2
Celebi, E. 79
Cellini, B. 58, 60
Celtic decoration 83
Celtic identity 83–4
Cézanne, P. 88
Champion, S. 84–5
Champollion, J. 116, 118
Chartier, R. 115
Chesterfield, Lord 18, 20, 29n22
Chinese style 114–15
Chippendale, T. 118, 122n11
chiton (robe) 37
Cicero 129
Cirencester forum 139, 142
Citadel mosque 76, 77, 78, 80
civilization/dress 42

civilization/nature (Rousseau) 17, 20
Civitas Cornoviorum 145
Colchester forum 140
Cole, M. 5–6
Coliva, A. 57, 60
Collard, F. 112, 114
Collegium Peregrinorum 145
Colley, L. 104, 114
colonialism 15–16, 29–30n24
color/body ornamentation 88–9
Colt-Hoare, R. 118
Connerton, P. 3
consciousness, core/extended 86–7
consumption 110
 see also cultural consumption
Cook, Captain J. 4, 13, 17, 23, 26–7
Copts 73
coral branches 88
Cordier, N. 64
 St Sebastian 58, 59, 60
Cosa 130–1
Coste, P. 75, 77–8
courtship 46
crater (wine-mixing bowl) 47, 49
Craven Cottage, Fulham 119
cultural capital 104, 106, 108
cultural consumption 7, 101, 136
cultural treason 111
cup-skyphos (drinking vessel) 35
curia 139
Cuvilliés, F. de 105

Daguerre, D. 113, 114, 115
Damascus 69, 71
Damasio, A. 86
Dance, N. 22
De' Rossi, V. 64
 Hercules and Cacus 58
De Vries, A. 62
decoration
 abstract 69–71
 Egyptian motifs 101, 102

decoration (*cont'd*)
 forum-basilica 138, 141–2
 light in 90–1
 see also body decoration
decurions 145
Deepdene, Surrey 121
Denon, D.-V. 102, 114, 116, *117,*
 118, 120
Derrida, J. 86
difference, politics of 110
Dionysos 37, 46–7, 49
Directoire style 115–16
Douglas, B. 30n27
dress
 civilization 42
 feminization 37
 masculinity 41–2
 pottery 41–2, 44
 symposion *33,* 34, 37–8
 women's 3, 42, 44
drinking vessels, phallic imagery 36–7
Duchess Street House 120–1

Edgeworth, M. 121
Egypt
 Alexandria 70
 Amr mosque 71, 72
 as British Protectorate 78
 Copts 73
 European influences 77–8, 79, 80
 Islamic art 72–3
 Mamluk style 68, 73–5
 modernity 68–9, 79–80
 mosques 70–1, 74
 Ottomans 68, 79
 power symbols 116
Egyptian expedition 7, 101
Egyptian motifs 101, 102, 116, 118
Egyptian Revival style 67–8
 Britain 104–9, 114–15, 118, 120
 furniture-making 7, 101–4
 short-lived 121

Egyptiana 101–3
elections 129
elites 95, 108, 112, 115
emperor: *see* imperialism
Erstfield burial site 93
Euripides
 Bacchae 37
Europe, prehistoric 83
Exeter forum 134
exoticism 15
experience 3
exploration 102
 see also Denon, D.-V.

facial imagery 89, 93
Farington, J. 119, 122n3
Fastnedge, R. 116
Fatimid dynasty 73
feminization 37
Ferrari, G. 44
Finelli, G. 55, 60, 62
Fiore, K. H. *56,* 65n4
Fontaine, P.-F.-L. 102–3, 114, 116,
 118, 120
foreignness 111
forum 7, 127–8, 136–41
 see also forum-basilica
Forum Augustum 131
Forum Iulium 131
Forum Romanum 129–30
forum-basilica 127
 Cosa 130–1
 cultural meaning 136
 decoration 138
 provinces 131–2
 Roman politics 129–32
Foundry Painter 32, *33,* 36
Fox, C. J. 7, 104, 106, 108, 109,
 114
France
 culture/politics 7
 Egyptiana 101–3. 120

influence on British taste 104–5,
108, 110–11, 113–14
New National Convention 107
French Revolution 106, 115
Frere, S. S. 140
Furneaux, Captain 4, 13
furniture-making
Egyptian Revival style 7, 101–4
English 102, 105
history of 112–13
pattern-books 102–4, 105, 118
rococo 105
al-Fustat 70, 73

Gallic provinces 134
Gaubert, G. 110, 113
gender differences 3
gentlemanliness 16, 17–19, 27, 28
Gentleman's Magazine 105
George III
cultural capital 106
French influence 7, 104
Mai 4, 16, 21, 23
mobbed 108
Prince of Wales 109
Windsor Castle 111
gestures 45–6, 92, 93
al-Ghawri, Sultan 75
Giambologna 57, 58
gift exchange 46
Gloucester forum 142
Goodwood 118
Goody, J. 85
Grandjeau, S. 103
grave goods 84
Greece 118
Greek Revival form 118
Grohmann, A. 102
Guest, H. 20

habeas corpus suspended 108
Hackforth-Jones, J. 4, 5

al-Hakim 73
Halstatt period 88, 93
Harrison-Moore, A. 7
Hasan, Sultan 78
Hawkesworth, J. 17
Hector 47
Herodotos 50
Hibbard, H. 55
himation (cloak) 32, 34, 37, 41
Hippokleides 50
Hirschlanden Lemberg statue 89, *90*,
92–3
Holland, H. 104, 113, 114, 119, 120
Holzgerlingen site 89
Homeric epic 41
Hope, T. 103, 125–6n72
Household Furniture 103, 120–1
Huguenot craftsmen 105
A Human Sacrifice 24, *26*
hypocausts 134, 140

Iberian provinces 134
Ibn al-As, Amr 70
Ibn al-Khattab, Umar 70
Ibn Tulun 71, *72*, 73, 77
identity 3–7
body 85
body decoration 82, 95–6
creation of 84–7, 92
expressions of 94
negotiation of 87–92
objects 2
performance 5
phantasmagoria 6–7, 87–92
in process 86–7
projections 5–6, 31, 40–1, 50–1
self-reflexivity 34–5
social relations 86
symposion 5
transformation 5–6, 94–5
image-making 89
imitation 16, 20–1, 22–3, 29n22

imperialism
 iconography 131–2
 political space 143
 statues 141, 142–3
 temples 143–4
Iran 67, 69, 73
Iraq 69–70
Islamic architecture 6, 67
Islamic art 69–71, 72–3

Jacob-Desmalter, F.-H.-G. 103–4
Jacobinism 105
Jacobsthal, P. 82, 95
Janus imagery 89
Jones, I. 111
Joséphine (de Bearharnais) 103
Jourdain, M. 124n39

Kleisthenes 50
kottabos (drinking game) 32, *33,* 34
kylix (drinking vessel) 32, *33,* 35–6

Landi, G. 120
landowners 112
Laocoön 57
Le Pautre, J. 105
Leicester forum 134, 140, 142
light in decoration 90–1
Lignereux, M. E. 115
Lincoln forum 142
lion motif 120
Locke, J. 18–19, 20
London Corresponding Society 107,
 108
London forum 134, 138
Lorenz 88
Louis XVI 106, 116
lyre 32, *33*

maenads 46
magistracies 129, 144–6
Mai 4–5

as comic buffoon 16, 22–3
as cultural interpreter 16, 23–4
imitation 22–3
in London 13, *14,* 15–19
mimicry 20–1, 24, 26, 27, 28
performance 21, 27, 28
portrait *14,* 21–2, 30n26, 30n27
repatriation 16, 24, 26
social status 26–7
subversiveness 24
al-Malik al-Kamil 73
Mamluk style 68, 73–5
manners 20
 see also gentlemanliness
al-Mansur 69–70
Marot, D. 105
masculinity 4, 16, 41–2
materiality
 aesthetic 2, 3
 Bann 2
 cultural consumption 101
 identity 3–4
 meaning 1, 2
 memory 85
 social relations 1–2, 3, 85–7, 121
mausoleum, Shafei 73
meaning/materiality 1, 2
Megaw, V. 89
memory 85
men, bearded/beardless 45–6
Merinid dynasty 67
meritocracy 112
Merleau-Ponty, M. 88, 92
Michelangelo 57, 58
mimicry 16, 29–30n24
 Mai 20–1, 24, 26, 27, 28
 performance 5
 as resistance 20–1
minarets 74, 75
Mochi, F. 58
modernity
 architecture 68–9

Egypt 79–80
mosques 77
Montagu, J. 55, 65n4
Morocco 67
mosaics 134, 140
mosques
 Cairo 74
 Egypt 70–1, 74
 minarets 74, 75
 modernity 77
 Muhammad Ali Pasha 76, 77, 78, 80
 Ottoman architecture 77
 Samarra style 71
 Sultan Hasan 78
 see also specific mosques
Muhammad 'Ali Pasha 68, 76, 77, 78, 80
Munatius Bassus 140
munificence, collective 144–5
Murad III 68

nakedness/weakness 41
Napoleon I 7, 101, 112, 116
al-Nasir Muhammad 77
nationalism 105, 108
natives 15–16
 see also noble savage imagery
nature/civilization (Rousseau) 17, 20
neck rings 84
neo-classical style 111
neo-Mamluk style 75–6, 77
New National Convention 107
Nikosthenes Painter circle 39, 40
noble savage imagery 13, 14, 15, 22
non-literate societies 85
Norden, F. 102
North, Lord 106, 109
Nuru Osmaniye mosque 68

objects
 experience 3
 identity 2

mnemonic function 95
social relations 113
 see also materiality
O'Gorman, Frank 109
oinochoe (jug) 33, 34, 35–6
Omai: *see* Mai
Omai's entry into Tahiti (Rickman) 24, 25
Omiah, the Indian from Otaheite 15, 22
Orléans, Duc d' 110
Osborne, R. 4, 5
other/self 86
Ottoman architecture 67–8, 77

Pacific islands 17
Paine, T. 107
Painter of Longon E55 42, 43, 44, 45
Palladio, A. 111
Parry, W. 22
Passeron, J.-C. 8–9n7
patriotism 105–6, 108
pattern-books 102–4, 105, 118
Percier, C. 102, 114, 116, 118, 120
performance
 gentlemanliness 18–19
 identity 5
 Mai 21, 27, 28
 mimicry 5
 provinces 128
 reputation 49–50
 transformation 94–5
Persian art 67
phallic imagery 36–7
phantasmagoria 6–7, 87–92
Piranesi, G. 102
Pithos Painter 38
Pitt the Younger, W. 7, 104, 106, 108, 112
Plato 31
politeness 18, 20
political space 140–1, 143
politics 7, 141

politics of difference 110
politics of opposition 104, 109
Pompeii 132
Porter, W. 119, 120
Porterfield, Todd 116, 118
Portland, Duke of 109
pottery
 bearded/beardless men 45–6, 47, *48*, 49
 black-figure technique 39
 Dionysos 46–7, 49
 dress 41–2, 44
 frontal face depictions 40–1
 komast pose 39
 maenads 46
 non-sympotic scenes 39–49
 paired men and women 42, *43*, 44–5
 phallic imagery 36–7
 public/private life 45
 red-figure technique 38, 39
 sympotic scenes 5, 32–9, 49
 warfare imagery 39–40
 women's dress 42, 44
 wool-basket 44
power 7, 116
Preimesberger, R. 57
Priam 47
Price, R. 107
Priestley, J. 107
projection, identity 31, 40–1, 50–1
property qualification 129, 130
provinces 128, 130, 131–2
public/private life 45, 50

al-Qahira 73
Queen's House, Greenwich 111
Quintilian 129

radicalism 106–7, 114
rank 26–7, 130

Recueil d'antiquités égyptiennes,
 étrusques et romaines 101–2
Recueil des décorations
 intérieures 102–3
Regency style 111
Renaissance art theory 57
representation, visual/literary 13, 15
reputation 49–50
resistance, taste 110–11
Revell, L. 7
Revett, N. 102
revivalism movement 6, 67–8, 116
 see also Egyptian Revival style
Reynolds, Sir J. 13, 15, 109
 Omai 14, 21
Rickman, J. 24, *25*
rings 84, 88
Rockingham, Lord 109
Rockwell, P. 55, 60, 61–2
rococo 105, 122n11
Rodenbach burial site 89–90
Roman Britain
 fora 127–8, 132–41
 magistracies 144–6
Romanization 128
Rome 7
 archaeology 101
 architecture of city 128
 census 140
 Curia 139
 forum 137
 Forum Augustum 131
 Forum Iulium 131
 political space 129–32, 140–1
 provinces 128, 130, 131–2
Roquepertuse shrine 89
Rousseau, J.-J. 17, 20
Royal Academy 109

Safavid dynasty 67
Safiyya, Queen 74

sakkos (head-covering) 37
Salah al-Din 73, 78
Samarra style mosques 71
Sandwich, Lord 17, 21, 24
sans-culottes 108
Scalza, I. 57
sculpture
 hiding joins 57–8
 monolithic 57
 repairs 60
 risk zones 58, *59*, 60
 sprues 62
 struts *59*, 60–1, 62, 63–4
 transformation 63
Scythian cap 38
self 86
self-reflexivity 34–5
Selim II 68
sensibility 29n10
Seven Years War 105
Shafei mausoleum 73
Shahzade mosque 68, 77
shape-changing 89
Sheraton, T. 118, 119
Shia faith 73
Silchester
 Collegium Peregrinorum 145
Silchester forum 132, *133*, 134, 140,
 143
 basilica nave 138–9
 decorations 141–2
Sinan 67, 68, 77
skyphos (drinking vessel) 35, 36
Smith, G. 102, 121
Snettisham burial site 93
social relations
 body ornamentation 85
 identity 86
 materiality 1–2, 3, 85–7, 121
 objects 113
Solander, D. 17

Southey, R. 111
Spence, J. 107
Standards, Shrine of 144
Stanhope, P. 20
statues of emperor 141, 142–3
 see also sculpture
Stevens, F. 6–7
Stourhead library 118
Stowe 118
Stuart, J. 102
subversiveness 24
Suleyman the Magnificent 68
supernatural, relations with 82
symposion
 andron 31, 36, 49
 descriptions of 31–2
 dress *33*, 34, 37–8
 entertainment 32, *33*, 34–8
 identity 5
 negotiation of 49–50
 performance/reputation 49–50
 pottery 32–8
 public/private life 40, 50
 see also pottery, sympotic.
Syrian expedition 7, 101

Tahiti 16, 17
Tammonius Vitalis, Titus 142
taste/resistance 110–11
Tatham, C. H. 120
tattooing 13, *14*, 15
temples 131, 132, 143–4
La Tène decoration 83, 88, 89, 95
Thomas, N. 17, 27
The Times 107
torcs 92, 93
Traitorous Correspondence Bill 107
transformation 2, 5–6, 63, 89, 94–5
transubstantiation 2, 8–9n7, 8n6
tribunal forms 138–9
Tuilleries 116

Turkey 67–9, 79
Turner, C. 21

Ulpius Januarius, Marcus 145
Umayyad caliphate 69
Urban VIII, Pope 63

Venus Genetrix temple 131
Verulamium (St. Albans) 134, *135*,
 137, 139–40, 142
Victorian dress 3
virtus, political 129, 141
Vitruvius 128, 143
Vix burial site 88, 89
Volney, C. 102
Volusia Faustina 145
voting 129, 130

Wales, Prince of (later George IV) 7,
 104, 106, 109, 110–11, 113–14
 see also Brighton Pavilion; Carlton
 House
al-Walid 69
Wallis, S. 16–17
weakness/nakedness 41
Webber, J. 23, 24
Wellington, Duke of 104
Williams, D. 47
Windsor Castle 111
Wroxeter forum 132, 134, 140, 142

Xenophon 31

al-Zafir, Shaykh, shrine of 68
Zanker, P. 131